SAINT EXUPÉRY

ART, WRITING AND MUSINGS

Copyright © 2003 by Éditions de le Martinière

First published in the United States of America in 2004
Rizzoli International Publications, Inc.
300 Park Avenue South
New York, NY 10010
www.rizzoliusa.com

First published in France in 2003 by
Éditions de le Martinière
2, rue Christine
75006 Paris, France
www.lamartiniere.fr

Design and layout by Rampazzo & Associés

2004 2005 2006 2007 2008 / 10 9 8 7 6 5 4 3 2 1

Printed in France by Pollina s.a. - n° L90110C

ISBN: 0-8478-2594-9

Library of Congress Catalog Control Number: 2003094563

SAINT EXUPÉRY

ART, WRITING AND MUSINGS

NATHALIE DES VALLIÈRES

with Roselyne de Ayala

Translated from the French by Anthony Zielonka

RIZZOLI
NEW YORK

From the very first letter of a child who was anxious whilst away from his mother, at boarding school, and who told her about his worries and problems, to the last message that he sent to Pierre Dalloz, the day before he and his plane went missing, in July 1944, this book reveals the writing styles and the artistry of Antoine de Saint Exupéry, whose calligraphy and handwriting were always evolving and shedding light on the diverse situations he found himself in during his lifetime. In his letters, applications for patents, film scenarios, and personal thoughts jotted down hastily in the notebooks which he always carried with him, we discover that Saint Exupéry's writing style changed according to the circumstances and the places in which he found himself when he was writing. We see how diverse were the writing styles of the student who, in spite of his earnestness at his studies, had to cross out many of the things he had written; we see the writer's margins growing wider, as he expressed his thoughts in the letters he wrote, the brief notes he scribbled to his fellow pilots during flights, as well as sentences in his manuscripts that were corrected over and over again, and the changes and deletions he made to his texts. We see the light and sometimes illegible, spidery scrawl of his hand on the flimsy paper on which he wrote *Citadelle (Wisdom of the Sands)*. All of these testify to the care Saint Exupéry took, and the demands he made upon himself, to find the *mot juste*.

The paper that he wrote on and its visual appearance were just as important as what he was writing: sheets of paper bearing the letterheads of the many hotels that Saint Exupéry stayed at throughout his active life and which he regularly used for his correspondence, were also utilized as manuscript pages whenever he did not have any other paper at hand. The handwritten text of *Courrier Sud (Southern Mail)* like that of *Vol de Nuit (Night Flight)*, written in the desert of Mauritania, thus consists of illustrated sheets that astonish researchers. Paper napkins from restaurants, on which the author of *The Little Prince* created his characters, and on which the inventor solved mathematical problems, flimsy sheets of paper whose lightness contrasts with the intensity of what he was writing – these are just a few examples of the extremely diverse kinds of paper that he used, on which to set down his ideas with a fountain pen or a pencil.

Saint Exupéry was not a sedentary writer who would sit comfortably in a room devoted to writing. The conditions in which he wrote his texts were often spartan. But readers discovering these manuscripts, both those that are illustrated and those that consist solely of text – the vast majority of which appear here for the first time – will be amazed and delighted to see the elegance and the refinement of the calligraphy, the writing and the artistic styles of this great writer.

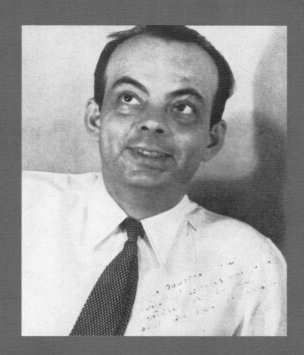

Saint Exupéry, Writer

« I come from my childhood,
as though it were my homeland. »

The literary output of Antoine de Saint Exupéry is like that of few other writers. Active as both a player and a witness of his time, he was one of the only authors who could declare: "Writing is the fruit of experience." A pilot, poet, philosopher, journalist, and inventor, Saint Exupéry did not belong to any literary school. The originality of his writing is rooted in the fact that his writings were modeled on his life; a life made up of very brief episodes, but filled with new developments. He was by no means a prolific author: apart from his substantial correspondence and newspaper articles, of which no handwritten record has been preserved, Saint Exupéry wrote only a few books in the course of fourteen years he spent as a writer. At each intense moment in his life, he felt the need to give an account, and let others share in his experience. After spending eighteen months as the director of the aerodrome of Cape Juby, in the desert of Mauritania, Antoine de Saint Exupéry returned to France with his first novel, *Southern Mail (Courrier Sud).*

Out of his participation in the Aeroposta Argentina network in South America, would emerge *Night Flight (Vol de nuit).*

Wind, Sand and Stars (Terre des hommes) is the account of his life as a pilot from 1926 to 1936. *Flight to Arras (Pilote de guerre)* tells the story of the heroic combat missions flown by the pilots of 2/33 squadron, during World War II, prior to the signing of the Armistice.

Letter to a hostage (Lettre à un otage), addressed to Léon Werth, is a meditation on the suffering of those who endured the burden of the German occupation in their own country.

Only *The Little Prince* seems not to have been subjected to this need to testify to a life of action. In this, the last of his books, Saint Exupéry was writing for those who were, mentally, still living in the land of childhood that had marked him so deeply.

Finally, the posthumously published *Wisdom of the Sands (Citadelle),* is an unfinished essay that marked a turning point, as the respected novelist emerged as a philosopher in the making, who would never be recognized as such because of his premature disappearance.

Saint Exupéry was a nomad and the precarious nature of the situations in which he found himself is apparent in his writing. It is therefore interesting to examine the manuscripts of his texts, in order to better understand the conditions in which his literary creations came into being and his talent as a writer found expression. Whether he was writing letters at a café table, or beginning his first novel in the solitude of Cape Juby, bent over a plank on his knees by the light of a gas

***Below* : Covers of the first editions of some of Saint Exupéry's books in the "Livre de Poche" paperback collection (Hachette).**

lamp, or seeking refuge in an inhospitable cellar in Barcelona or Madrid when he was reporting during the Civil War, or sitting comfortably at his writing table in Paris or New York, or lying on the lawn of Bewin House, in the heat of the American summer, as he thought up *The Little Prince*, his writing underwent variations of intensity, clarity and readability, depending upon where he was and his state of mind at the time. We can also imagine him scribbling ideas furiously, as they occurred to him, in one of the small notebooks he carried around with him from 1935 until his arrival in the United States in 1940.

Saint Exupéry was not one of those writers who sat down at their desk at a precise time every morning, and went off to dinner in the evening, satisfied that they have filled up their quota of blank pages with ink marks. His writing was very fine, despite the wide nib of the pen he used, and is sometimes barely legible, as those who have deciphered the manuscript of *Wisdom of the Sands* can attest. The words skirt around each other, overlap, condense, stretch out indefinitely, contract, and lead a life of their own under the feverish hand of the man who modulated them. Most of the time, they were bits of information that only Saint Exupéry was capable of reading and utilizing, transcribing them onto his favorite medium, the continual bible paper.

In addition to these piles of paper covered in undeciferable signs, the writer also used other media to express his ideas: embossed paper table-cloths from restaurant tables were the cradles on which *The Little Prince* was graphically conceived. A thousand graffiti can testify to the mathematical imaginings that Saint Exupéry explained to his friends at a dinner party. The letterheaded papers of the hotels where he stayed, in France and abroad, have retained the traces of his correspondences and the caricatures he drew to amuse the recipients of his letters. They were also used as manuscripts of his novels, including *Night Flight*. There were also the sheets of paper on which he wrote hastily during his flights over the desert. An entire world of small notations, thrown down one after another and often altered or crossed out, form the body of the manuscripts of Saint Exupéry, which were covered with constant corrections. Later on, after returning to the cheerful disorder of his apartment or hotel room, he revised his texts and, once satisfied with the results, he would pick up the phone at any hour of the night and think nothing of keeping a sleepy friend awake, reading his prose to him and listening to the harmony of the words more intently.

Above : Edition in the "Folio" collection (Gallimard) of *The Little Prince*.

Right : Preparatory drawing for the illustrations of *The Little Prince*.

Légende déssins

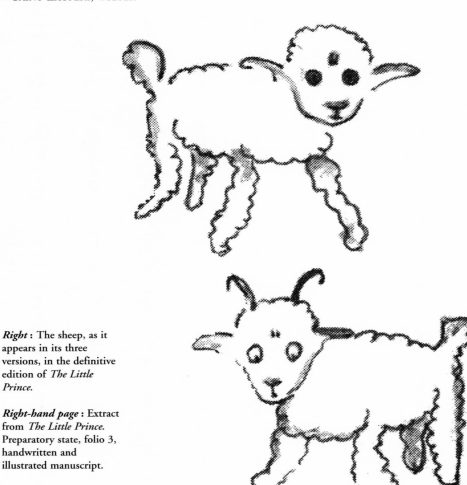

[I] recalled that I had studied, above all, geography, history, arithmetic and grammar.
– I don't know how to draw!
– That doesn't matter, draw me a sheep.
As I had never drawn a sheep, I made for him the only drawing I knew I could do.
– No, I don't want an elephant inside a boa constrictor. I'm not interested in boa constrictors. They [illegible] me. Elephants are better, but they're too bulky. What I want is a sheep; I need one. Mine is really small.
So I did a drawing.
He looked at it gravely and said:
– That one is sick, draw another one.
I started over.
– That's not a sheep, that's a ram. It has horns.
I started over.
– That one is too old. I want one that will live for a long time.

Right : The sheep, as it appears in its three versions, in the definitive edition of *The Little Prince*.

Right-hand page : Extract from *The Little Prince*. Preparatory state, folio 3, handwritten and illustrated manuscript.

« Draw me a sheep »

The Little Prince was conceived in the desert, possibly at Cape Juby, as was believed by Didier Daurat, possibly as a result of an airplane accident that had left a strong mark on Antoine de Saint Exupéry. The idea for it may have occurred to him after a providential encounter at that time that saved his life: "As for you who are saving us, Bedouin from Libya, you will disappear forever from my memory. I shall never remember your face. You are Man and you appear to me with the face of all men. You never looked at us closely and already you have recognized us. You are the beloved brother. And I, in turn, shall recognize you in all men"
Terre des Hommes (Wind, Sand and Stars).

m'apparu qui s'avait mutin appui la popoja l'hutin le cessure,
et la frumeau.

— ... mon pour serria !

— Ça m'fait avi, dessini mon un mouton.

Comme ji n'avani jamani dessini un mouton ji lui im
lui le seul essin que ji savani fair, je lun siupeuni devuit
le petit lunbomim un dor.

— non. je ne vaux pas d'un elephant dann un boa. les
boas so un intérion pau, de un dangenou, les elephans
lui encombrani. le un je veu c'on un mouton. Clien vui
c'en tion petit.
pluv je dessinai

Il regada gravement cении
— celu le eu moradé fori en un auto.
le recommenca

— o nu pas un mouton c'on un belin. il a des
cornes.
ji recommencai :

— celu le ut tion noui , envou un an une
longtimp.

PIERRE G. LATÉCOÈRE

79. Avenue Marceau.

PASSY 52-72

PARIS, le *8 Juillet 1929*

Mon cher Saint-Exupéry,

J'ai voulu lire votre "Courrier Sud"

avant de répondre à votre hommage.

C'est l'âme de nos pilotes qui

a permis de créer la "Ligne.",

cette âme, je la retrouve qui magnifie

chaque page de votre œuvre : je vous

félicite et vous remercie.

Pierre Latécoère

Left : Card from Pierre Latécoère, thanking and congratulating Saint Exupéry for *Southern Mail*.

Right-hand page : Extract from *Southern Mail*. Preparatory state. Illustrated manuscript.

Rocks in Spain, the sands in Africa, humus (illegible) earth is rare, like a precious pastry! …

The last towns will pass, the last wheat fields [two illegible words] pure as water. This evening, Bernis will witness the [undressing] [stripping] of the earth... And here is Málaga already [the last smile of Europe]. Algeciras shines goodbye from Europe.

Bernis is [sad] weary. Two months earlier, he was going up to Paris, intent on winning Geneviève. He was returning to the Company yesterday, having put some order into his defeat. Night is close. When a turn to the left detaches him from Europe [it will be dark], the lighthouse [of Algeciras] of Tangier will shine.

Flight over Spain

The hero of *Southern Mail*, published by Gallimard in 1929, is a pilot on the airmail route Toulouse-Dakar. Jacques Bernis experiences solitude and the nomadic life. In addition to his isolation, he experiences the regret of not having found, as his childhood friend Geneviève has found, stability in a home, a group of friends, an ordered life. And as cracks begin to appear in Geneviève's world, with her unhappy marriage and the death of her child, and as she subsequently grows closer and closer to him, the inconvenience of an exhausting, dangerous and uncomfortable life that is often so different from the great adventure he had dreamed of, becomes more and more unbearable to him. Disappointed by the other forms of bliss that he has tried to achieve, through religion and easy women, Bernis throws himself with conviction and enthusiasm into a job whose hours are marked by the wind, rain and night. That is, until the day when his airplane goes down into the desert. "Pilot killed, airplane broken up, mail intact. Stop. Am going on to Dakar," cables the comrade who has found him, later sending another cable: "From Dakar to Toulouse: mail arrived safely Dakar. Stop."

[handwritten manuscript, largely illegible]

pilote · poste · avion

(courrier aérien en Espagne)

Below : *Wind, Sand and Stars* was inspired by Saint Exupéry's accident at the end of December 1935 in the Libyan desert. Here he stands in front of the wreckage of the crashed Simoun.

Right-hand page : Extract from *Wind, Sand and Stars*, folio 61. Preparatory state, numerous variants as compared to the published text.

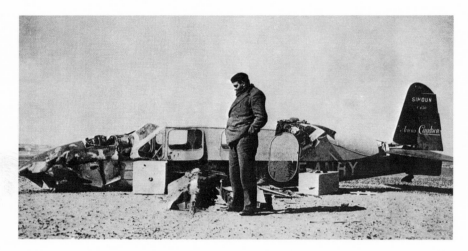

The rooster's crowing

This extract from *Wind, Sand and Stars* reproduces part of the series of articles that Saint Exupéry had published from January 30 to February 4, 1936, in *L'Intransigeant*, entitled "The Broken Flight. Prison of Sand," in which he writes about his accident in the Libyan desert.

Encouraged by the bonus that would reward the winner, Saint Exupéry had decided to take up the challenge of beating a record held by André Japy, who had flown from Paris to Saigon in 98 hours and 52 minutes, at a speed of 102.52 km per hour. Flying a more powerful aircraft, the "Simoun" Caudron, equipped with a Renault engine, the writer and aviator took off accompanied by his mechanic Prévot, with a good chance of cutting roughly twenty hours from Japy's flight time. They left Le Bourget on December 29, after a rather hasty preparation of the itinerary and crash-landed 19 hours and 38 minutes later in the sands of the Libyan desert.

So we walked on and, suddenly, I heard the crowing of the rooster. Guillaumet had told me: "Towards the end I used to hear the roosters in the Andes. I would also hear trains…"

I remember his story at the very moment when the rooster crows and I say to myself: "It was my eyes that had deceived me at first. It must be the effect of the thirst. My ears withstood it better…" But Prévot grabbed me by the arm:

"Did you hear?

– What?

– The rooster!

– So…so…"

So, naturally, dummy, it means life.

I had a final hallucination: the one about the three dogs that were chasing one another. Prévot, who was also watching, did not see anything. But there are two of us stretching out our arms towards this Bedouin. There are two of us making use of all the air in our lungs as we call out to him. There are two of us laughing with joy! … Water!

Water, you have neither taste, nor color, nor smell; you cannot be defined. We taste you without knowing you. You are not merely necessary for life – you are life. You fill us with a pleasure that cannot be explained by the senses. With you, all the powers that we have given up come back to us. By your grace, all the dried-up springs in our heart open up within us again.

You are the greatest wealth that there is in the world, and you are also the most fragile wealth, you who lie so pure in the belly of the earth. One can die over a spring of magnesian water. One can die a few feet from a lake of salt water. One can die even if you have a gallon of dew which has a few salts dissolved in it. You do not accept the idea of being mixed with anything; you can not stand to be altered; you are a shadowy divinity…

- Mon ami ...
- Oui ?
- le coq !

- Alors... Alors...

"L'eau !"

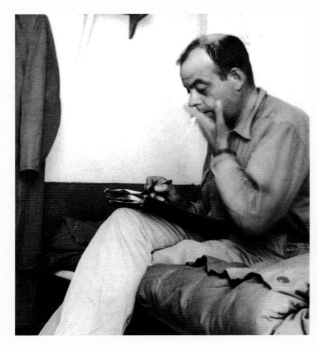

Left : Saint Exupéry, writing. Photograph taken by John Phillips.

Right-hand page : Beginning of *Letter to an American*. Handwritten manuscript.

« Friends from America »

Letter to an American is an article written during the night of May 29 to 30 at the request and under the watchful eye of John Phillips, a reporter for *Life*. He would later write: "Sitting down to write [...] was as exhausting a struggle for him as putting on his flight suit; it was a ritual to which he always submitted by taking deep sighs. Resting his immense body on a creaking wicker chair that was too narrow for him, he put his feet together, with the determination of a studious pupil, hunched over, resting his desk blotter on his knees, and dutifully wrote out long lines of very small black characters, which lacking in hope, ran up towards the top and right of the page."

Saint Exupéry pays homage in this text to the young American soldiers who, in the name of liberty, agreed to sacrifice their lives in the European theater of operations, without giving a second thought to material or geo-economic interests.

I left the United States in April 1943, to meet up with my war comrades from *Flight to Arras* in North Africa. I traveled on board an American convoy. This convoy of thirty ships was transporting fifty thousand of your soldiers from the United States to North Africa. Whenever, upon getting up, I would walk around on deck, I found myself surrounded by this moving city. The thirty ships weighed heavily on the ocean. But I felt something other than a simple feeling of power. This convoy filled my mind with the elation of a crusade.

My friends in America, I want to give full recognition to you for what you are doing. One day, perhaps, serious or less serious disagreements may arise between ourselves and you. Every nation is self-interested. Every nation considers its self-interest as sacred. It is possible that the feeling of your material power may, some day, lead you to take advantages that may appear to us to be unjustifiably harmful to us. It is possible that, one day, serious or less serious disputes may arise between you and ourselves. If war is always won by believers, peace treaties are sometimes dictated by businessmen. Well, even if one day I formulate in my heart some reproaches against the decisions of those people, these reproaches will never make me forget the nobility of the war aims of your nation. I will always give the same testimony about the quality of the people you are. It was not for the pursuit of material interests that the mothers of the United States gave their sons. It was not for the pursuit of material interests that those boys accepted the risk of death. I know, and I will tell my people later, with what spiritual crusade in view each of you agreed to fight in this war.

I have two memories, among others, to share with you as proof of this.

J'ai quitté les États Unis en Avril 1943 pour rejoindre
en Afrique du nord mes compagnons de guerre de Flight to Arras.
J'ai voyagé à bord d'un convoi américain. Ce convoi de trente
navires transbordait des États Unis en Afrique du nord cinquante
mille soldats ~~américains~~ de chez vous. Quand, au reveil, je me
promenais
~~retrouvais~~ sur le pont je retrouvais autour de moi cette ville
en marche. Les trente navires pesaient puissamment sur la mer.
Mais j'éprouvais autre chose qu'une simple sensation de puissance.
Ce convoi évoquait pour moi l'allégresse d'une croisade. Amis
d'Amérique, je voudrai vous rendre pleinement justice. Un jour
peut-être des litiges plus ou moins graves s'eleveront entre vous
et nous. Toute nation est égoïste. Toute nation considère son
égoïsme comme sacré. Il se peut que le sentiment de votre
puissance materielle vous fasse prendre aujourd'hui - ou
demain des avantages qui nous paraitront nous leser
 un jour
injustement. Il se peut que s'~~elevent~~ entre vous et nous, des
discussions plus ou moins graves. Si la guerre est toujours
gagnée par les croyants, les traités de paix quelquefois sont
~~rédigés~~ dictés par les hommes d'affaires. Eh bien si même
un jour je forme dans mon cœur quelques reproches contre
les décisions de ceux là, ces reproches ne me feront jamais
oublier la noblesse des buts de guerre de votre peuple. Sur la
qualité de votre substance profonde je rendrai toujours le
même temoignage. Ce n'est pas pour la poursuite d'interets
materiels que les mères des États Unis ont donné leurs fils.
Ce n'est pas pour la poursuite d'interets materiels que ces
garçons ont accepté le risque de mort. Je sais et je dirai
plus tard chez moi en vue de quelle croisade spirituelle
chacun de vous s'est donné à la guerre. J'ai, parmi
d'autres, ~~deux~~ souvenirs, ~~qui me montrent votre noblesse.~~
à verser comme preuves.

I, myself, do believe in the Archangel Gabriel. You can absolutely sense his presence when he is there.
But I cannot stop myself from knowing that I have been led by the hand. For the first time in a very long time, I am closing my eyes on the peace that is in my heart. I do not have to search for my path any longer. Nobody can prevent me from closing my eyes if I am happy. They are a little like the doors or windows of the [illegible word]. You close them once they are full. You are inside me like a marvelous source of protection.
Of course, I will hurt you. Of course, you will hurt me. Of course, we shall feel pain, but that is the condition of existence. Accepting spring means that one is also assuming the risk of experiencing winter. Being present means that one is also taking the risk of experiencing absence.

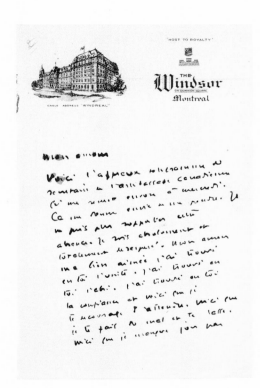

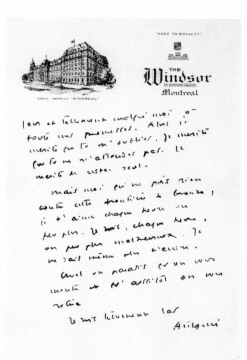

Right-hand page : Extract from an unpublished letter to Natalie Paley. 1942.

Left : Another letter from Saint Exupéry to Natalie Paley, 1942.

« Taking the risk of absence »

Seven letters from Saint Exupéry to Natalie Paley have been preserved, sent when they were in New York or while he was giving lectures in Canada. This was in the first months of the year 1942, and Saint Exupéry expresses his admiration and his affection to this Russian princess, a niece of Tsar Alexander III, a prominent actress before the war, who had married the fashion designer Lucien Lelong. He excelled at such epistolary flirting incorporating just the right phrases and delicately expressed feelings: "My beloved," he writes, "I haven't used that word for a very long time. I am delighted by its sweetness as I would be delighted by a Christmas present. You know, last night I felt like a worker in a silk or sheet-metal factory who finds himself lying in a field beside a stream with white pebbles in it. He closes his eyes quickly in order to lock the miraculous landscape inside himself. My cool stream, full of white pebbles, my flowing water, my beloved…."

4

Moi je crois en l'archange Gabriel, heureusement
pour la... il ne dévise.

Mais je ne puis pas ne pas connaître que je
viens d'être pris par la main. Pour la première
fois depuis bien longtemps je ferme les yeux.
Sur la paix de mon cœur, je n'ai plus à chercher mon chemin.

On ne peut pas m'empêcher de fermer les
yeux si je suis heureux. Un peu comme les
portes ou les fenêtres aux hangars, on les ferme
une fois qu'elles sont pleines. Tu es en moi
comme une provision merveilleuse.

Bien sûr je te ferai mal. Bien sûr tu me
feras mal. Bien sûr nous aurons mal, mais
ça c'est la condition d'existence. Se faire
mal c'est prendre le risque de l'hiver. Se
faire présent c'est prendre le risque de l'absence.
(C'est pourquoi bien s'appépie au téléphones, de lettres

21



Chère Nadia — Un la ai joint
mon petit ours. Pardonnez
moi mon retard, les
inévitables complications de
la dernière heure ne m'ont
tout exprès son texte
[...] personnes, V
est Gourné ce tard mai
il m'est fallu 48 heur
pour les arranger car
je ne sais plus les voir.

Affecter les et la
docilité ji un trouver
[...] de choses absurdes...

[...] savez quelle immense estime et
quelle profonde affection j'ai pour
vous. Je suis bien heureux de vous
donner un peu de notre manuscrit.
Mais j'avoue pour votre lettre
TSUS

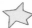

Right : Antoine and Consuelo de Saint Exupéry, at the Gare Saint-Lazare, at the time of their departure for the United States, in 1938.

Right-hand page : Extract from an unpublished letter, typed with handwritten revisions, December 18, 1942.

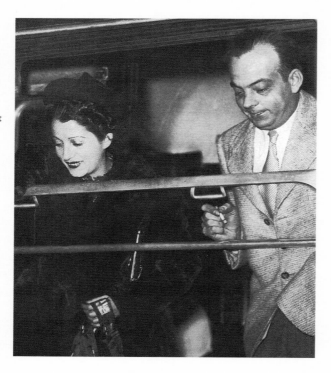

18 December 1942

$ 30 monthly

Dear Doctor:

I am proposing to pay the balance of my bill in monthly installments of $30. It is impossible for me to make larger payments for the simple reason that I don't have a penny in my bank account and am at present living off the advances that my publisher has granted to me. My financial situation is easily verified and my offer is higher than the legal minimum.

When my wife arrived from France, I told her to see you because my relations with you were more amicable than professional. My wife was not sick, but, like all women, she wanted continual attention to be paid to her health. Not having the means to procure for her such costly distractions, I believed I might hope that a doctor friend would give her one or two consultations, some sound advice, a harmless syrup and a reasonable bill. It would have been unfair to my wife to try to influence your diagnosis, and insulting to you, to weigh on your conclusions by telling you of my wishes in advance. I let you judge absolutely freely. But the day came when I confided in you that my savings were blocked and that I only had the minimum to live on. That day, you in turn told me, with similar confidence, that my wife was not sick at all and that it would be better to replace the medical treatment she was getting with good walks in the open air. I was a little saddened by the fact that that just remark was weighed down with a bill of more than $200, but I really did admire the therapeutic value of the decrees of the [American government, which had so miraculously cured my wife.]

« Dear Doctor »

Consuelo de Saint Exupéry had joined her husband, who had been living in New York for several months, in January 1942, a few weeks before the appearance in New York of *Flight to Arras*, illustrated by Bernard Lamotte. That year, they lived first in a New York apartment, then in houses rented for the summer in Connecticut and, later, on Long Island, and finally, from November on, back in New York, at 55 Beekman Place, in a house that had belonged to Greta Garbo.

Sent to a friend who was a doctor, in December, this ironic letter, which does not at all disguise the couple's financial problems, clearly suggests that the rigors of a severe winter in New York were harming the health of this young woman from El Salvador, who missed the warm climate of Latin America and whose health had, even before the War, made it necessary for her to spend long periods in Switzerland and on the French Riviera.

30 $ (mensuels)

Cher Docteur :-

 Je vous propose le règlement du solde de ma note par
versements de $30 mensuels. Il m'est impossible de faire plus
pour la simple raison que, n'ayant pas un centime de réserve
en banque, je vis actuellement sur des avances consenties par mon
éditeur. Ma situation financière est aisée à vérifier, et mon
offre est supérieure au minimun légal.

 Lorsque ma femme est arrivée de France je l'ai adressée
à vous parce que nos relations se situaient comme plus amicales
que professionnelles. Ma femme n'était pas malade, mais souhaitait
come toute femme, que l'on s'intéressât en permanence à sa santé.
N'ayant pas les moyens de lui procurer des distractions coûteuses,
je comptais sur votre sympathie pour moi pour lui accorder une ou
deux séances, de sages conseils, un sirop inoffensif et une facture
modeste. J'eusse lésé ma femme en influençant votre diagnostique,
et je vous eusse fait injure en pesant sur vos conclusions par des
souhaits préliminaires. Je vous ai laissé juger en toute liberté.

 Il s'est trouvé qu'un jour je vous ai confié que, mes fonds
étant bloqués, je ne disposais que du minimum indispensable. Ce
jour-là vous m'avez confié en retour, avec une confiance égale,
que, ma femme n'étant point malade, les soins médicaux, à elle
accordés, seraient avantageusement remplacés par de bonnes prome-
nades au grand air. J'ai été un peu attristé de ce que cette
juste remarque fût grevée d'une facture de plus de $200, mais
j'ai admiré par contre la valeur thérapeutique des décrets du gou-

page 4

et trois voitures pour les collégiens.

Arrivé à Notre D. de Notre-Dame

du Chêne on a entendu la Messe et

on est parti on a déjeuné à Notre Dame

du Chêne après comme les élèves

de l'infirmerie de 7me de 8 et de 9

et de 10me allait en voiture

pour aller à Solesme

comme je ne voulais pas aller en voiture

j'ai demandé la permission

page 5

d'aller à pied avec les élèves

de 1re et de 2me division

on était plus de 100 en rand,

notre file tenait une rue entière

après le déjené on est allé visiter

les saint septembre et on est allé

dans le Magasin des Rds Pères

et on s'est acheté des choses.

après on fit la 1re et la 2me division

et nous est allé à pied pour

Solesme

page six

arrivé à Solesme on a continué la

promenade et on a passé au pied

de l'abée elle était immense

seulement on n'a pas

pu la visiter parce qu'on

avait pas le temps au pied

de l'abée on à trouvé des marbres

et quantité il y en avait des

gros et des petits il j'en

ai pris six et j'en ai donné

trois

7 page 7me page

après on et il y en avais

un qui avait environ 1m 50

et 2m de longeur alors on

m'a dit de le mettre dans

ma poche seulement

je ne pouvais même pas

le remuer et il était trop grand

après on est allé gouté sur l'herbe

à solesme

Above : Extract from a letter to his mother, sent from Le Mans, 1910.
Right-hand page : Antoine, around 1907.

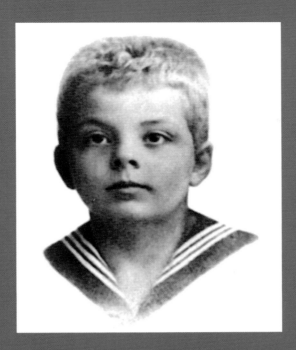

The Youth of a Little Prince

« I have been writing since I was six years old.
It was not airplanes that brought me to books.
I think that if I had been a miner,
I would have tried to draw lessons from below the ground.
And if I had been a man of letters,
I may possibly have found my topic in the library. »

Born on June 29, 1900, in Lyons, Antoine de Saint Exupéry was the third child and the first son of Jean de Saint Exupéry and Marie de Fonscolombe. Preceded by Marie-Madeleine and Simone, and followed by François and Gabrielle, he was the elder of the two boys and exerted a good-natured tyranny over his siblings. Very close to each other in age and interests, they formed a closely-knit family: "We were a tribe," said Antoine, speaking of his brother and sisters, who were brought up in an artistic and literary atmosphere. In 1904, after the death of her husband of a heart attack, Marie de Saint Exupéry found herself with no means of support. She went to live in Lyons with her children, at the home of her great aunt, the Comtesse de Tricaud. Around young Antoine, there moved only feminine figures: Tante, his widowed great-aunt, his mother, the governesses Paula and Moisi, the piano teacher, and the servants. The only men were the priests, who came to lunch every week, and Cyprien, the valet, whom the children called "Zizi the toad". Of course, there were uncles, his mother's brothers, who visited them from time to time, but they were not there every day to impose a degree of discipline. The lives of the Saint Exupéry children were marked by the rhythm of the seasons. They spent the winter in Lyons, in their aunt's apartment on the Place Bellecour. During the warmer months, they migrated to the château, or country house, of Saint-Maurice-de-Rémens, in the Ain (east-central France). It was a home that Antoine was very fond of and he alluded to it in every one of his books. The childhood that marked him so profoundly included the experience of listening to their mother reading or telling Bible stories and fairy tales. In a totally free and natural way, Antoine wrote out his own versions of episodes in the Scriptures and classical mythology, collaborating with his siblings to put together and perform playlets for "grown-ups". During vacations, when bad weather did not allow them to play in the gardens of the family homes of the Fonscolombe grandparents in Saint-Maurice and De La Mole, the children, supervised by the adults, got an introduction to rhymes; verse or charades, to "If it was...", or "Monsieur and Madame". These were all parlor games that allowed their imagination to have free reign. Writing became a game, a way of expresssing themselves without taking themselves too seriously. Three of the Saint Exupéry children were to have books published: Antoine, Marie-Madeleine (posthumously, a collection of short stories about

Below : The five Saint Exupéry children. From left to right : Marie-Madeleine, Gabrielle, François, Antoine and Simone.

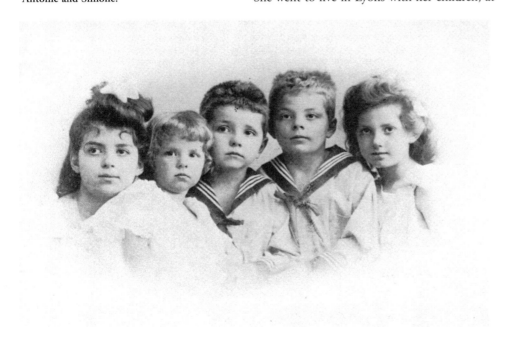

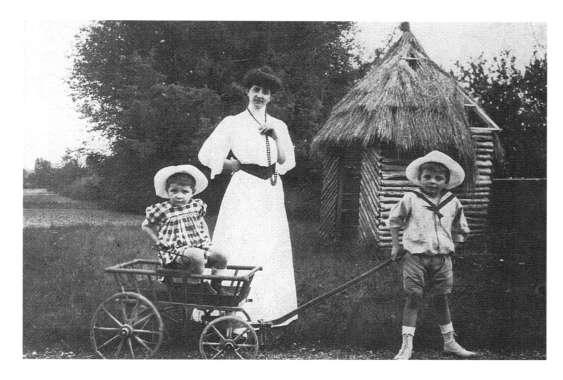

Left : Mme. de Saint Exupéry with François (in the wagon) and Antoine.

nature, entitled *The Friends of Biche (Les Amis de Biche))*, and Simone, an archivist in Indochina, who would write several stories that were published in a book entitled *Meteors (Météores)*, under the pseudonym of Simone de Rémens, which she used in order not to overshadow her brother's works.

Saint Exupéry's youthful works were eclectic: verse, prose, and even the beginning of an opera libretto, *The Umberella (Le Parapluie)*. Inspired by a rather bizarre subject, he suggested to Mademoiselle Anne-Marie Poncet, his former piano teacher in Saint-Maurice, that she write the music for it. Her refusal to do so put an end to the young man's operatic vocation.

Saint Exupéry's correspondence is an important part of his writings and is a mine of information about his childhood and education. Even though many letters have been lost, those that have been preserved reveal his constant need to communicate with those he loved.

In 1949, Marie de Saint Exupéry bequeathed to the Department of Private Archives of the National Archives of France 185 letters that her son wrote to her between 1910 and 1944. Some of these have never before been published and they are now reproduced in this book.

In 1909, when Antoine and François were sent to Le Mans to be educated at the Jesuit high school of Sainte-Croix, as their late father had been, writing became a means of escape for Antoine. A regular exchange of letters with his mother, whom he called his "reservoir of peace", enabled him to hear all her news. She, in turn, made the most of the fact that her sons were in Le Mans and her

Above : « L'Amusette (The Amusement) » : small notebook in which Antoine and his brother and sisters wrote playlets, which they illustrated and acted out.

When World War I broke out in 1914, Marie de Saint Exupéry wanted her sons to be closer to her and she enrolled them at the high school in Mongré, in Villefranche-sur-Saône. But Antoine and François had a hard time adapting to the rigors of life at the boarding school. It was deemed inappropriate for them and they went back to Le Mans and completed the school year there. In 1915, they were both boarders at the Villa Saint-Jean in Fribourg, Switzerland, whose modern educational principles were similar to those that were successfully being followed at the Collège Stanislas in Paris. Antoine was very pleased with the independence that pupils were allowed there. An avid reader, he discovered Dostoevsky, and above all Baudelaire, Leconte de Lisle, Hérédia and Mallarmé, who became real sources of inspiration for his own poetic works.

Antoine successfully passed his philosophical baccalaureate in 1917. But this great joy was followed by his first deeply sorrowful experience: his younger brother, François died in the summer of that year, aged only fifteen, of rheumatoid arthritis. Saint Exupéry would allude to this immense sorrow only once, in *Flight to Arras*, describing François' final moments in a few sentences: "… A brother, younger than me, was considered to be on the point of death." This loss, which was to be followed by that of many of his relatives, would leave a deep mark on him: "He realized that he had lost a friend whose company would have been precious to him at every moment."

Young Antoine threw himself into student life: despite being weak in mathematics, he wanted to get into the Naval Academy, and prepared for the entrance examination at the Lycée Bossuet. He divided his time between his studies and going out with his many cousins, who took turns to take him to the theater, on walks and to parties. His letters from that time display the delight of the young

daughters in Lyons, by making regular trips between the two cities. In his correspondence, Antoine relates even the slightest details of his daily life and his constant wishes to be with his mother.

He wrote little about his progress at school as he was a rather unreliable and unruly pupil who applied himself only when a subject really interested him. Several texts showing his first literary efforts have come down to us: *The Odyssey of a hat (L'Odyssée d'un chapeau)*, the manuscript which is still preserved in the archives of the high school in Le Mans, and *The Ballad of the Small Office (La Ballade du petit bureau)*, which he wrote while preparing for the entrance examination to the French Naval Academy; at the Lycée Bossuet in Paris: they reveal that Saint Exupéry did indeed have a sense of humor.

man from the provinces discovering the full range of experiences that Paris had to offer. They also show the evermore insistant requests that he sent his mother for ways in which she could improve his lifestyle (confectionary, personal objects, and pocket money). The War does not seem to have had much effect on him. There was little mention of the capital city in wartime in the letters he sent to his family, except in two letters, one describing how surprised he was to see Paris draped in blue, which was done to diminish the intensity of the street lamps, and the account of a night spent on the roof of the Lycée Saint-Louis, during an air raid, watching the German bombardment of the city.

Once the war was over, Antoine, who had failed in his three attempts at the entrance examination to the Ecole navale (the French Naval Academy), and one at the Central School of Engineering, was too old to try for a fourth time. He did not have any other plans and registered to sit in on lectures at the Ecole des Beaux-Arts, in the Architecture division. He did not attend many of the lectures, but became a regular customer at the café on the corner of the Quai Malaquais and the Rue Bonaparte, where he busily filled up notebooks with poems. At the age of twenty-one, like all young Frenchmen, Saint Exupéry had to do his military service. He gave up his life as an artist and began his life in the military. As he had not been able to join the navy, his greatest wish, he was admitted into the air force when he was drafted in 1921.

Then comes the day when you take exams.
When you receive a diploma.
When you anxiously cross
a certain threshhold,
beyond which, you become a man.

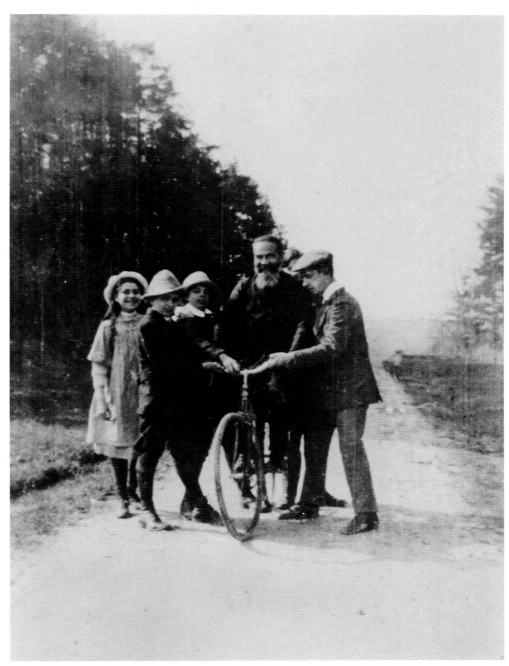

Above : Family scene during the vacations.

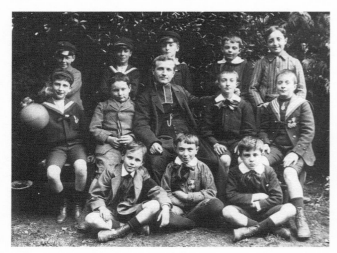

Left : The class at Sainte-Croix, 1910-1911. Antoine is in the back row, second from the right.

Right-hand page : Letter to his mother, sent from Le Mans, 1910.

Pilgrimage to Notre-Dame-du-Chêne

Notre-Dame du-Chêne, whose hymn celebrating the Virgin Mary has been sung for generations at the close of Mass in many parishes in the Sarthe département, is one of the sanctuaries dedicated to the Virgin in that département. It was a place of pilgrimage that was important enough for the Jesuits of Notre-Dame-de-Sainte Croix of Le Mans to organize an annual pilgrimage to it, which ended with a visit to the Benedictine Abbey of Solesmes in Sablé-sur-Sarthe, an important center of Gregorian chant.

His description of that day, enables one to conjure up the enjoyable outing of the pilgrimage, in the company of pupils wearing heavy dusty clogs, caps worn at all angles and capes worn negligently, carriages reserved for the high school, pampered choirboys and carriages pulled by old horses into which they had all climbed. We can also imagine the young Antoine's anxiety, as he was teased by the other students at Sainte-Croix, most of whom were boarders, until he decided to walk for part of the way, like the older students.

One also notices Antoine's very personal approach to spelling, at the age of 10, which often earned him some very serious criticisms from the Jesuits. That subject could not be joked around with at the high school!

My Dear Mama,
I would very much like to see you again soon.
Aunt Anaïs is here for a month.
Today, I went with Pierrot to the home of a high school student from Sainte-Croix. We had tea there and had fun. I took Communion this morning at school. I shall tell you what we did on the pilgrimage: we had to be at the school by 7:45 am. We walked to the station in double file. From the station, we went by train as far as Sablé. In Sablé we got into carriages. As far as Notre-Dame-du-Chêne there were more than fifty-two people per carriage. There were only high school students, they were on top and inside; the carriages were very long and each was pulled by two horses. We had fun in the carriage. There were five carriages, two carriages for the choristers and three carriages for the high school students. After arriving at Notre-Dame-du-Chêne we attended Mass and we ate lunch at Notre-Dame-du-Chêne afterwards. As the pupils from the infirmary, in 5th, 6th, 7th and 8th grades, were going to Solesmes, as I didn't want to go by carriage, I asked for permission to go on foot with the pupils of the 1st and 2nd division. There were more than two hundred of us, walking in twos and our group took up an entire street. After lunch we went to visit the holy sepulchre and we went to the Fathers' shop and we bought ourselves some things. Afterwards, the 1st and 2nd division and I went to Solesmes on foot.
After arriving in Solesmes we continued our walk and walked past the abbey. It was immense, but we couldn't visit it because we didn't have the time. In front of the abbey we found large quantities of marbles. There were large and small ones. I picked up six of them and gave away three and there was one that was between five and six feet long, so I was told to put it in my pocket. However, I couldn't even move it and it was too big. Afterwards we went to have tea on the grass in Solesmes.
I have written eight pages to you.
Afterwards, we went to prayers and we got into twos to walk to the station. After getting to the station we took the train to return to Le Mans and we arrived home at eight o'clock. I came 5th in Composition and Catechism.
Goodbye my dear Mama. I kiss you with all my heart.

Machère Maman

Je voudrais bien vous revoir

tante et naïr et là pour un mois

Aujourd'hui je nous sommes allé ave Pierrot

chez un collègien de Ste Croix on y a gouté

on s'est bien amusé. J'ai communié

ce matin au collège. Je vais vous raconter

ce qu'on a fait au pèlerinage il fallait

se trouver au collège à 8 heure moins

le quar on s'est mis en rand pour aller

à la gare. A la gare on est monté

en train jusqu'à Sablé. A Sablé

on est monté en voiture. Jusqu'à

Notre Dame du chêne il y avait

plus de 52 personne par voiture

il y avais que de collègiens

il y en avais par dessus et en dedan

les voitures étaient très longues

et étaient trainés par 2 chevaux

chacune. en voiture on s'est bien

annuyé il y avais 5 voitures

8 deux voitures pour les enfants de cœur

et trois voitures pour les collègiens.

Arrivée à Notre-Dame

du chêne on a entendu la messe et

on est parti on a déjeuné à Notre Dame

du chêne après comme les élèves

de l'infirmerie de 7me de 8 de 9

et de 10e allait en voiture

pour aller à Solesme

comme je voulais y aller en voiture

j'ai demandé la permission

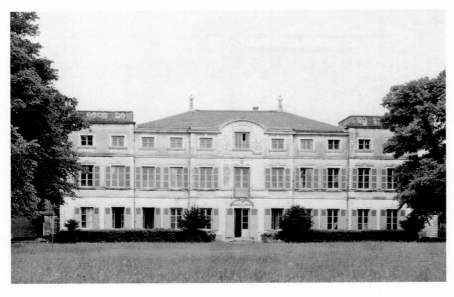

Above : Saint-Maurice-de-Rémens in 1914.

Right-hand page : Extract from a letter to his mother, Buenos Aires, January, 1930.

The little stove at Saint-Maurice

"There was a park somewhere full of dark fir trees and linden trees, with an old house that I liked."

Saint-Maurice-de-Rémens, the property of the Comtesse de Tricaud, Marie de Saint Exupéry's aunt, is located in Le Bugey, a few miles from Ambérieu. It was there that Antoine's parents had been married on June 6, 1896, and there that the "five children in a park" forged their memories. It was also where the young François would die, in the summer of 1917.

At her death, in April 1919, Aunt de Tricaud bequeathed the chateau of Saint-Maurice to her niece, who, unfortunately, had few financial resources to keep it up. Despite all her efforts, she was unable to hold onto the property and it was sold in 1932 to the School Fund of the city of Lyons.

[The "best" thing, the most peaceful, most friendly thing that I have ever known was the little stove in the upstairs room in Saint-Maurice. Nothing has ever reassured me more about life. Whenever I woke up at night it was humming like a top and it created fine shadows on the wall. I don't know [why] I used to think of it as a faithful poodle. That little stove protected us from everything. Sometimes you would come upstairs, you would open the door and find us enveloped in a friendly warmth. You would listen to it humming at full speed and then you would go back downstairs.

I have never had a friend like it.

What taught me about immensity was not the Milky Way, or aviation, or the sea, but that second bed in your room. It was marvelous luck to be sick. We all wanted to be sick in turn. It was an infinite ocean to which having the flu gave us a right. There was also a living fireplace.

What taught me about infinity was Mademoiselle Marguerite.

I am not really sure whether I have lived since my childhood.

Now I am writing a book about night-time flying. But in a profound sense, it is a book about the night. (I have only ever lived after nine o'clock in the evening.)

Here is the beginning, the very first memories of the night:

"We were dreaming in the hall when night fell. We would look out for passing lamps: they were carried like a load of flowers and each one stirred, on the wall, shadows that were as beautiful as palm trees. Then the mirage turned, and we would lock this bouquet of light and of dark palms in the sitting room.

"Then, the day was finished for us and, [in our children's beds, we were packed off on our journey toward the next day.]…

pourquoi je pensais à un couche fidèle. Ce petit poêle
nous protégeait de tout. Quelquefois nous montiez, vous
ouvriez la porte, et nous nous trouvions bien entourés
d'une bonne chaleur. nous l'écoutiez ronfler à toute
vitesse et nous redescendiez.

Il n'en avait pas un d'aussi pareil.
Ce qui m'a appris l'immortalité ce n'est pas
la mort lâchée par l'aviateur dans la nuit mais le second
lit de notre chambre. C'était une chance merveilleuse
d'être malade. On avait envie de l'être chacun à son
tour. C'était un océan sans limite auquel la grippe
donnait droit. Il y avait aussi une cheminée
vivante.

Ce qui m'a appris l'éternité c'est une demoiselle
transparente. C'était mal écrit, mais vraiment.
Je ne savais pas bien sur l'avoir vu depuis la première
enfance. Tout a bien, tout à Dijon, tout...
maintenant au le côté sinistre
mais dans son sens intime c'est un livre en la nuit
(que j'ai jamais vécu auparavant sans que soit) Voilà
les de tout qui est les premiers souvenirs de la nuit
Nous venions dans le vestibule quand tombait la
nuit, on guettait le passage des lampes ou les portait
comme une charge de fleurs et chacune semait au
mur des ombres belles comme des palmes. Puis le
mirage tournait, puis nous enfermait sans salon ce
bouquet une lumière et de palmes sinistres.
Alors le jour était fini pour nous, et

I was born in a large hat factory. For a few days, I suffered all kinds of tortures: I was cut into pieces, I was stretched, I was polished. Finally, one evening, I was sent with my brothers to the greatest hatter's shop in Paris.

I was placed in the window; I was one of the finest top hats in the display. I was so shiny that the women who passed by never failed to look at their reflections in my glossy surface; I was so elegant that no distinguished gentleman could see me without looking at me with desire.

I was living in perfect repose [waiting for the day when I would make my appearance in the world.]

Odyssey of a hat

Antoine was 13 years old when he had to write on a composition topic of his choice and that is when he wrote this complete little story, which "Caesar" liked. That was the nickname of Father Launay, who thus discovered his young pupil's stylistic talents. In spite of his mixed comments: "Good. Too many spelling mistakes. Heavy style at times", he gave the piece a good grade (13 out of 20), which he soon reduced to 12 out of 20 because of the too numerous spelling errors. And yet, he asked his class to comment on this text for more than two hours. It was to earn Antoine the prize for best French essay of the year, at the prize-giving ceremony of 1914.

We may recall the eight episodes in the life of this top hat. Acquired and worn first by an elegant gentleman, it was given to its owner's coachman for his wedding. He did not look after it properly and it was sold to a secondhand clothes dealer and bought by somebody called Mathieu, on the advice of his wife, Caroline (which was also the name of the bell at the Sainte-Croix high school). But it was thrown into the Seine on a very windy day and, fished out by a ragman, was sold in Africa, to the King of Niger, Bam-Boum 2nd, who kept it all his life.

Right-hand page: French composition for 8th grade. Handwritten manuscript, Le Mans, 1914.

Above: Other sheets from the composition on the Odyssey of a hat.

Antoine de Saint Exupéry Troisième

Narration Française

Je naquis dans une grande usine de chapeaux. Pendant plusieurs jours je subis toutes sortes de supplices : on me découpait, on me tendait, on me vernissait. Enfin un soir je fus envoyé avec mes frères chez le plus grand chapelier de Paris.

On me mit à la vitrine ; j'étais un des plus beaux hauts de forme de l'attelage, j'étais si brillant que les femmes qui passaient ne manquaient pas de se mirer dans mon vernis ; j'étais si élégant qu'aucun gentleman distingué ne me voyait sans avoir pour moi un regard de convoitise.

Je vivais dans un parfait repos

It was a rickety old bridge
On the banks of my river
It was all covered in ivy
And beautiful light effects
Brightened up its shaky timbers

It wasn't splendid or handsome
My pretty little rustic bridge
It wasn't very artistic,
But something mystic
Made it shine over the water

Sometimes a pretty chaffinch
Landed in its shadow,
And large numbers of warblers
Came to sing beneath it
In every season

It must have been really old
That pretty bridge with its pink reflections
Whose gentle dull shades
Made one think of many things
Every day, at every sunset

[And I liked that old rickety bridge,
I loved it with such a tender love
That I always wanted to go to it
To stretch out for a moment
In the shadow of its sleeping timbers

One day I was very unhappy,
I had come down to my river
To see my bridge covered in ivy,
And I saw lying on the ground
A few dusty remains

Since then it has been rebuilt
But it's no longer the bridge that I loved,
It won't ever be the same,
And looking for a sublime fragment
I wept for my friend…

Memory of a friend
Antoine de Saint Exupéry]

Right-hand page :
Unpublished handwritten
manuscript by Saint
Exupéry, in one of his
female cousins' notebook.

Below : The 8th grade
class at Sainte-Croix of Le
Mans in 1914. Saint
Exupéry is in the back
row, second from the
right.

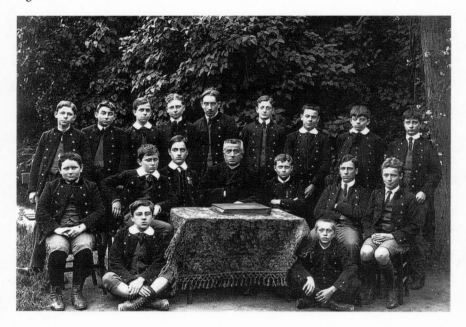

My pretty bridge

Like other girls of their generation, Antoine de Saint
Exupéry's De Sinéty cousins had small drawing pads
in which they asked their friends to write a few lines,
accompanied, or not, by a drawing. Antoine willingly
agreed to do this and gave them, among other texts,
several poems, including "My pretty bridge", which he
wrote out carefully in his cousin Renée's book, dedi-
cating it to her. These beautifully illustrated lines evoke
the bridge over the moat in the Château of Passay, the
Sinétys' residence near Le Mans, in the Sarthe,
Normandy.

Antoine was, most probably, twelve years old when he
wrote this poem, which was inspired by an affection
for nature and a liking for these places, which he knew
well.

Mon joli pont

C'était un vieux pont chancelant
Sur les rives de ma rivière,
Il était tout couvert de lierre,
Et de jolis jeux de lumière
Embellissaient son bois branlant

Il n'était pas splendide et beau
Mon joli petit pont rustique,
Il n'était pas bien artistique,
Mais quelque chose de Mystique
Se faisait rayonner par l'eau

Quelquefois un joli pinson
Venait se poser à son ombre,
Et des fauvettes en grand nombre
Venaient chanter sous son berceau
En n'importe quelle saison

Il devait avoir bien des ans
Ce joli pont aux reflets roses
Dont les douces teintes moroses
Faisaient songer à bien des choses
Tous les jours à tous les couchants

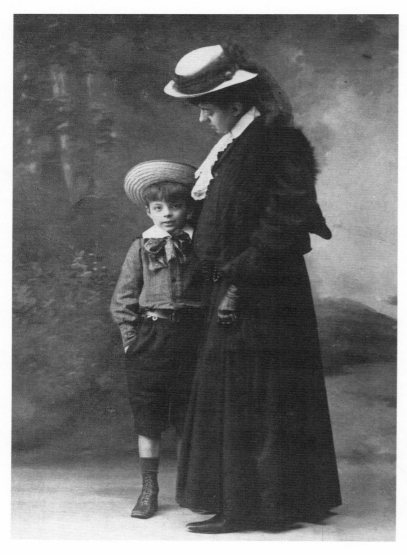

Left : Antoine
at the age of six, with his
Aunt « Mad » de
Fonscolombe, the sister of
Marie de Saint Exupéry.

Right-hand page : *The
Little Prince*. Preparatory
state, illustrated
handwritten manuscript.

When I was six years old, I once saw a
magnificent drawing. It was a boa
constrictor that had swallowed a wild
animal. It looked something like this :
[space]
But I didn't know how to draw. [I] drew it
once. That was my first drawing.
[drawing]
And I said to the grown-ups: "What is this?"
They replied; It's a hat. It wasn't a hat. It
was a boa constrictor that had swallowed an
elephant. The boa constrictor swallows its
prey whole without chewing it. And it [goes
off to sleep] for six months. It has two
meals every year. After six months the boa
constrictor had become slim again.
I made a drawing to explain this to the
grown-ups and I drew
[drawing]
the inside of the boa constrictor.
It was a second drawing.
I was advised to study grammar. I studied
history, arithmetic and grammar, with a
great deal of reluctance and I never made
drawings again. Grown-ups ask for a lot of
explanations. They have done too much
history, arithmetic and grammar. But it's
tiring for children to always give them more
and more explanations.

« When I was
six years old… »

The Little Prince opens with a drawing of an unlikely
looking boa constrictor and ends with the departure of
the child, who gets himself bitten by a snake in the
desert in order to return to his planet. Between these two
things, the main characters of the book appear from
the author's pen and paints: the child, the narrator, the
Rose, the Snake and the Fox.

Unable to cope with the heat of New York, Saint
Exupéry had rented the manor of Bewin House, in New
Jersey, in order to spend the summer of 1942 there and
to start writing a book for children, at the request of
his publisher. He wanted his friend Bernard Lamotte to
illustrate it, but dissatisfied with various sample drawings,
he decided to illustrate his text himself. Armed with
an impressive array of pencils and watercolors, he
devoted that summer to writing and illustrating the
work, which was to have been published by Christmas
but which only appeared in the following spring, just
before Saint Exupéry's departure for North Africa.

1)

Quand j'avais six ans j'ai vu une fois une magnifique image. C'était un serpent boa qui avalait un fauve. C'était à peu près comme ça.

Mais je ne savais pas dessiner [...] [...] j'ai une fois dessiné ça. C'était mon premier dessin.

Et j'ai dit aux grandes personnes : qu'est-ce que c'est ?

Elles m'ont répondu c'est un chapeau.

Ce n'était pas un chapeau. C'était un serpent boa qui digérait un éléphant. Le [...] serpent boa avale sa proie toute entière sans la mâcher. Et il [...] ne peut plus [...] il faut alors [...] J'ai fait un dessin qui explique ça.

J'ai expliqué [...] les grandes personnes [...] j'ai dessiné

L'intérieur du serpent boa.
C'était mon second dessin.

On m'a conseillé [...] de laisser de côté les [...] et d'apprendre la géographie. J'ai appris [...] dessiner avec tous ces [...] humeur et si on se perd, [...] les personnes demandent des explications. [...] rien fatiguant pour les enfants toujours et toujours [...] de leur donner des explications.

SAXSAM

Dearest Mama,

I have just left the Sorbonne, where I finished my Latin composition as well as my neighbor's, a very nice boy who is really hopeless; tomorrow I will do his translation from the Greek for him…

The unseen translation was not at all easy but I believe that it was well written; as for the French composition subjects, each of the three was more boring than the others. I chose the least stupid one and I didn't do anything wonderful with it!

The day after tomorrow, I will take my oral (if God allows my written examination to make it!)… How shall I come out of the lecture theater?

Quinet? What uncertainty. On Friday, Villoutreys will arrive at his aunt's in Fonscolombe, and that's really great.

My uncle Saint-Mares (?) has invited me to spend 4 days with him. I don't remember where: it will be delightful because you can hear the cannon and the countryside is full of trenches. It's only that my wallet (that's only a metaphor because I don't have one) my wallet is no gold mine (another metaphor, aren't I amusing!). There won't be much left in it!

Send me a little money if you can! (by cable money order)

The weather was very bad yesterday and today and I was delighted! It's getting better now, unfortunately! Pity about the Greek unseen translation!

Right-hand page:
Unpublished letter to his mother, 1916.

Antoine takes his high school graduation exams

After their years as day pupils at Sainte-Croix of Le Mans, Antoine and François followed their mother who, in 1914, installed an ambulance at the station of Ambérieu-en-Bugey, not far from Saint-Maurice. She enrolled them in the high school of Mongré, which was also run by Jesuits, in Villefranche-sur-Seine, so that she could keep them near her. That school's strict discipline discouraged the children to such a degree that they went back to Sainte-Croix of Le Mans in order to complete the first term, before being sent to the Marian Fathers of the Villa-Saint-Jean in Fribourg, whose system of teaching was similar to that of the Collège Stanislas, in Paris. It was there that Antoine was to form some long-lasting friendships, with Louis de Bonnevie and Charles Sallès.

In spite of some dubious exam results, Antoine did pass his literary baccalaureate, whose examinations took place in two parts (at the end of eleventh and at the end of the twelfth grades), which he took in 1916, in Paris, and in 1917, in Lyons.

Account of money spent

Supplement for the ticket	6.75
Porter	1.50
Plan of the Metro	1.00
Taxi	1.75
Pocket inkwell for "Bac" exam	2.50
Blotting paper	0.45
Papier rouge	0.20
Shoe shine, duster, etc.	0.75
Restroom	0.50

Trams
- Station-rue St Dominique
- rue St D-Sorbonne } Information
- Sorbonne-rue St D
- Sorbonne-rue St D } Composition
- one way was by taxi
- Rue St D-Sorbonne } Latin unseen translation
- Sorbonne-rue St D

That is 7 trips at 0.15	1.15
I have remaining	3.36
Total	20.00

You can see that the account is accurate!

Explanations

Porter: I took a porter who carried my suitcase, instead of a taxi which was too expensive

Taxi: the tram doesn't start until 7 am. I had to take one, as my examination began at 7 am precisely and I was late

See the other side

My eyes are absolutely fine – I don't understand it at all.
Everybody is wonderful to me, it's just that I am terribly bored.
I met various chaps from Ste Croix and Mongré.
Goodye, dearest Mama, I kiss you with all my heart
Your respectful son

Antoine

I received the cake, thank you very much
I have just come back from the Comédie Française where I saw a performance of a Greek tragedy and *The Learned Women* (*Les Femmes savantes*, [by Molière]).

Maman chérie

Je sors en ce moment-ci de la Sorbonne où je viens d'achever ma composition latine et celle de mon voisin, un bien gentil garçon mais bien nul, demain je lui ferai sa version grecque...

La version n'était pas du tout facile mais je crois qu'elle est très bien faite, quant aux devoirs français ils étaient tous les trois tous plus ennuyeux les uns que les autres: j'ai pris le moins bête et je n'ai rien fait de merveilleux!

Après demain je passe mon oral (si Dieu prête vie à mon écrit!)... comment sortirai-je de l'Amphithéâtre

Quinet! Quelle incertitude.
Vendredi Villouteys arrive chez Lante de Ponsolombe le ça c'est très chic!

L'oncle de Saint Marc m'invite à passer 4 jours chez lui je ne me rappelle plus où: ça sera délicieux car on y entend le canon et le pays est rempli de tranchées. Seulement mon porte monnaie (c'est une métaphore parce que je n'en ai point) mon porte monnaie n'est pas une mine d'or (encore une métaphore - je suis épatant!) Il me reste 25 ct en billet ou en 10 cm ... en argent trois sous en bronze - Or après demain il n'en restera pas lourd!

Envoyez moi... si vous pouvez un peu d'argent! (par mandat télégraphique)

Il faisait très mauvais hier et aujourd'hui je m'en étais ravi! de temps se lève, hélas! tant pis pour la version grecque!

Compte rendu de l'argent

Supplément de billet	6.45
Commissionaire	1.50
Place métro	1.00
Taxi	1.75
Encres poche pour bac	2.50
Porte plume " "	0.45
Buvard " "	0.20
Papier rayé " "	0.20
Ciseaux, épingles etc...	0.45
Cabinet toilette	0.50

Trams {
gare - rue St Dominique
rue St.D. - Sorbonne } renseignements
Sorbonne - rue St.D.
Sorbonne - rue St.D.
(d'aller oraux en faire) } Dissertation
rue St.D. - Sorbonne
Sorbonne - rue St.D. } Version latine

Soit 7 voyages à 0.15 = 1.15

me Reste 3.35

Total 20.00

Vous voyez que le compte est juste!

explications {
commissionaire { J'ai pris un commissionaire qui m'a porté ma valise à la place d'un taxi qui était trop cher -
taxi { les tramps ne marchant qu'à 7h j'ai dû en prendre un mon bac commençant à 8 heures exact et je ne voulais pas être en retard -

- voir au verso -

Mes yeux vont ... ne rendent bien, je n'y comprend rien. Tout le monde est délicieux pour moi, seulement je m'ennuie terriblement -

J'ai rencontré divers types de Ste Croix et de Hongrie.

Au revoir maman chérie je vous embrasse de tout mon cœur

Votre fils respectueux

[signature]

J'ai reçu la galette merci beaucoup

Je viens de la comédie française où j'ai vu jouer une tragédie et les femmes savantes -

Left : Antoine de Saint Exupéry, while he was a boarder at the Ecole Bossuet, in 1918-1919.

Right-hand page : Extract from an illustrated letter to his mother, written at the Lycée Saint-Louis [high school] in Paris in 1918.

Math !

Holding a literary baccalaureate, Antoine nevertheless wanted to take up a career that required an excellent knowledge of mathematics and science. He decided to apply to the Naval Academy and he prepared for the entrance examination at the Lycée Saint-Louis in Paris. In order to make up the numbers, which had been decimated by the war, the administration decided that in 1919 there would be two sessions, one in the spring and the other in the fall. Antoine spent a part of the summer in Besançon, in order to improve his German, which was still very weak when he took the examination. He passed in November, but failed his oral, which was only passed by 60 candidates out of the 112 who had passed the written exam.

Friends of the family then convinced him to try the entrance examination to the Central School of Engineering (to give up sailing in favor of "pistons"!), and he took the preparatory course for it at Saint-Louis, while boarding on the other side of the Jardin du Luxembourg, at the Ecole Bossuet. Yet another failure did not discourage him because he tried the Naval Academy for the last time in the following year. Once again, he passed the written but failed the oral examination. This experience marked the end of his ambition to be admitted to one of the prestigious "grandes écoles" [elite state universities], and he decided to turn, for a time, towards the Fine Arts.

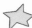

... You are very lucky to be in the South of France, but it's impossible for me to go there. How long was your delay?
The weather here is dismal and horrible, it's freezing cold, I have chilblains on my feet... and in my mind, because I am disgusted by the whole subject of math, I've just had more of it than I can take. It's fun to wade into discussions of hyperbolic parabolas, to glide through infinities and to struggle for hours with so-called imaginary numbers, as they don't exist (real numbers are merely particular cases of them) and to integrate differentials of the second order and to... and to... DARN IT!
That strong exclamation helps to clean the mud of it all off me and brings back some clarity to my mind. I chatted with QQ', I mean Pagès. I gave him the cake; you owed him 405 francs, but he will put the balance onto next term's bill. He told me that there is some hope for me, which consoled me about the problem with mathematics.
Don't worry if I get a bit depressed, it will pass! Luckily you are in a lovely part of the country! With kind old Diche, a comfort for you at your time of life.
The small books, known as the "Madame Jordan type" have appeared here and are being read with amazement. I believe that they will do a lot of good. I will ask him for several of them tomorrow. There is also another very good moral message in a theater play (by Brieux I think), *The Rotten Ones.*
I will say goodye, dearest Mama, having nothing more to tell you. I kiss you with all my heart and beg you to write to me every day as before!
Your respectful and loving son,
Antoine

Vous avez bien de la chance d'être dans le midi mais c'était impossible que j'y aille - Quel retard avez vous mis?

Il fait un Temps morne et détestable, un froid de chien etc..., j'ai des engelures aux pieds... et à l'esprit= car je suis aujourd'hui au point de vue des Maths c'est à dire que j'en ai par dessus le dos c'est bien amusant de patauger dans des discussions de paraboloïdes hyperboliques et de planer dans les infinis, et de se casser des heures la tête sur des nombres dits imaginaires parce qu'ils n'existent pas (les nombres réels n'en sont que des cas particuliers) et d'intégrer des différentielles du second ordre et de.. et de.....Zut!

Cet énergique exclamation adoucit me désembarrasse un peu et me rend quelque lucidité. J'ai causé avec QQ' c'est à dire Pagès; je lui ai donné la galette; vous lui devez 40 fr. mais il mettra le surplus avec la note du prochain trimestre - il m'a dit que j'avais quelque espoir

Ce qui me console des mathématiques.
Ne vous en faites pas si...

j'ai un peu le cafard ça passera! Heureusement que vous êtes dans un joli pays! Avec la gentille Doche, la consolation de vos vieux jours!

Les petits Bouquins genre madame Jordan se sont introduits ici et sont lus avec stupeur. Je crois qu'ils pourront un très grand bien - je vais leur en demander plusieurs demain. Il y a aussi quelque chose de très bien comme moralité aussi c'est une pièce de Théâtre (de Brieux je crois) "les avariés"

Je vous quitte maman car n'ayant plus à vous dire je vous embrasse de tout mon cœur et vous supplie de m'écrire tous les jours, comme avant!

Votre fils respectueux qui vous aime

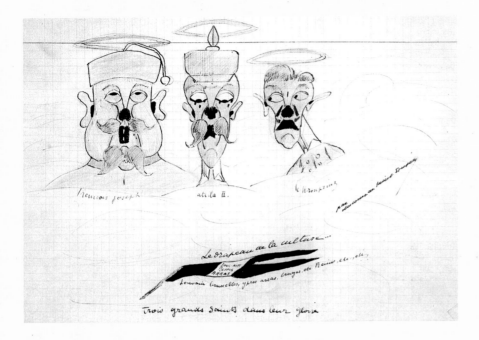

The Germans bomb Paris

Experiencing the war in Paris does not seem to have left a particularly strong impression on the young boarder in the Lycée Saint-Louis, in that spring of 1918. The Germans were close enough to the capital, at the time, to enable their bombers to do some serious damage in the city, with the help of "Big Bertha", whose incendiary bombs were pounding the city. Many air raids took place from February to June, terrifying the population but exhilarating the students who, refusing to seek refuge in the shelters, climbed up to the roofs of the school to watch the spectacle: "The sky was filled with airplanes and projectors, shells were streaming across it, it was surreal. You could hear the machine guns and above all, the cannon, which didn't stop for a second: pan… panpan… panpanpan… panpan… and from time to time we saw a flash and heard the bombs exploding "it was complete havoc, my friend!" I saw a French airplane falling and in flames (the Jerries shot down several of them) it was like a huge torch."

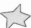

… Since the last two air raids everybody has been running away, the stations are being besieged, people are getting crushed, it's total mayhem. It's obvious that if the Germans come back tonight and if I don't get a cable from you by noon tomorrow it will be absolutely pointless to try to leave, in any direction. There's general panic here. Cable me quickly to let me know where to get a ticket for!

Everything is going well. I received a note from grandfather saying that Le Mans is full of Parisians fleeing from Paris: how scary! As for us, we don't worry about something as minor as that, in fact we're having a lot of fun about it and we're happy to write calmly on the walls "When will Fritz drop some bombs on the 'Louis bazaar'?"

It's just that we're spending half of our nights in the cellars, and that's exhausting. Goodbye dearest Mama, I kiss and hug you. Dammit! All the window panes of the bazaar have been knocked out as there's just been [a terrifying explosion I'm not sure where, in the direction of Saint-Denis. We all just climbed up to the attic to see it. There is a huge column of smoke. It's amazing, unimaginable.

N.B. We've just learned that it was a factory that was completely blown up.

I kiss you

Antoine]

Above : « Some profiles of Krauts, by Antoine de Saint Exupéry », 1914.

Right-hand page : Extract from an unpublished letter to his mother, April, 1918.

depuis les deux derniers raids tout le
monde fuit, les gares sont prises d'assaut,
les gens se ruent, c'est l'affolement le
plus complet il est clair que si les bothas
reviennent cette nuit et j'ai grand crainte
aussi que (n'ai pas) une dépêche de vous il sera
absolument inutile d'essayer de partir
dans n'importe quelle direction. C'est la panique.

Télégraphiez moi vite pour où prendre
mon billet !

Ça va bien à tous les points de vue
j'ai reçu le grand père un mot où il me dit
que le Mans refuse les Parisiens fuyant
Paris : quelle frousse ! Nous on ne
s'en fait pas pour si peu ça nous amuse
au contraire énormément et on se
contente d'écrire philosophiquement sur
les murs "quand donc les bothas lâcheront
ils leurs bombes sur le "Bazar Louis" ? "

Seulement cependant la moitié de ces
nuits dans les caves : c'est éreintant.

Au revoir maman chère je
vous embrasse li H

Bon sang ! tous les carreaux du
bazar ont sauté il vient d'y avoir

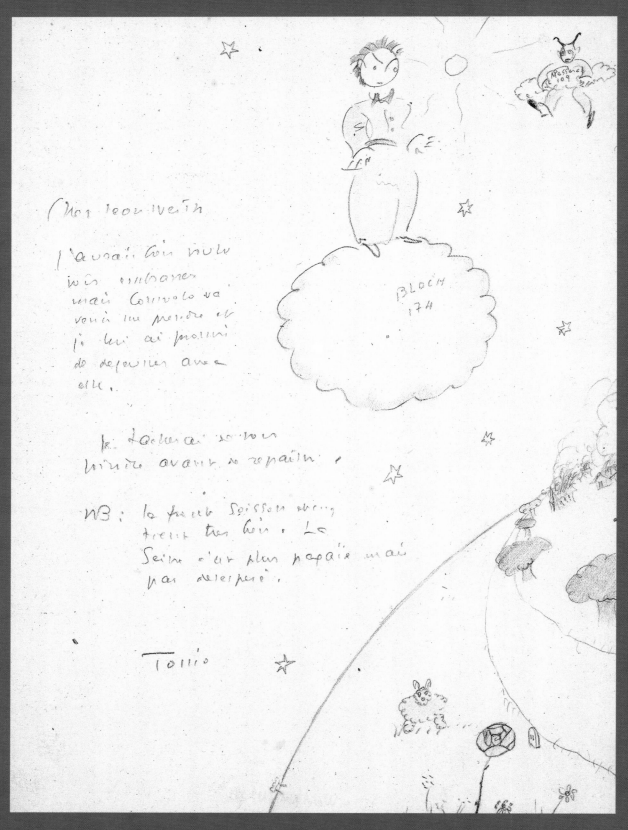

Above: Illustrated letter to Léon Werth.
Right-hand page: Antoine de Saint Exupéry in 1921.

The Friends of Saint Exupéry

« There is only one true luxury,
and that is the luxury of human relations. »

T he first children who shared in the games of young Antoine were his brother, sisters and cousins. Blessed with an open and imaginative character, he had no difficulty making friends among his classmates who liked his fertile imagination. At Sainte-Croix of Le Mans, Antoine, who was nicknamed Tatane or Pique-la-Lune (Catch the Moon), was the editor of a class newspaper he created with some friends entitled *L'Echo des troisièmes (The Echo of the 8th-graders)*. Unfortunately, there was to be no second issue of the paper.

During World War I, Saint Exupéry formed a friendship with Charles Sallès, a fellow student at the boarding school in Switzerland, whose parents owned a house not far from Saint-Maurice. From their first meeting, Antoine told him about an experience he had had three summers before: "You know what? I went up in an airplane; it was great!" From that moment on, a deep friendship developed between Sallès and Saint Exupéry. This is confirmed by the long letters they wrote to each other while they were students and, later as adults, by the hiking trips they improvised whenever they had a few days off, and by Saint Exupéry's surprise arrivals in Paris or at the cottage Sallès owned near Tarascon in Provence. In spite of Antoine's somewhat chaotic lifestyle, the two men remained in regular contact by letter and telephone up until Saint Exupéry's departure for the United States at the end of 1940.

In Fribourg, Marc Sabran and Louis de Bonnevie became his friends, and he had several others in Lyons. Saint Exupéry joined them both in 1921, in Morocco, where each of them would be lost, one only a year after the other.

Back in Paris, he became a friend of Henry de Ségogne in class where he prepared for the entrance examinations, and at the Ecole des Beaux-Arts, he became friendly with Bernard Lamotte, whom he would see again in the United States in 1941, and who agreed to do the illustrations for *Flight to Arras (Pilote de guerre)*.

The post-war years were lively: Antoine enjoyed the whirlwind of Parisian life. Through Bertrand de Saussine and his younger sister Rinette, with whom he exchanged particularly interesting letters, he met the Vilmorins, who invited him to visit them in Verrières. He fell in love with Louise, to whom he became engaged in 1923. But these plans were abandoned and the engagement was broken off that autumn. In spite of the break-up, Louise de Vilmorin and Saint Exupéry continued to write to each other. Antoine remained in Paris, where his cousin, Yvonne de Lestrange, the wife of the Duke of Trévise, welcomed into her salon on the Quai Malaquais all the famous names of the literary world in Paris. It was there that he met Gaston Gallimard, André Gide, Jean Schlumberger and Jean Prévost, who published his first text in 1926, in *Le Navire d'argent (The Silver Liner)*, Adrienne Monnier's literary review.

His two-year military service finished on June 5, 1923. At the request of his fiancée's parents, he gave up his vocation as a pilot and started a more earthbound career as a representative of the truck manufacturing firm of Saurer in the central provinces (Bourges, Montluçon, Vichy, etc.). But, whenever he could, he got away from this rather morose heartland of France and went to Paris to see his friends.

Right-hand page :
Drawings by Antoine
de Saint Exupéry.

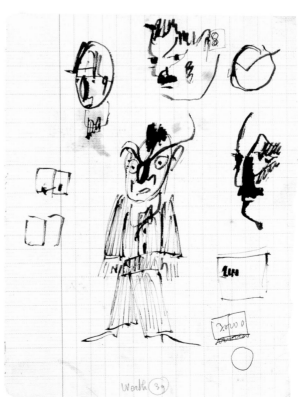

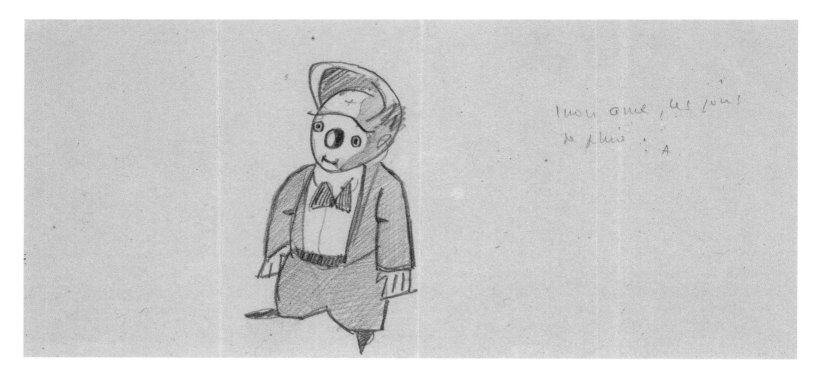

Above : Drawing by
Antoine de Saint Exupéry.

After eighteen months of a life devoted to trucks, which he just wasn't any good at selling, and weary of a boring routine that depressed him, Saint Exupéry, to his great joy, joined the Latécoère Company in October 1926, with the help of Beppo de Massimi, whom he had met through Father Sudour, his former counselor at the Lycée Bossuet. There he met some exceptional individuals who would become his comrades and fellow adventurers: Mermoz, Guillaumet, Serre, Reine, Riguelle… After spending a year in the solitude of Cape Juby, Saint Exupéry joined Mermoz and Guillaumet in South America in 1929. All three became pilots for Aeroposta Argentina, and each of them had his quite specific missions: Mermoz was the pioneer of the sky; he set out in search of new air routes. "Thus Mermoz had cleared a path through the

sands, the mountains, the night and the ocean." Guillaumet transported mail over the crests of the Andes. In June 1930, when Guillaumet's airplane was caught in a storm in the middle of the Andean winter and he made an emergency landing on the frozen Laguna Diamante, everybody believed that he had died; except Saint Exupéry. He flew over the Andes for three days to find the missing pilot. Nobody could see Guillaumet in the middle of the snowy wasteland, even though he could see the airplanes that were flying around in circles looking for his plane. He was convinced that it was Saint Exupéry who was braving the elements, searching for him, "because nobody but you would have dared to fly so low." Mermoz, his "unbearable" friend, who was so different from him in education and political leanings, and Guillaumet, his "brother", were to

remain, right up until their tragic disappearances in 1936 and 1940, close companions of Saint Exupéry, in a friendship rooted in ties that went far beyond beliefs and appearances.

1931 marked the end of the Aeropostale adventure. Famous now, because of *Night Flight (Vol de nuit)*, which won the Femina Prize, Saint Exupéry moved to Paris, where he made friends with other writers: Léon-Paul Fargue, Joseph Kessel, Henry Jeanson, and, above all, Léon Werth. Twenty-two years his senior, Jewish, anarchist, and a free-thinker, this writer was to become, for Antoine, the paternal figure he had not had in his youth, friend, confidant, correspondent, as well as a critical and attentive reader. As soon as he could take some time off, Saint Exupéry visited Léon Werth in Saint-Amour, in the Jura mountains, and read him sections of his works in progress, especially *Wisdom of the Sands*. *The Little Prince* would be dedicated to Léon Werth. When World War II broke out in 1939, Saint Exupéry requested a posting to an airborne reconnaissance unit. When he joined 2/33 squadron in Orconte, in the Aisne, he was met with some apprehension by the pilots who felt intimidated by the new arrival, complete with his noble name and his recent literary fame. How surprised they must have been when Saint Exupéry held out his hand and introduced himself with these plain words: "Saint Exupéry, pilot"! With Gavoille, Hochedé, Dutertre, Laux and Israël, he endured the rigors of an icy winter, the tension of the mission ahead, the sadness at the disappearance of comrades, and the joy of seeing pilots returning alive. All of these men would have their names immortalized in *Flight to Arras*.

At the end of 1940, Saint Exupéry set off for the United States in order to convince the Americans to intervene in the war in Europe. Aboard the ship to America, he met and shared a cabin with Jean Renoir. During the crossing, the two men became friends and planned to make a film of *Wind, Sand and Stars*. Later in 1942, the film director played host to the pilot during his stay in Hollywood. The American exile, which was to last only a few weeks, in fact lasted longer than planned. Saint Exupéry was champing at the bit. Luckily, he met up with his friend, the painter Bernard Lamotte. Also among his friends in the United States, were his American editor Reynal, Pierre Lazareff and Jean-Gérard Fleury, to whom he confided over and over again how much he wanted to go back into combat. Finally, in April 1943, Saint Exupéry received his orders and his mission. He travelled back across the Atlantic to the 2/33 unit. "I am coming home. 2/33 unit is my home." In Lagouath, in Tunisia, he rejoined his comrades in arms.

When he went missing on July 31, 1944, Saint Exupéry "left incurable wounds in the hearts of those who had seen him smile, even once."

Above: Drawing by Antoine de Saint Exupéry.

« It's great…
to have friends »

It was in Switzerland, at the Villa Saint-Jean, in Fribourg, that Charles Sallès first met Antoine, in November 1915. He would always remember that their first conversation, on the benches of the refectory, had been about aviation. "You know? I went up in an airplane. It was fantastic!", the future aviator had told him on that occasion. Charles' family owned a property in Ambérieu-en-Bugey, opposite Saint-Maurice-de-Rémens, where the Comtesse de Tricaud used to welcome her niece, Marie de Saint Exupéry and her children.

The two young friends were inseparable. Charles went to the Hautes Etudes de Commerce, the elite state business school in Paris, graduating in 1923, and then devoted his time to running a farm at the Mas de Panisse, near Tarascon, in Provence. That was where Antoine went to stay with him, in 1940, after the armistice, while waiting for his visa to the U.S.A., which he was to receive in mid-October. Riding on a tandem, in spite of a strong Mistral wind that was blowing, with the traveler's small suitcase strapped to the rack, the two friends went to the train station. They were never to see each other again.

My dear old friend,
I have been here, touring through my region for the last two days, my training period having lasted for a month longer than I thought it would. I still don't have a car and am traipsing around by train, which, on these local lines, has very little charm to it. Your letter pleased me, as you know. It's very pleasant in life to have friends like you, but it's really sad not to see you any more. If my presence isn't enough to bring you to Paris, there's a wonderful movie at the Max Linder, *The Pilgrim*, by Chaplin, which really is a comic masterpiece, with great sensitivity. That guy's gift of observation is marvelous.
I saw the one you told me about. I really liked the opening. There is a seriousness about it, every gesture reveals a powerful intensity of a life of the mind. Even the most insignificant thing is dense, but after the opening I no longer found that quality which delighted me. It's well done, well observed; it's funny, it's sad, it has all the secondary qualities, but the first ten [minutes of the film formed a longer, more important drama than all the rest, the development of the ending is told rather than being naturally expressed, in the way that was so necessary at the beginning.]

Right-hand page:
Letter to Charles Sallès.

Montluçon, le _____ 192_

CAFÉ RICHE

H. MILLOT
PROPRIÉTAIRE

Téléphone 21

R. C. 5226

Mon vieil ami

Me voici depuis deux jours en tournée dans ma région. mon stage ayant duré un mois de plus que je ne le pensais et n'ai pas encore de voiture et me transbahute en chemin de fer à peu sur ces lignes de Montluçon marque de charmes.

Ta lettre m'a fait plaisir comme tu le sais. c'est doux dans l'existence d'avoir des amis comme toi. mais c'est bien triste de ne plus te voir. si ma présence ne suffit pas il y a pour t'attirer à Paris un film adorable qui passe où Max Linder "le Pèlerin" de Charlot, qui est vraiment un chef d'oeuvre. — comique et d'une sensibilité si fine. le don d'observation de ce type là est merveilleux.

J'ai vu celui dont tu me parles. le début surtout m'a plu. Il y a de la sobriété, chaque geste décèle un capital puissant de vie intérieure. le plus insignifiant est dense mais après le départ je ne retrouve plus cette qualité qui me ravit. C'est fin, c'est observé, c'est drôle, c'est utile, ça a toutes les qualités nécessaires, mais les deux

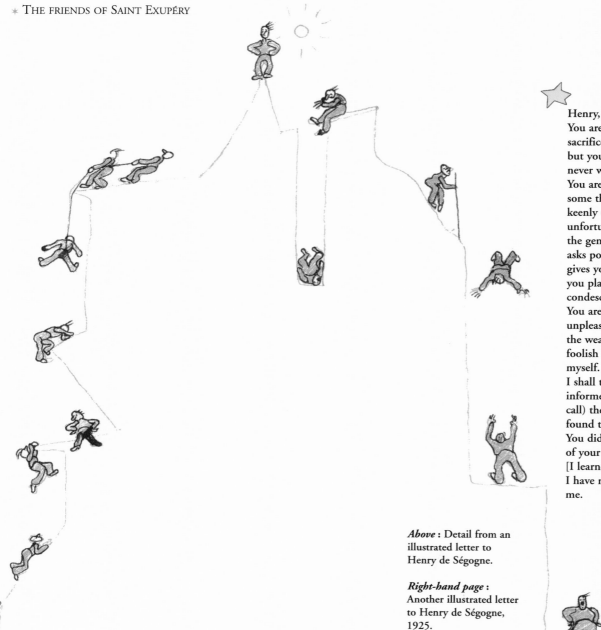

Henry,

You are a bastard. I was depressed. I sacrificed 3 F 75 to hear your siren's voice but you didn't want to get out of bed. You never want to be bothered.

You are a bastard. I would like to tell you some things that are horrible to hear. I'm keenly enjoying criticizing you – unfortunately you're indifferent to it. You're the gentleman one looks for, telephones, and asks politely what evening you are free. One gives you one's regards. During that time you play bridge and bow your head with a condescending air. I find that disgusting.

You are a bastard. I would like to be totally unpleasant to you. My affection for you is the weakness of a young virgin, the sign of a foolish character. I am also disgusted by it myself.

I shall take revenge: Reliable sources have informed me that when you made (what you call) the first trip of the Green Needle, you found the following lines written up there. You didn't boast about it, naturally, because of your rather unsportsmanlike pride.

[I learned with joy that you were alive. I have nothing to say to you except: write to me.

Antoine]

Above : Detail from an illustrated letter to Henry de Ségogne.

Right-hand page : Another illustrated letter to Henry de Ségogne, 1925.

Dearest

Antoine had made the acquaintance of Henry de Ségogne in the fall of 1917, while he had been a boarder at the Ecole Bossuet. They soon became good friends, a friendship that was sealed when Saint Exupéry came to Ségogne's aid during a brawl in the school yard, when the latter was attacked by a giant from the military academy of St-Cyr. They studied for the entrance exams to the Naval Academy together, organized the classic uproars of graduation and both failed the examination.

Their paths subsequently diverged, but they remained very close and, after Antoine's first airplane accident, in 1923, it was Henry de Ségogne who was informed first, as the injured man had on his person a note that mentioned his friend as "the person to inform in case of accident". It was, in fact, Antoine who arranged for Ségogne to take his first flight. The latter, an avid rock climber and mountaineer, used to spend his vacations amid the rocks of Fontainbleau or doing alpine climbs. This earned him taunts, in this letter, from Antoine, who was attracted to higher summits.

GRAND HOTEL CENTRAL

Place Bonnyaud

GUÉRET (CREUSE)

GARAGE

TÉLÉPHONE 80

R. C. Guéret 824

Guéret, le

192

Henry -

Tu es un salaud. J'avais le cafard, je sacrifiais £+75 pour
entendre ta voix de Sirène mais tu n'as pas voulu quitter les
draps. Tu ne veux jamais te déranger.

Tu es un salaud. Je voudrais te dire des choses pénibles à
entendre, j'éprouve une joie vive à t'expliquer — malheureusement
ça t'est égal. Tu as le moucrieu que l'on dérange, à qui on
téléphone, à qui on demande poliment pour le priver d'venir libre
ou te présenter ses hommages. Pendant ce temps tu joues au
bridge et inclines la tête d'un air condescendant. Ca me dégoûte.

Tu es un salaud. Je voudrais t'être infiniment désagréable. Ma
sympathie pour toi est une faiblesse de jeune pucelle, la marque
d'un caractère niais. Ca me dégoûte ami de moi.

Je vais me venger on m'a raconté de
nouvelles que forsque tu as pris
la première (que tu sais) de l'aiguille
verte tu as trouvé en haut les inscrip-
tions suivantes. ——————→

Tu ne t'es pas vanté bien sûr à
cause de ton orgueil peu sportif.

Left : Saint Exupéry and
Henri Guillaumet in front
of a Latécoère 28 airplane
in1929 (detail).

Right-hand page : Letter
to Henri Guillaumet,
around 1932 (?).

« My dear old Guillaumet »

Immortalized by Saint Exupéry in *Terre des hommes
(Wind, Sand and Stars)*, Henri Guillaumet, who was
two years younger than Antoine, was born in Bouy, in
the Marne and had been the student of Nungesser
before obtaining his pilot's licence. After leaving the Air
Force, like Jean Mermoz, he joined Latécoère, twenty
months before Saint Exupéry, who met him there in
1926; at the time, he was in charge of the Casablanca
line. On February 7, 1927, Guillaumet and René
Riguelle's Bréguets, Saint Exupéry accompanying
Riguelle, left Cape Juby for the Villa Cisneros. It was
during that flight that the second airplane, experienc-
ing a mechanical problem, crashed in the desert, with
its occupants, near Nouakchott. Guillaumet landed
there and picked them up, safe and sound. Three years
later it was Saint Exupéry who would be looking for a
whole week in the Andes for his missing friend's air-
plane; after being rescued, his friend would tell him:
"What I did, I swear to you, no animal could have
done."
His death, on November 27, 1940, at the controls of an
airplane carrying Jean Chiappe, who had just been
named high commissioner in Lebanon and Syria, per-
manently affected Saint Exupéry: "Guillaumet is dead.
It seems to me, this evening, that I have no friends
left."

My dear old Guillaumet,
You can see from the photograph above that
I'm eagerly awaiting your arrival: they can't
drag me away from the dune from which
I'm scouring the horizon.
And from the drawing below you can see
with what fervor I'm writing to you. – I'm
not even trying to put any order into it!
Your report was splendid. There is one seat
left at the Academy, and I firmly urge you to
try to win it. You'll get it. [I have nothing
to say to you because I have a hangover, so I
can't say anything too clever.
(I erased this sentence because it's vulgar
and you are very prim and proper.)
It's a crazy affection. I console myself with
my seat in the gallery. I have more and
more of a hangover. I have thought hard
and that's all the news I have to tell you.
Well, I shall put some order into it, just to
please you.
I did it. Good night. Your old

Antoine]

Mon vieux Guillaumet

Tu vois par la photographie ci-dessus que j'attends impatiemment ton arrivée. On ne peut plus m'arracher de la dune d'où je considère l'horizon.

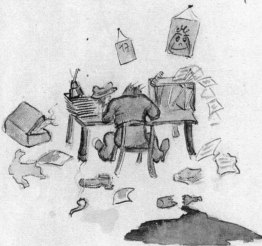

↑
encore cette sacrée pesanteur.

Et par le dessin ci-dessous avec quelle ardeur je t'écris — je ne pense même plus à mettre de l'ordre !

Ton rapport était épatant. Il reste un fauteuil à l'académie je te conseille vivement de l'achever. c'est une affaire.

Tourne la page tu verras si c'est beau !

Dear Jean,

Here I am in Vierzon. I'm going to have dinner and go to sleep, a sleep I have really earned. I had a really pleasant trip:
[drawing]
my guardian angel is here but I can't draw him
[drawing]
road from Paris to Orléans
road from Orléans to Salbris
road from Salbris to Vierzon
(it was night-time)

As I don't have any other entertainment here in my exile, I imagine the disorderly lifestyle that you're leading.
[drawings]
End

What else could I tell you? I shall leave it at that. I can't find anything more.
[drawing]

Good night

Antoine

Left and right-hand page:
Illustrated letter from
Antoine de Saint Exupéry
to Jean Escot.

Small echo of Vierzon

It was in May 1921, in Strasbourg, where he was doing his military service in the 2nd R.A.C., that Jean Escot got to know Antoine de Saint Exupéry. He had already been studying at the School of Pilots and had successfully obtained his military wings at Villacoublay. The two pilots met up again at the Avord school, where they were both in the officer cadet program of the Aeronautical Reserve, and then in Versailles, where their training continued. They both obtained permis-sion to fly at will there and, in these daily expeditions they cemented a friendship that was never weakened by distance and different life-paths.

Saint Exupéry's confidence in his friend was real and he asked him to read the stories he had written, before showing them to others. In this way, "the aviator" appeared in *The Silver Liner*, by Adrienne Monnier, which Escot liked and commented on, and to whom Antoine wrote: "Of all my friends, you are the one who has the finest judgment."

ça, je n'en sais rien.

garagiste de Linas.

TÉLÉPHONE 19

GRAND HOTEL DU BŒUF
& CENTRAL HOTEL
VIERZON
(CHER)

LOUIS SAPIN, PROPRIÉTAIRE

Chauffage Central

Électricité

Garage Recommandé

GUIDE MICHELIN

R. C. BOURGES 487

Vierzon, le _XX^e Siècle_ 192

Mon cher Jean.

Me voici à Vierzon. je vais aller dîner et dormir d'un sommeil bien gagné. j'ai fait un bien joli voyage : ↓

mon ange gardien est là mais je ne sais pas le dessiner.

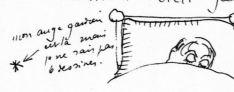

route de Paris à Orléans —

route d'Orléans à ~~Saglitais~~

route de ~~Saglitais~~ à Vierzon

(il faisait nuit)

Comme je n'ai pas d'autre distraction j'imagine dans mon exil la vie patachon que tu mènes. —

(1)

(2)

Dear Jean,
I'm writing to you from Bourges. It's a very
pretty city. The inhabitants are called
Bourgeois. When they are young they are
known as Bourgeons [buds].
[drawing]
Above, a view of the city.
There is another street that is very
interesting [drawing]
And empty cafés.
Symbol of the cafés of Bourges: [drawing]
Hide in the spittoons
The annual customer has just left

People walking [drawing]

[drawing]
the only occupation…
Good night, I'm going to see another
customer
Antoine

[drawings]
this is me yawning, but you'd have to know

Here lies the last of Saurer's buyers
R I P

Small echo of Bourges

When Saint Exupéry reluctantly left the French Air
Force upon the insistence of the family of his fiancée,
Louise de Vilmorin, and decided to go back into civil-
ian life, he worked first for a tile-making company whose
prestigious address in the Rue du Faubourg Saint-
Honoré could not disguise the uninteresting nature of
the work. He soon left it in order to sell Saurer trucks,
for which he became the representative in Central
France. Jean Escot lent him his car for the trips he had
to make and he received frequent reports on these, often
with illustrations. Several of these letters have been pre-
served. They relate the painful trials and tribulations of
a very specific kind of commercial representative, work-
ing at a particularly slow time of year, and finding him-
self in a sinister environment.

Antoine humorously tells his friend, in just a few lines
and wielding an avenging pencil, about the principal
events of his routine existence: a tricky breakdown, the
solitude of deserted restaurants, the unappealing nature
of his job and the sadness of this life, which he evidently
had not been destined to lead.

*Above, below and
right-hand page :*
Illustrated letter from
Antoine de Saint Exupéry
to Jean Escot.

E. Gautier

LE GRAND CAFÉ
RESTAURANT
BOURGES

16, Rue Moyenne, 16

*Rendez-vous de MM. les Voyageurs
et Négociants*

Bourges, le 192

Mon cher Jean

Je t'écris de Bourges. C'est une bien jolie ville. les habitants s'appellent des Bourgeois. Quand il sont petits, des bourgeois.

MERCERIE

ARTHUR TAILLEUR

(chien)

Ci dessus une vue de la ville.
Il y a une autre rue très curieuse ⟶
et des cafés vides

Symbole des cafés de Bourges :

crachez dans les crachoirs

le client annuel vient de sortir.

Promeneurs.

… I would really like you to know something that you are already very well aware of. I really need you because I believe that you are the friend I love most among those I have – and also because you are my moral sense. I think I understand things somewhat the way you do and you teach me well. And I often have long discussions with you. And I am not biased. I almost always admit that you are right. But, in addition to that, Léon Werth, I like to drink a Pernod with you on the banks of the Saône while munching on sausage and country bread. I can't express why that moment gives me such a perfect sense of completeness – but I don't need to express it because you know it better than I do. I was fine, happy and I would like to start again. Peace is not something abstract. It's not the end of risk or of cold weather. I don't care, I have no fear of risk or of the cold and I am proud of myself as far as Orconte is concerned. On waking up, I heroically reached my fireplace. But the peace lies in the sense in which it is like munching on sausage and country bread on the banks of the Saône together with Léon Werth. It saddens me that the sausage doesn't have a stronger taste.

Come and see me – but we shan't go to the group which is – not sad – but saddening. We'll go and spend the day in Rheims. We'll try to find a good restaurant. And then we can arrange to meet with Delange who could bring Cam and Suzanne. I invite you all to a great banquet – come quickly and make me happy. You must hurry because if I emigrate in 1/52 I shall be very far from Paris.

« I almost always admit that you are right… »

Nothing would suggest that a long and exceptional friendship would develop between Saint Exupéry and his elder by 22 years, the writer Léon Werth, a true man of the Left, the author of many politically engaged books, whose ideas he very often did not share. The two men had met one evening in 1931, at the Deux Magots café, through René Delange. "It wasn't a meeting of minds, because they never stopped arguing; but for one and the other, it was a kind of love at first sight", notes Curtis Cate in his biography of Saint Exupéry. In 1943, he published *Lettre à un otage (Letter to a hostage)*, which was to be a preface to a book by Léon Werth and, in the same year, *The Little Prince*, which he dedicated as follows: "I ask the children to forgive me for having dedicated this book to a grown-up. I have a serious excuse: that grown-up is the best friend that I have in the world. […] All grown-ups were once children. (But few of them remember it.)"

Above : Illustration in the margin of a note from Antoine de Saint Exupéry to Léon Werth.

Right-hand page : Letter to Léon Werth.

Je voudrais bien que vous sachiez ce que vous savez d'ailleurs très bien. J'ai infiniment besoin de vous parce que vous êtes d'abord, je crois, celui que j'aime le mieux de mes amis — et puis parce que vous êtes ma morale. Je crois que je comprends les choses un peu comme vous et vous me renseignez bien. Et j'ai souvent de longues discussions avec vous. Et je ne suis pas partout ; je vous donne presque toujours raison. Mais aussi, leur Worth, j'aime causer avec vous en prenant un verre dans les bois de la Saône en mordant dans du saucisson et du pain de campagne. Je ne sais pas dire pourquoi cet instant-là me laisse un goût de plénitude si parfaite — mais je n'ai pas besoin de le dire puisque vous le savez mieux encore que moi.

J'étais bien content. Je voudrais bien recommencer. La paix a n'est pas quelque chose d'abstrait. Ce n'est pas la fin de guerre et de froid. Ça me serait égal. Je n'ai peur ni de guerre ni de froid et puis loin très de moi quand ô beauté, au soleil, j'ai tellement atteint ma domicile. Mais la paix c'est que ça ait un sens de mordre dans du saucisson et du pain de campagne sur les bois de la Saône en compagnie de leur Worth. Ça m'attriste que le saucisson n'ait plus de goût.

Venez me voir — mais vous n'irez pas me rappeler qui est — mon tristi — mais attristant. Nous irons passer la journée à Reims. Nous tâcherons de découvrir un bon artiste. Et puis on pourrait revoir vers ô Dolange qui amènerait Cori et Suzanne. Je vous invite tous à un pour banquet — venez été ne vendre joyeux. Il faut vous répondre parce que peut-être au 1/12 je serai très loin de Paris.

Left : Preparatory
drawing for
The Little Prince.

Right-hand page :
The Little Prince.
Preparatory state.
Illustrated manuscript.

Some drawings for my friends

This passage, which was not retained by the author for the definitive edition of his book, appears in the original manuscript of *The Little Prince*, which Saint Exupéry gave to one of his friends, Sylvia Hamilton, before his departure for North Africa in April 1943. Preserved in the Pierpont Morgan Library, in New York, it consists of 175 loose sheets, eight of which bear an illustrated text and 35 others drawings, or, generally, watercolors by the author.

One may also consult, at the Bibliothèque Nationale de France, a later typescript, with revisions by the author, which is partially illustrated, and which belonged to Nadia Boulanger, to whom Saint Exupéry had given it in New York.

These two texts differ from the definitive version, the first French-language edition which was published in the United States by Raynal and Hitchcock in April 1943. There have been more than one hundred and forty translations, to date, into different languages of this book, which is one of the world's best sellers.

As I am outside the game, I have never told grown-ups that I wasn't like one of them. I hid from them the fact that, in the depths of my heart, I was always five or six years old. I also hid my drawings from them. But I would really like to show them to my friends. These drawings are memories. Once upon a time there was a little prince who inhabited a planet that was too small and he was really bored.
Every morning he would get up and sweep. When there was a lot of dust, there were
[several illegible words]
[two drawings]
But he took his bath in the sea.

He had problems with the volcanoes which made everything dirty. He also had problems, on account of the seeds, because he kept a garden to feed himself. There were radish, tomato, potato and bean seeds. But the little prince could not eat fruit. Fruit trees are too big. They would have destroyed his planet. But in his packet of seeds, there were baobab seeds. As nothing is ever perfect, baobabs have a circumference of ten [one illegible word]. They would have split open his planet. And the little prince could not recognize the baobab seeds. He thought he would let everything sprout and he would pull out the weeds once he recognized them.

(4)

Comme si mon crayon brusquement mît aux
crayon survenu ne se vessait pas en leur milieu. Ce qui causai tout
ce j'avais toujours cinq ou six ans au fond de coeur. Il leur au
aussi senti un espoir. mais je veux bien les montrer ce vous
aussi. ces traits ce vous souvenir.

? et au un [.....] voulu faire le portrait un l'hau
tiez partir et il recommençai travaux.

Tout se matin il se levait au à se betayant. Alors je
j'avai beaucoup ce pouvais ... sa façon en ta selon
[........]

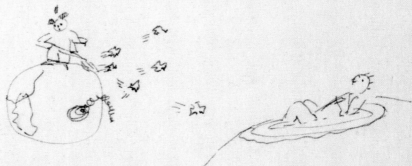

Puis il prenait un bât dans les mains.

[........] qui celui qui toutes ·
Il avai un tres [......] c'était un volcans · Il avai un
second ami à cause ses chaines. Cela l'avais va pauvre jour
se mettre. Il ne s'avais pas se rati . au contraire, il homme se
tous ce se hanuris. mais le pain sifflu un cumbai pas
mouser se fumi. Les autres ce l'avoir l'aurai [.......] afin se
pleur. mais ce un risque se chaini et y avai un
grand se travaux. Mangu rai mes j'amai persan. Les boabres
ont dix ans ce bon · en ennui l'au à dans sa pleur. Et
le pain jour ce s'avais pas recommande les boabres. Il clan star.
se l'anoz tous prouxon · et au à arroché les mauvais tan
Ca au à les reconneuren. les mauvais [.....] caractez,

Left : Drawing by Saint Exupéry in the margin of the typed manuscript of *Wisdom of the Sands*.

Right-hand page : *Wisdom of the Sands*, handwritten manuscript.

« And we are happy now »

This homage to true friendship, which makes up Chapter CVIII of *Citadelle (Wisdom of the Sands)*, confirms the terms in which he wrote about it in the *Letter to a Hostage*, and which Léon Werth would later comment on in these terms in *Saint Exupéry tel que je l'ai connu (St Ex. As I knew him)*: "It is obvious that he distinguishes friendship from comradeship or cool sympathy based on shared ideas or obsessions. We are living at a time when friendship is often confused with the attraction animals of the same herd feel for each other. I have seen friendships, apparent and inauthentic friendships formed by the effect of converging ideas. I have seen friendships dissolve by the effect of diverging beliefs. But friendship through the coinciding of ideas, ontological friendship, what a lack of it there is! To which Saint Exupéry replied: 'I recognize true friendship by the fact that it cannot be disappointed…'"

A friend, above all, is somebody who does not judge you. I have told you that he is somebody who opens his door to the vagabond, with his crutch, with his stick, which he has set down in a corner and he does not ask him to dance, so that he can judge his dance. And if the vagabond tells of the spring he passed on the road outside, a friend is somebody who welcomes the spring within him. And if he tells of the horror of the famine in the village he comes from, he suffers that famine with him. For I have told you, the friend in the man, is the part that is for you and that opens a door for you which he may possibly never open anywhere else. Your friend is true and all that he says is true, and he loves you even if he hates you in the other house. And the friend in the temple is he who, thank God, I brush past and meet, he who turns to me the same face as my own, lit up by the same God, for then unity is achieved, even if, elsewhere, he is a shopkeeper, while I am a captain, or a gardener while I am a sailor on the sea. Over and beyond our discussions, I have found him and am his friend. And I can be silent near him, that is to say, not fear anything from him concerning my interior gardens and my mountains and my ravines and my deserts, for he won't place his feet there. You, my friend, what you receive from me with love is like the ambassador of my interior empire. And you treat it well and you let it sit down and you listen to it. And we are happy.

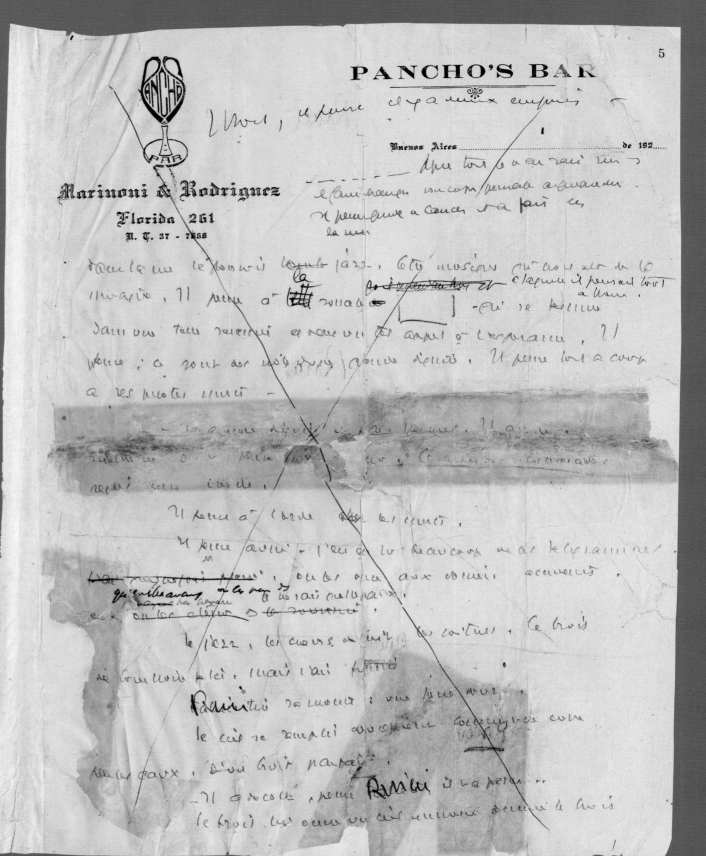

Above : A page from the manuscript of *Night Flight,* on a piece of paper with the letterhead of "Pancho's Bar".
Right-hand page : Antoine de Saint Exupéry, airline pilot.

The Airline Pilot

« I believe, and I am not the only one who does, that Aeropostale has lost a lot of its charm ever since we have had dependable engines and radios on board. We no longer experience that little pang of anguish that was so appealing: Will I make it? Won't I have a breakdown? Where am I? Those are the questions that we used to ask ourselves, before. Now, our engines are secured against any incident; there is no skill involved in finding our route because the direction finder displays it for us. Really, in these conditions, flying a plane has almost been reduced to a simple bureaucratic task. It's a life that is lacking in the unexpected. We like this one too, but the other one... »

The aerodrome of Ambérieu lies a few kilometers from Saint-Maurice-de-Rémens. In 1912, it was merely a vast meadow on which the "strange machines," made of wood and canvas landed and took off noisily. Antoine was fascinated by the ballet of the planes whose paths crossed above his head. His dream was to climb into those large insects one day and gaze at the earth from above. Accompanied by his younger sister, Gabrielle, known as Didi, his bicycle trips often took him to the edge of the runway. An outgoing and friendly child, he would go up to the mechanics who repaired the aircraft and bombard them with questions. At the end of the conversation, he finally asked the one that was closest to his heart.

Above : Sketch of an airplane. Drawing by Antoine de Saint Exupéry.

The answer was like a bolt from the blue: "If you get your mother's permission, we can take you for a ride." Therein lay the problem: Marie de Saint Exupéry would not allow her son to embark on such an adventure. After several fruitless attempts, Antoine, knowing that his mother would never waver, decided to go without her consent. And here he was, sitting in the cockpit for a twenty-minute aerial excursion. At the controls of the aircraft was Gabriel Wroblewski-Salvez, flying one of the planes that he had built with his brothers. For Antoine, it was dazzling. His vocation was born, he would become a pilot! And yet, it was in the navy that he wanted to make his career and he prepared for the entrance examination to the Naval Academy after his baccalaureate. A twist of fate: he failed the entrance exam several times. Drafted into the military in 1921, he chose to serve in the air force, and was sent to Strasbourg, to join the Second Fighter Regiment in the French Air Force, based at Neuhof. Unfortunately for him, he was sent to join the ground crew without any possibility of undergoing pilot training, as he had not taken any training course. Quickly, life in the barracks began to bore Saint Exupéry. "Nothing new. Obviously, there are more interesting things than life in the barracks. You gradually become depressed." That was when he decided to get his civilian pilot's license, which at the time required twenty-five hours of flying time. Even if the training was time-consuming and difficult, it would enable him to obtain his air force pilot's license without having to spend more time in the military. He persistently urged his mother to agree, even though she preferred to see her son devote his free time to studying. She grew tired of resisting and finally agreed to pay for the training course. Robert Aéby, who had been a pilot in World War I, gave Antoine his first flying lessons on a Farman

40, fitted with dual controls, and then on a Sopwith. After three months, Saint Exupéry was sent to Morocco to take a specialized training course in Casablanca. He obtained his air force pilot's license in December 1921. He was promoted to corporal, returned to France in February 1922 and spent several months at the Avord camp.

Saint Exupéry wanted to become a professional pilot, but when he became engaged to Louise de Vilmorin in 1923, his in-laws asked him to give up this adventurous life in favor of a more stable career. Saint Exupéry became an accountant in a tile factory, and then a representative for a trucking company in central France… He accepted these jobs even though he had no interest in them. After his engagement broke off, it took him two years to go back to what he considered his true calling, flying. On June 26, 1926, he obtained his license as a public transportation pilot, which allowed its holder to carry passengers. Saint Exupéry joined the French aviation company and earned his living by giving people their first flights over Paris. In October of that year, through Father Sudour, his mentor at the Lycée Bossuet, he met Beppo de Massimi, the director of the Latécoère Company. Impressed by the young man's enthusiasm, Massimi sent Saint Exupéry to Toulouse for a series of interviews. Didier Daurat, the managing director of the company, hired Saint Exupéry and immediately sent him to the workshops to learn how to repair an aircraft engine. After several weeks' training, he was able to fly Breguet 14s, first as far as Perpignan, and then over the Pyrenees and the Mediterranean. Finally, in January 1927, Saint Exupéry was posted to the Casablanca to Dakar line. From these dangerous flights over a country in turmoil, where the rebels were not averse to firing at planes or people, Saint Exupéry gained a feeling of free-

dom, which he tried to describe in his letters to family and friends. Flights over these hostile regions were always carried out by two aircraft, one of which carried an interpreter who was to get the pilots out of difficult situations in case of emergency landings. He experienced his first mechanical breakdowns in the desert, his first contacts with the Moors, his first nights spent out in the open, all of which would be included as episodes in his books. After a year spent carrying mail, Saint Exupéry was made director of the air station at Cape Juby. His work was more sedentary as it was his responsibility to receive airplanes and to ensure that they took off again in good condition. Returning to France, Saint Exupéry brought back with him the manuscript of a book that was published by Gallimard, entitled *Southern Mail*: this was one of the first books to deal with aviation, a mode of transportation which no one believed was viable for a long time. For a few months, he became a test pilot on Laté 25 and 26s, before being sent to Buenos Aires, as the director of the Aeroposta Argentina. He experienced many difficulties flying in a country where the strong and violent winds coming from Patagonia often prevented planes from landing and taking off and where crossing over the high crests of the Andes was always a risky exploit. In charge of setting up an airborne route from Buenos Aires to Tierra del Fuego, Saint Exupéry scoured the country for locations where new bases could be created: "And so, we were welcomed like Messiahs by the councils of the obscure little

Left: Antoine de Saint Exupéry as an aviator.

Above : Sleeping
aviator, preparatory
drawing for *The
Little Prince.*

Right-hand page :
Cape Juby in 1928 :
Saint Exupéry, Dumesnil,
Guillaumet, Antoine
and Reine.

towns, which we were suddenly putting in contact with life in the outside world." He also felt fear while flying at night, having anguishing experiences that he described in his second book, *Night Flight*, which was awarded the Prix Femina in 1931.

In March 1931, Aeropostale underwent compulsory liquidation. Without a stable job, Saint Exupéry went back to Morocco to fly between Casablanca and Port Etienne on more modern aircraft. But he had lost the enthusiasm he had felt during his early flights on the Bréguets. He worked for a time as a test pilot on hydroplanes, but quickly gave up this new career as a result of an accident that almost cost him his life on Christmas Eve 1933 in the bay of Saint-Raphaël. From then on, Saint Exupéry's career as a pilot was marked by stops and starts. He undertook publicity tours for Air France, which did not want to make him a member of its team of pilots. These lecture tours led him to go around the Mediterranean, from Casablanca to Athens, via Cairo and Damascus. He was then picked to search for locations to set up a new air route in Africa, from Saint-Louis-du-Sénégal to Bamako.

Saint Exupéry also took part in timed flights organized by the Ministry of the Air, which wanted to test the capabilities of aircraft flying at higher speeds. Large sums of money were awarded to those who broke the speed records. This was a godsend to Saint Exupéry whose finances were always precarious. His first flying mission aboard a hydroplane in July 1934, took him as far as the Mekong straits, where he had to make an emergency landing, before returning to France, suffering from tropical fevers. In 1935, accompanied by his mechanic André Prévot, Saint Exupéry decided to set off from Paris, in his Caudron "Simoun", hoping to reach Saigon in less than 98 hours and 53 minutes. Preparations for the flight were rushed and the crew took off from Paris on December 29. The adventure was to end in the Libyan desert, in the early morning of the 30th, when the plane hit a sand dune. The plane could not be salvaged, but the two men were unharmed. In February 1938, Saint Exupéry took part in a second race against the clock, which was to establish a link between New York and Tierra del Fuego. During a refueling stop in Guatemala City, an error in the fuel pumping made the aircraft too heavy. Take-off was impossible and the plane crashed at the end of the runway. "When they got me out of the plane, I was the biggest piece of wreckage." He suffered eight fractures, a dislocated shoulder, swollen eyes, and almost lost his right arm, from gangrene, as a result of this accident.

Saint Exupéry's life as a civil pilot came to an end on the eve of World War II. Despite the rapid developments in the art of flying and the progress made in the level of comfort in airplanes, Saint Exupéry would always remain nostalgic about the earliest era of aviation:

All of my comrades who experienced them speak with sadness about the good old days of the Bréguets. We miss the joie de vivre, the quality of the things we experienced, back then, which we will never find again. By comparison, flights today seem to us to be dull.

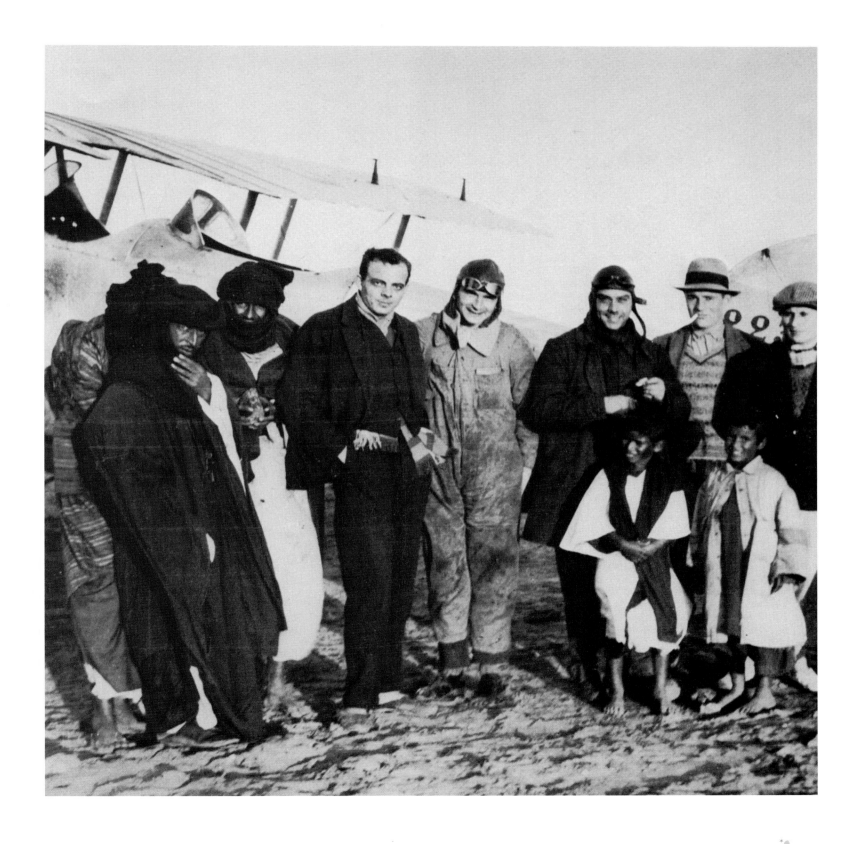

AMBÉRIEU-AVIATION
Monoplan W, moteur 70 H.P., piloté par Gabriel SALVEZ

SALVEZ

« I've flown…
along the Chevreuse valley »

After Strasbourg, Casablanca, in Morocco, Istres and finally Avord, near Bourges, the young officer cadet Antoine de Saint Exupéry, was sent to Versailles for the final part of his military service, where, as we saw above, he and Jean Escot received special permission to fly as often as they wished, in order to accumulate the hours needed to obtain the required diploma.

The young pilot's jubilation, palpable in this letter to his mother, confirms what he had sensed about his vocation. It had declared itself to him when he was still a child, spending his vacation in Saint-Maurice-de-Rémens, which was situated less than three miles from the airfield of Ambérieu.

Violating his family's wishes, he had received his baptism in flying there, in July 1912, in a Berthaud-Wroblewski, after managing to convince his pilot, Gabriel Wroblewski-Salvez, with a 70 h.p. Labor engine, that he had finally received permission from his mother to go on that flight, which enabled him to circle over the airfield twice aboard the monoplane.

EOR
Center for Aeronautical Studies
Quartier Croÿ
Versailles

My Dearest Mama,
At last, for the last four days I have been flying every day and it will go on like that: I am as happy as a king. I took off by myself today, not having to take any comrade anywhere. At first I turned over Versailles and then I flew right along the Chevreuse valley, at low altitude.
Here; I am flying the Breguet; it's a large airplane with a noisy 300 HP engine, but which is weak and sluggish and obeys only grudgingly. You'd think you were in a locomotive. It's a very reliable aircraft.
I am at Aunt Hélène's, where I just arrived. My darling Mama, they didn't send me my socks! And I don't have any!
How is Biche? I'm going to reply to her today or tomorrow. She sent me a delightful letter. How is she?
Our classes end between the 29 and 30th. I would really like to go to Switzerland and fetch the dear girl myself.
Important: could you have my civilian black suits sent to Lyons today to be cleaned [the end of the letter is missing]

Above : The Berthaud-Wroblewski aboard which Saint Exupéry had taken his first flight, in Ambérieu.

Right-hand page :
Unpublished letter from Antoine to his mother, Versailles, 1922.

135

E.O.R. Ave—
Centre d'école de l'aéronautique
Quartier Croÿ

Versailles

Ma petite maman

Enfin depuis quatre jours je vole tous les jours et cela va continuer ainsi : je suis heureux comme un roi. Je suis parti seul aujourd'hui n'ayant pas de camarade à convoyer — J'ai d'abord

tourné sur Versailles et puis j'ai fait tout au long, à faible altitude, la vallée de Chevreuse

Je pilote ici le Breguet. C'est un gros avion muni d'un 300 HP sonore mais qui est mou et flasque et n'obéit que pesamment. On se croit dans une

locomotive. L'atterrissage très sur..

Je suis chez Tante Hélène où je viens d'arriver —

Ma petite maman on ne m'a jamais envoyé mes chaussettes ! Et je n'en ai pas !

Comment va Biche. Je vais lui répondre aujourd'hui ou demain. Elle m'a

envoyé une lettre exquise. Comment va-t-elle ?

Nos cours finissent entre le 28 et le 30. Je voudrais bien aller chercher moi-même la dore Biche en Suisse ?

Important : Pourriez vous envoyer décidés à Lyon aujourd'hui mes costumes civils noirs et

Right : « Latécoère
Airlines ». Advertisement
for the France-Morocco
line, around 1930.

Right-hand page :
Southern Mail,
handwritten manuscript.
Working document, 1929.

« I have the moon »

1927. A year after joining the Société Latécoère; Saint
Exupéry was named, by his boss, Didier Daurat, who
would become Rivière in *Night Flight*, director of the
airspace of Cape Juby. Awaiting him there was a land-
scape worthy of both *The Desert of the Tartars* and of
The Shore of Syrtes: on the edge of the Western Sahara,
a small Spanish fort overlooked the Atlantic Ocean.
The desert and the ocean stretched out to infinity.
The task was not easy: in this troubled region, with
constant rebellions going on, they had lost count of
the number of pilots captured or massacred by the dis-
sident Moors. Saint Exupéry's mission lasted for eight-
een months. That was precisely the amount of time
he needed to finish his first novel. He gave it the title
of the precious cargo destined for Dakar, for which the
pilots of Latécoère daily risked their lives: *Southern
Mail.*

[He turned around. A mechanic, the only
passenger, with a flashlight on his knees, was
reading a book. His bent head was all that
emerged from the] cabin, with inverted
shadows. It seemed strange to him, lit up
from within like a lantern. He shouted
"Help!" but his voice could not be heard.
He struck the metal wall with his fist: the
man, emerging from his light, was still
reading. When he turned the page, his face
appeared ravaged. "Help!" shouted Bernis
again: two armlengths away, this man was
inaccessible. Giving up trying to
communicate with him, he turned to face
the front. "I must be approaching Cape
Guir, but they may as well hang me… it's
going very badly." He reflected: "I must be
a bit too far out over the sea." He corrected
his route using the compass. He felt
strangely pushed out into the open space,
towards the right, like a shadowy mare, as
though the mountains on his left were
weighing against him. "It must be raining."
He stretched out his hand, which was struck
by the rain. "I shall go back to the coast in
twenty minutes, there's the plain… I'll be
taking less of a risk… " But suddenly, what
a clearing! The sky, swept of its clouds, all
the stars washed, new. The moon…, oh the
best of all lamps! The plain of Agadir was
lit up in three stages like an illuminated
poster." I don't care about its light! I have
the moon…!"

My dear old friend,
Blame this shameful silence on the climate, on an unforgivable laziness, on an impossibility still to comprehend all that I am seeing again! And yet, I did write to you three or four times and my letters were not mailed. I was trying to explain to you and I couldn't manage it. It's something that is both marvelous and bizarre. With every mail flight I do two thousand kilometers through the Sahara and two thousand kilometers on the return journey. A thousand of these over dissident tribes. You can imagine all that sand, always that sand. And I have already spent one night there, after a breakdown, in a small, isolated fort. And I love that isolation, but I don't know how to speak about it. And the Moorish tribes and Moorish faces are fascinating. I shall tell you about all of that one day. On the other hand, I hate Senegal, what a trash can! Dakar is the most horrible suburb. It's not […]

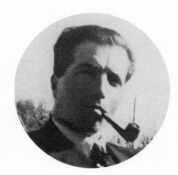

Left : Charles Sallès.

Right-hand page : Letter from Antoine de Saint Exupéry to Charles Sallès, 1927.

« This shameful silence »

Saint Exupéry was made director of the airspace of Cape Juby in 1928, where he was also put in charge of negotiating with the rebel populations of the desert over the conditions under which pilots of the Aeropostale (Airmail) Company who had been lost or had had accidents and had been held as prisoners, could be released.

Having arrived at Cape Juby at the controls of a Bréguet 14 A2, Saint Exupéry moved into a modest shack next to the Spanish fort and reflected on how he could fulfill his mission. Building relations with the Moorish leaders, on whom he paid courtesy visits and whom he received, in accordance with local customs, he managed to establish friendships that led, after many months, to the reestablishing of normal relations with the Moors and to the resumption of the air link.

Mon cher ami

...sur le compte du climat, d'une impardonnable paresse, d'une impossibilité à comprendre encore tout ce que je vois de nouveau — ce honteux silence !

Pourtant je t'ai écrit trois ou quatre fois et mes lettres ne sont pas parties. J'essayais de t'expliquer cette vie et je n'y parvenais pas. C'est pourtant quelque chose de merveilleux et de bizarre. Je fais à chaque courrier deux mille kilomètres de Sahara aller, deux mille retour. Dont mille au dessus des tribus dissidentes. Tu imagines ce sable, toujours ce sable. Et j'y ai déjà passé une nuit, en panne, sans un petit poste isolé.

Et j'aime cet isolement. Mais je ne sais pas en parler. Et les tribus maures et les visages maures me passionnent. Je te raconterai tout ça un jour.

Par contre je déteste le Sénégal. Quelle probable. Dakar est la plus immonde banlieue. Ce n'est pas

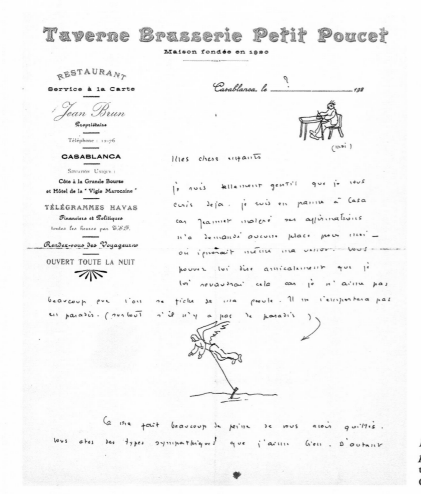

Left and right-hand page : Illustrated letter to Henri Guillaumet, Casablanca, 1927 (?).

« I'm writing to you already »

This letter, addressed to Henri Guillaumet, was destined for all of his pilot friends, whom Antoine de Saint Exupéry had had to leave when, struck down by an attack of dengue fever, which had brought on a long and dangerous spell of rheumatism, he had been confined to his bed for several weeks, before spending his convalescence at his sister's home in Agay, where his friends had come to visit him.

Returning to Morocco, he gives them news of Aeropostale, for which he flew from Toulouse to Casablanca and Dakar.

[My dear children,
I am so good that I'm writing to you already. I'm stuck in Casa because Jeannet, in spite of what he said, did not ask for a seat for me – or didn't even know that I was coming. You can tell him affectionately that I will have my revenge on him as I really don't like to be made a fool of. It won't get him into heaven (especially if there is no heaven).
It was very painful for me to have left you. You are good people whom I'm very fond of. Especially] as I have made peace with Riguelle, who is a fine fellow. And he has made peace with me, and I'm a fine fellow too. He did try secretly to have me caught by the Moors but it failed and I forgive him. And with a hero like Jeannet I had nothing to fear. (He even wanted to take me with him straight away and to leave the trail.)
I believe that Guillaumet continues to beget four babies a day. He really should leave one for me.
But stop him from getting too tired, so that one will be left when I get back. Now I just have to thank you for being so kind during my illness, for giving me rubs, for feeding me and entertaining me. I really wish I could be back with you very soon and I hug you all to my large heart.

Saint Ex

Write to me at: "Château d'Agay, Agay (Var)" and tell me all the gossip about the airline and its life; don't cut me off and I will write to you to tell you what I find out in Toulouse and Paris.

plus que je me suis réconcilié avec Riguelle qui est un chic type. Et lui avec moi, qui suis un chic type. Il a bien essayé sournoisement de me faire chiper par les maures mais ça a raté et je le lui pardonne. Et puis avec un heros comme Jeanniet je ne craignais rien. (Il voulait même m'emmener tout de suite et laisser la poste .)

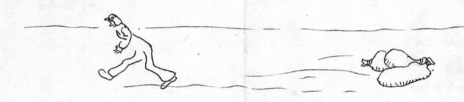

Je pense que Guillaumet continue à faire quatre petits par jour . Il devrait bien m'en garder un.

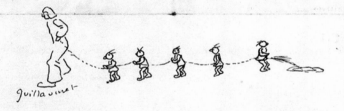

Guillaumet

mais empêcher le de trop se fatiguer pour qu'il en reste un peu lorsque je reviendrai.

Maintenant il me reste à vous remercier d'avoir été si gentils pendant ma maladie. De m'avoir frictionné massé de m'avoir nourri, de m'avoir distrait. je me souhaite d'être bien vite de retour parmi vous et vous serre tous sur mon vaste cœur

Saintex

écrivez
"chateau d'Agay
Agay
Var

et raconter moi tous les petits tuyaux sur la ligne et sur votre vie . ne me laisser pas tomber. et je vous enverrai de mon côté tout ce que j'apprendrai à Toulouse et Paris.

My dear old friend,
Here I am in Dakar. I flew a plane from
Toulouse to Agadir. That's a long-distance
trek that would intimidate military men.
Then I flew from Agadir to Dakar as a
passenger. And for my baptism… a
breakdown overnight, the airplane having
gone down into the dunes, right in the
middle of the Sahara. Luckily, we were
picked up by the other plane.
It's an epic life and the sort you should be
leading. You are only young once.
Don't think that I have forgotten about you.
I don't think that my old affection for you
will ever decrease. And I'm worried about
your depression and, above all, I understand
you so well. My old friend, I escaped from
that galley. How about you joining me?
Here I get 7,800 a month and sometimes as
much as 8,100. That's not too bad.
Dakar is not absolutely awful, but I miss
Morocco which is the dream of my dreams.
At least the one I'm pursuing, and which I
manage to find, not the café Morocco of my
colleagues.
If I come back from my dangerous exploits I
will tell you about all that. And already I'm
consoling myself with the idea of buying a
car, during my first leave and of going on a
really long drive with you, just the two of
us, when we'll drive all night long, with the
enormous headlamps. And all that I did
professionally in the Creuse and Allier, we'll
do for fun. And the ladies running the
hotels would recognize me and colleagues of
former times would give me jealous looks –
and we would be free.
But here too, what freedom! A week of
flying – ten days of freedom! Can you
imagine the possibilities?
I swear that I shall write to you with each
mail, every week and at greater length. I
would like to help you with all my heart.

Antoine

Latécoère Airlines Dakar
Airmail (3 F 50 I think)
Address lost, please send it to me

« Here I am in Dakar »

After meeting in Avord and continuing their training as
aviators in Versailles, Antoine de Saint Exupéry and
Jean Escot shared a room, in November 1924, at the
Titania Hotel, on Boulevard d'Ornano, before Antoine
was hired by Latécoère. Despite their separation, their
letters continued a dialogue that had led to many con-
versations lasting through the night. Saint Exupéry
clearly missed those conversations when he was iso-
lated in Dakar.
Jean Escot wrote: "What I'm trying to say is that I
have never been disappointed by our friendship. That
was also the criterion that was cited by Antoine in his
letters to his mother, to define friendship. A friend is
someone who has never disappointed me. Saint
Exupéry was disinterestedness itself. I never saw him do
any harm to anyone; he never sought revenge. I don't
remember ever having had an argument with him. It
is true that I may have been a bit more conciliatory
than he was…" (*Icare*, I, p. 114).

Right-hand page : Letter
to Jean Escot, 1927.

Mon vieil ami

Me voici à Dakar. J'ai emmené un avion de Toulouse à Agadir. Voici un raid à faire pâlir les militaires. Ensuite, j'ai fait Agadir - Dakar comme passager. Et pour mon baptême... une nuit en panne, l'avion écrasé dans les dunes, au beau milieu du Sahara. Heureusement repêchés par l'autre avion.

C'est une vie épique et comme tu devrais la vivre. Ou n'est-ce jamais qu'une vie pas. Ne crois pas que je t'ai oublié. Je ne pense pas que

ma vieille affection se démente jamais. Et ton cafard me désole et surtout je te comprends tellement. Mon vieux je me suis évadé de ce bagne où tu venais me rejoindre.

Tu 7.000 par mois et peut-être jusqu'à 8.000. Ce n'est pas trop mal.

Dakar n'est pas absolument antipathique. Mais je regrette le Maroc qui est le rêve de mes rêves. Ou moins celui que je cherche, que je trouve, non la marque de café des camarades. Si je reviens de ma vie hasardeuse je te raconterai cela. Et déjà je me berce de l'achat d'une voiture à ma première permission

et d'une immense promenade à nous deux seuls et où nous roulerions toute la nuit avec des phares énormes, des gros marchant à 100 coupures. Et tout ce que j'ai fait par métier dans la Beauce dans l'Allier nous le ferions pour le plaisir. Et les patronnes d'hôtel me reconnaîtraient et les coupures d'autrefois me jetteraient des regards jaloux —

Mais ici aussi quelle liberté! Une semaine de ... - dix jours de liberté! Aussi de ... tu imagines?

Je te jure de t'écrire à chaque courrier, toutes les semaines et plus longuement. Je voudrais

t'aider de tout mon cœur

Antoine

Lignes aériennes Latécoère Dakar par avion (3f50 je crois)

adresse perso envoie STP.

85

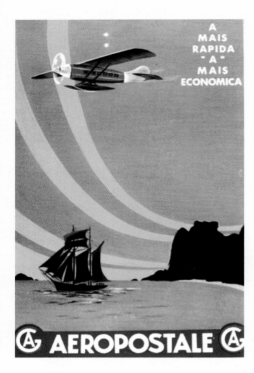

Left : Publicity poster in
Portuguese (Brazil) for
the Aeropostale company,
1933.

Right-hand page :
Night Flight. Handwritten
manuscript.

« This night was
without a shore »

This extract from *Night Flight* gives a realistic account
of the difficult job of those pilots who inaugurated the
airmail lines in South America and made possible the
regular transportation of mail there. Named director of
the Aeroposta Argentina company, a branch of France's
Aeropostale, which was created for internal routes, Saint
Exupéry was bitter: "I have a network of 2,500 miles,
which, second by second, is sucking away all that I
have left of youth and of the freedom I love", he wrote
in 1927 to his childhood friend, Rinette (Renée de
Saussine). The story of those adventures, which sup-
plied the plot of his second novel, would distract him
from these concerns. At the controls of his airplane, at
night, Saint Exupéry meditated on his childhood
impressions, dreams and plans even though he found
that night-time flights were "less well-protected cross-
ings".

For the pilot, this night was without a shore
because it was not leading to either a port
(they all seemed inaccessible), or to dawn:
the kerosene would run out in an hour and
forty minutes. Because he would be
obliged, sooner or later, to plunge blindly
down into those depths.
If only he had been able to make it until
daybreak…
Fabien was thinking about dawn as a beach
of golden sand on which he might have
washed up after this difficult night.
Beneath the threatened aircraft the shore of
the plains would have appeared. The
tranquil earth would have brought its
sleeping farms and its herds of cattle and its
hills. All the wrecks that were rolling about
in the dark would have become harmless. If
only he had been able to, how he would
have swum toward the day!
He thought that he was surrounded. All
would be resolved, for good or ill, in these
depths.
It is true. He sometimes thought, when the
daylight came up, that he was entering into
convalescence.
But what good would it do to fix his eyes on
the east, where the sun dwelt; there was
between them such a depth of night that he
could not emerge from it.

Monte Caseros, _____ de 19_____

[manuscrit autographe — texte raturé et en grande partie illisible]

The day goes by slowly for the crew of airplanes. Midday dissolves shadows and the ground is just a bare map. The sun locks people into a shiny prison and separates them from an earth that is without color, almost black. Seated comfortably before the landscape, the pilot witnesses, hour by hour, a kind of flowing by of gray water, sands, cities and plains.

That was why, weary of the day, Fabien, who was bringing back the mail for Patagonia from the far South, was waiting for the first sign of night as though the earth was going to get dressed, to live and become soft but with a useless light. The shadows would give the hills their [illegible word], these hills which were starting to drag their blue trains through the gold of the evening; the plains would become luminous, because in this region they never stop giving up their snow.

He was entering the night: he could recognize it by the same signs you would recognize the water of a port: by that serenity, those slight ripples which calm clouds were gently forming. The sky was opening up like an immense and blessed harbor.

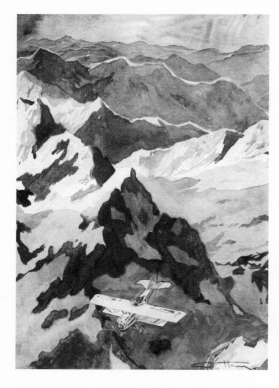

Left: Guillaumet crossing the Andes in a Potez 25. Géo Ham for *L'Illustration*, 1932.

Right-hand page: *Night Flight.* Preparatory state, variants compared with the definitive version.

« The sky was opening up… »

The manuscript of *Night Flight*, given by Nelly de Vogüé to the Bibliothèque Nationale de France, where it is presently located, is in itself a guide to its author's travels, as it was written on sheets of paper with letterheads of hotels, bars and restaurants, linked to his travels in America and Europe: Buenos Aires, Rio de Janeiro, Nice, Toulouse, Paris…

The book was published by Gallimard in October 1931, with a preface by André Gide, who had encountered Saint Exupéry in Agay in March and had noted in his diary: "Great pleasure seeing Saint Exupéry again, in Agay, […] he has brought back from Argentina a new book and a fiancée. Have read one and seen the other. Congratulated him warmly, especially about the book; I hope that the fiancée will be as satisfying."

This book was awarded the Femina Prize of 1931.

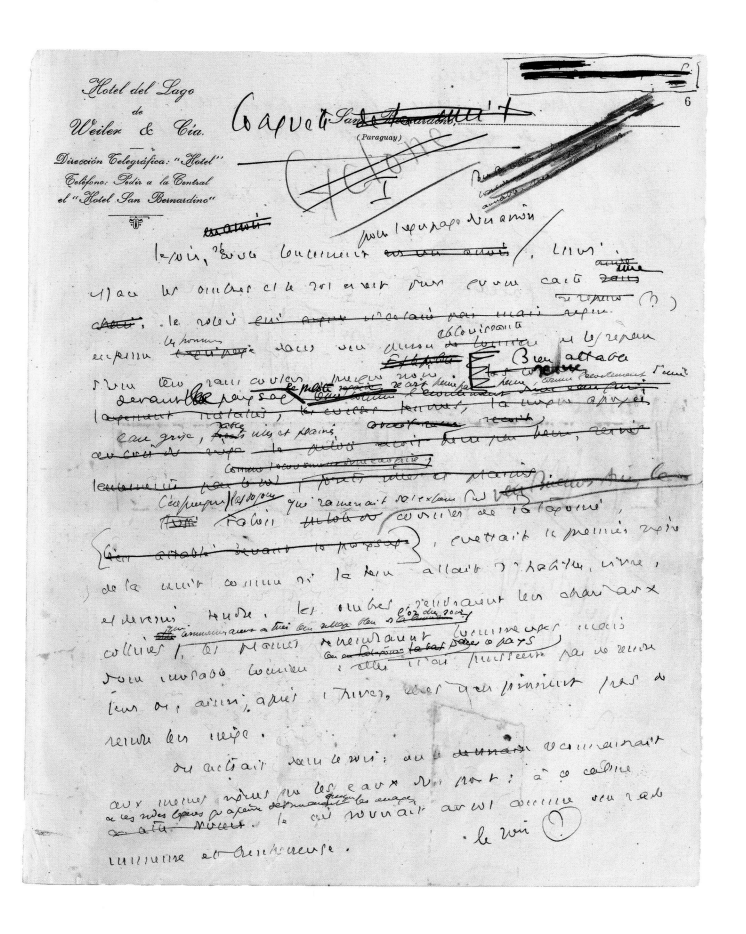

Hotel del Lago
de
Weiler & Cia.

Dirección Telegráfica: "Hotel"
Teléfono: Pedir a la Central
el "Hotel San Bernardino"

(Paraguay)

Left : Poster created by
Georges Parry, for *Wind,
Sand and Stars*, which
received the Grand Prize
for the best novel of
1939, awarded by the
Académie Française.

Right-hand page :
Wind, Sand and Stars.
Preparatory manuscript
for the chapter on the
desert.

The moon is dead.
Benghazi appears in the black night.
Benghazi lies surrounded by such profound
darkness that it has no halo at all. I caught
sight of the city when I reached it. I was
looking for the airfield but now its red
runway lights are switched on. The lights
mark out a black rectangle. I turn. The
light from a lighthouse pointing at the sky
shoots up like the flame of a fire; it swings
around and marks a golden road on the
airfield. I turn again in order to observe any
obstacles carefully. The night-time
equipment of this airport is admirable. I
slow down and begin my descent, as though
into murky water.
It is 11 pm local time when I land. I taxi
towards the light. The most polite officers
and soldiers in the world walk through the
red light of the projector, in turn visible and
invisible. They take my papers, they begin
to fill up my fuel tanks. My stop here will
be dealt with and completed in twenty
minutes.
"Do a turn and pass over us, otherwise we
won't know if your take off was successfully
accomplished."
Off we go.
I roll down this golden road, towards a
break with no obstacles. My airplane, a
"Simoun" model, takes off with its excess
load, well before running out of available
space. The projector follows me and I find
it difficult to turn. Finally it leaves me
alone. They guessed that it was blinding
me. I do a half-turn.

« The moon is dead »

This extract from *Terre des hommes (Wind, Sand and
Stars)* had been partially published in the second arti-
cle, by Saint Exupéry, in *L'Intransigeant*, under the title
"Prized flight. Prison of sand". Here, he continues
his account of his accident in the Libyan desert, of
December 1935, aboard his Caudron Simoun.
Marked by this tragic experience, the writer establishes
the moral and the message of his third novel: "The
earth teaches us more about ourselves than books do.
Because it resists us. Man discovers himself because
he measures himself against an obstacle."

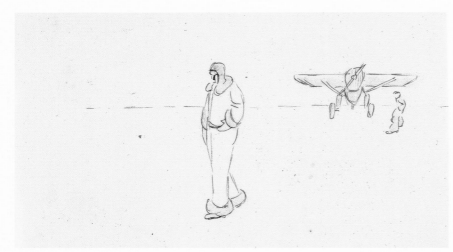

Left : Illustration in the margin of the handwritten manuscript of *Southern Mail.*

Right-hand page : *Flight to Arras,* manuscript, typed with handwritten revisions.

… I have lived the life of an airline pilot for eight years. I received a salary. Every month I could get myself a few of the objects I wanted with the money from my salary. But if my work as an airline pilot had not brought me something more than those trivial advantages, why would I have loved it so much. It has given me much more. But here I have to acknowledge that where it truly enriched me is the only area in which I gave more than I received. The nights that enriched me were not those during which I spent the money from my salary, but those in which, around two o'clock in the morning, in Buenos Aires, in the period when airlines were being set up, when I had just gone to sleep, exhausted by a series of flights which had kept me from sleeping for thirty hours, a sudden telephone call, prompted by some distant accident, dragged me from my bed: "You must come to the airfield… we have to fly to the Straits of Magellan…" And I dragged myself out of bed, grudgingly, in the depths of winter. And I filled myself with black coffee in order not to sleep too much while flying the plane. Then, after an hour's drive in the mud of provisional and beaten-up tracks, I came out onto the airfield and saw my colleagues. I shook their hands without saying anything, grumpy, only half-awake and struggling with the rheumatic pains that one feels after two sleepless nights in winter.

« I have lived the life of an airline pilot for eight years »

The story of this exceptional pilot had begun in 1912, in Ambérieu, with his first flight, and had continued with an apprenticeship in 1921, in Strasbourg, where he made his first dual command flight, lasting 15 minutes, in a Farman F40. On July 9, he flew solo for the first time, in a Sopwith F-CTEE, in Strasbourg. Admitted in 1922, to Avord, onto the list of E.O.R., he became a trainee in Versailles and flew from Villacoublay. On October 10 of that same year, he was named second lieutenant and chose to be stationed at Le Bourget. That was where he had his first airplane accident, at the beginning of the following year. He was immediately punished for it by 15 days under arrest for having flown on a HD-14 without permission. Admitted into the French Compagnie Aérienne (Airline Company), as a trainee pilot, on the recommendation of General Barès, he obtained his license as a Public Transport pilot on July 3, 1926 and, on October 14, he joined the Compagnie Latécoère, in Toulouse, from where he made many regular flights to Casablanca and Dakar. Antoine de Saint Exupéry had become an airline pilot.

sens. Car ailleurs il n'est plus d'homme. Et c'est bien le problème
posé au monde d'aujourd'hui. Car un jardinier peut etre un homme dans sa
fonction, mais comment augmenter celui-là qui visse son écrou d'un quart
de tour ? Que peut-il donner cet homme là à son écrou ? Car la part
importante, la part qui grandit, n'est point le du que l'on recoit de son
travail, elle est faite de ce qu'on lui donne./ J'ai vécu huit années la
vie de pilote de ligne. J'ai touché un salaire. Je puuvais chaque mois
me procurer quelques-uns des objets souhaités avec l'argent de mon salaire.
Mais si mon travail de pilote de ligne ne m'avait rien ~~donné~~ *procuré* d'autre que
avantages quelconques.
ces ~~quelques objets misérables,~~ pourquoi l'aurais-je tant aimé ? Il m'a
que le soir où il m'a
donné bien plus. Mais là il me faut reconnaitre ~~qu'il m'a exclusivement~~
enrichi véritablement c'est la recherche où j'ai donné peu.
~~donné ce qu'il a tiré de moi. C'est chaque fois que je lui ai sacrifié~~
que je n'ai reçu.
quelque chose que je me suis enrichi. Les nuits qui m'ont augmenté ne
sont point celles au cours desquelles je dépensais cet argent du salaire,
des
mais celles où vers 2 heures du matin, à Buénos-Ayres, à l'époque où l'on
fondait les lignes, quand je venais de m'endormir épuisé par une série de
trente
vols qui m'avaient tenu ~~30~~ heures sans dormir, un coup de téléphone brutal,
où à quelque accident lointain,
me tirait du lit : "Il faut que tu montes au terrain ... il faut filer sur
le détroit de Magellan... „ ~~On vient de casser l'avion du courrier...~~
~~courrier ..."~~ Et je me tirais de mon lit, dans le froid de l'hiver. ~~Et~~
~~en mangeant.~~ *en mangeant.*
~~je m'~~habillais en grognant, moite d'un sommeil encore mal lavé. Et je me
remplissais de café noir pour ne pas trop dormir en pilotant. Puis après
une heure de voiture à travers la boue de chemins provisoires et
défoncés, je débarquais au terrain et retrouvais les camarades. Je ser-
grincheux, mal reveillé et
rais des mains sans rien dire, ~~Tout~~ noué par ces rhumatismes que l'hiver
fabrique après deux nuits blanches.

Above : Marie de Saint Exupéry in the gardens of Saint-Maurice-de-Rémens, around 1910.
Right-hand page : Marie de Saint Exupéry at the age of 30.

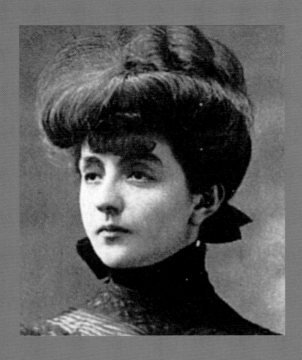

« My Dear Mama »

« It's because of you, Mama, that one comes back.
You, who are so weak, did you know that
you were such a guardian angel
and so powerful, and wise, and so full of benedictions,
and that one prays to you, when one is alone in the night? »

When Marie de Saint Exupéry gave birth to Antoine, after the birth of two daughters, Marie-Madeleine and Simone, in 1897 and 1898, she had the intuition that he would be "the glory of her life." Born into a family of musicians and art lovers (a great-great grandfather had been a collector, a great-grandfather a draftsman, painter and antique-dealer, a grandfather a botanist and entomologist, and her father had been a musician), Marie de Fonscolombe inherited the artistic gifts of her ancestors. She was an excellent musician and made sure each of her children played an instrument (Marie-Madeleine, Antoine and François the violin, the others the piano, and there was a vocal teacher for the whole family).

Below : Antoine with his mother, aunt, sisters and brothers at Saint-Maurice-de-Rémens, 1904-1905.

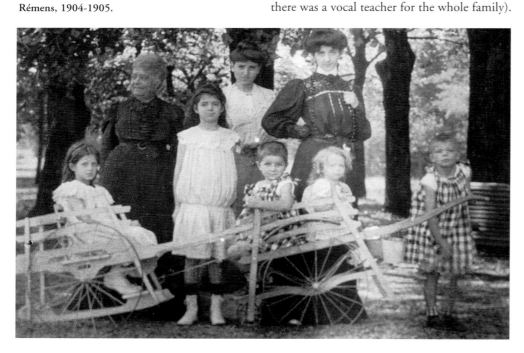

In the evenings at Saint-Maurice, everyone gathered around the piano and sang works by classical composers and old French songs that had been passed down from one generation to the next.

The children, who were lucky enough to grow up in the gardens of their aunt, De Tricaud's chateau, learned to respect nature with their mother's guidance. They could recognize the plumage and the singing of the different birds and created their own herbaria. Animals also played an important part in the children's education: a donkey, rabbits, dogs, doves and even a white rat!

The profound love and tenderness that Marie de Saint-Antoine showed her children, the way she brought them up, with both strict morals and creative imaginations, made her the model of the kind of women Antoine would seek out throughout his life.

Obliged by circumstances to assume the roles of both father and mother, educator and confidante, for her five children, Marie de Saint Exupéry always made sure that she responded to the immense need for attention that her son showed her: "I truly love you, from the bottom of my heart, my dearest Mama. […] There are very few people who can say that I have truly confided in them and who know me well. You are truly the one person who does…"

She was a reassuring mother when she was close to her brood: "It is true that you are the only consolation when one is feeling sad. When I was a boy, I would come home with my large bookbag on my back, sobbing because I had been punished, […] and just by kissing me you made me forget it all." She also knew how to be affectionate when they were far away from her: "Your letters do me good, they're like a cool breeze wafting over me. My dearest Mama, how do you manage to find all those delightful things that

you say? I remain moved by them all day long." As letters were still the only way of keeping in touch at the beginning of the 20th century, a tender and loving correspondence developed between Antoine and Marie de Saint Exupéry from the time when they were first apart, in 1909, up until the writer's disappearance in July 1944. It forms a tangible record of the depth of their affection and loving relationship. Antoine, who was always in need of money, knew how to influence his mother to get what he wanted: "Antoine proposes and the family disposes," he wrote, as early as 1917…

It is through these letters that one can comprehend the special relationship that tied the son to his mother. Marie de Saint Exupéry was always present at the moments of intense moral solitude that her son experienced: the preparation for the entrance exam to the Naval Academy, the military service, the years of wandering before becoming a pilot, and Cape Juby. He was able to overcome these depressing periods because of his mother's presence.

As the years went by, Saint Exupéry realized more clearly the importance of his mother in his life: "Mama, I have to tell you how much I love and admire you, even if I express it infrequently and badly. A love such as yours gives me such security, and I believe that it takes a very long time to really understand it."

Her regular letters encouraged him in 1925, when Saint Exupéry was not yet sure what direction to give his life: "I have just returned home and found your note. It's keeping me company. You can tell yourself, Mama, that even when I don't write, even when I'm a bad boy, nothing is equal to your love. […] I love you as I have never loved anyone."

As astonishing as it may seem, there was an interruption in the correspondence between Antoine

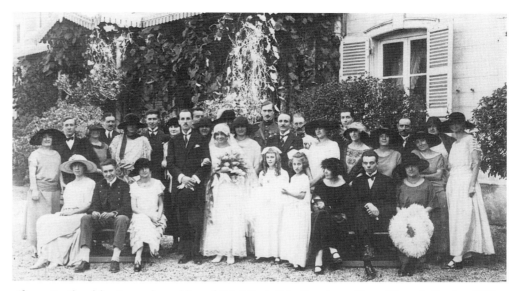

Above: Family celebration at the wedding of Gabrielle de Saint Exupéry to Pierre d'Agay, in October 1923.

and his mother after his stay in Argentina. From 1931 to 1939, no written testimony by him has been preserved, except for the brief note that he sent to his mother after his accident in the Libyan desert in January 1936. At that time, Marie de Saint Exupéry came to Paris and stayed at the Hôtel du Pont Royal for three days, waiting for news of her missing son. Once he had been picked up by the Bedouins and brought back to civilization, Saint Exupéry took the very first opportunity to send her a brief letter which reveals the exemplary intensity of the love they had for each other: "It was you that I needed; you were the one who should have protected me and sheltered me and I called out to you like a selfish little goat."

There was subsequently an exchange of several letters between them, during the "phoney war", before the great silence of Antoine's exile in America.

The last message that Marie de Saint Exupéry received from Antoine dated from July 1944. It was a letter that both aimed to be a reassurance and a declaration of love for the woman who always had pride of place in his heart:
"When will it be possible to tell those we love that we love them?"

My dear Mama
I am writing to you while on duty on the bank of a small river, where I have just spent the night. There are wild ducks and water hens which are giving a discordant and amusing concert. There are irises in the reeds and water-lilies near the banks. During the hours we're off-duty we take rides on a raft which, getting stuck in the mud, moves along extremely slowly. We fish with rods for tench which sometimes bite – or we snooze, lying on the grass. This jaunt in the country, enlivened with charming picnics, lasts two days each time. It is anticipated with terror by most of my comrades. There are two reasons for that. [...]

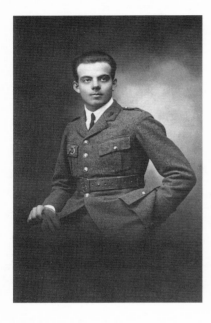

Left : Antoine
de Saint Exupéry
in 1920.

Right-hand page :
Extract from an
unpublished letter to his
mother from Strasbourg,
1921.

« I am writing to you while on duty, on the bank of a small river… »

Antoine de Saint Exupéry was drafted for military service in April 1921. He was attached to the 2nd French Air Force Regiment Base at Neuhof, near Strasbourg, as an airman, second class, in the S.O.A. unit, the section of aviation workers.

In this letter, the young recruit describes one of the obligatory work duties required of his unit: standing on guard to give the alert if the enemy showed up. With humor, he continues his account by describing the pathetic boredom of his unoccupied comrades who are made nervous by the noises of the countryside, especially at night, and who panic at the idea of not announcing the arrival of the patrols that regularly came to inspect them. This was matched by the terror of those patrols who, flouting the rules, noisily announced their arrival because they knew that the guards were authorized to open fire after the third call.

Strasbourg

128
1

Ma chère maman

Je vous écris de garde au bord d'une petite rivière où je viens de passer la nuit. Il y a des canards sauvages et des poules d'eau qui font un concert discordant et drôle — des iris dans les roseaux et des nénuphars près des rives — Pendant les heures de solitude

8

nous nous promenons sur un radeau qui, empêtré dans la vase, file avec une sage lenteur. Nous pêchons à la ligne des tanches qui mordent quelquefois — ou nous sommeillons allongés dans l'herbe — Cette fugue à la campagne égayée de pique-niques charmants orne chaque fois deux jours. Elle est attendue avec terreur par la plupart de mes camarades. Cela pour deux raisons. D'abord le

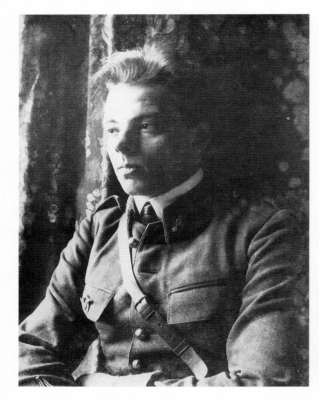

Left : Antoine de Saint Exupéry in the autumn of 1922 in the Avord uniform.

Right-hand page : Unpublished letter to his mother. Probably from Avord, 1922.

« I am so sad… »

Whether it was the fate of an inefficient postal service or a pious lie, some of these letters take on a harsher tone. This one, unusually, consists of the letter and the reply it provoked. Saint Exupéry used the sheet of paper his mother had sent him, covering what she had written. In spite of the irritation that is apparent in it, it reveals the demands each person made on the other to pursue these epistolary contacts.

Marie de Saint Exupéry had decided that the letters she had received would be given to the department of private archives of the Archives Nationales de France. It is likely that they have still not all been found, even though the thick folders containing them contain as many as 640 sheets, consisting of 185 letters written from 1910 to 1944, most of which are from the period 1910-1930.

In the hand of Marie de Saint Exupéry :

My child,
I feel extremely hurt. You left three weeks ago, now, and you haven't given me any sign of life. And yet I deserve better than that. I warn you that I shall not write again but I feel great sorrow.

Mama

In the hand of Antoine de Saint Exupéry :

My dear Mama,
I give you my word of honor that I did write to you. I was even eagerly waiting for your reply because I had enclosed a whole set of wood engravings with my letter and I anxiously wanted to have your view of them. It was full of details. I am so sorry because of the pain you felt, believing me to be so indifferent. But, mama, at least you can't reproach me, for the past year, of leaving you without any news!
I wrote to you this morning but I have just received this letter. I cannot prevent myself from telling you how sad I am that you thought that. And I am in despair at the idea that my prints have been lost. Not having any paper where I am and in order to write to you more quickly, I am using your letter. Forgive me for that. I kiss you tenderly.

Your respectful son

131

Ma petite maman

Je vous donne ma parole d'honneur que je vous ai écrit. J'attendais même votre réponse avec impatience parce que j'avais joint à ma lettre tout un lot de gravures sur bois et que je

mon enfant

désirais anxieusement votre avis — Elle était pleine de détails. Je suis si triste de la peine je suis excessivement peinée oublie que vous avez eu en me croyant si indifférent 3 semaines que tu es parti, et que tu vous ne pouvez tout de même pas, maman, me ne me donnes pas signe de vie — faire ce reproche depuis un an, de vous laisser j'mérite pourtant mieux que cela, sans nouvelles !

j'espérais que je t'écrirai plus, mais

Je vous ai écrit ce matin mais je j'ai du chagrin

reçois cette lettre à l'instant je ne peux

maman

pas ne pas vous dire combien je suis triste que vous ayez eu cela. Et puis cela me désespère de savoir mes gravures perdues — Faute de papier au lieu où je suis et pour vous écrire plus vite j'emploie votre lettre pardonne le moi — Je vous embrasse tendrement votre fils qui t'aime tant

[I read something delightful in the weekly review and am sending it to you "my daughter and I"] you will like it.
Mama, this article captured my heart. You did too much for us and I always recognized it so poorly. I have been selfish and clumsy. I have not been the support you needed. It seems to me that, every day, I learn to know you a little better and to love you more. Deep down, it is true, one's "mama" is the only true refuge of poor men.
But why don't you write to me more? It's dispiriting to wait so impatiently for the boat and not to receive anything.
I made six landings this morning, which I consider masterpieces… In theory, I follow a predetermined route, but each time I venture out a bit further and I play hooky. I'm going to survey the construction of two villas which are pink in the morning, at sunrise – barely a hundred meters high – I also do some [fine turns over a house that is all blue, its garden and its roof – almost a kind of small oasis. I wait for the sultanas of the *Thousand and One Nights* who will come to draw the fine green water, but at that hour everyone is asleep…]

« You did too much for us »

When he was a child, Antoine often closed his letters with: "Dearest Mama, I would really like to see you again soon." As an adult, he sprinkles his letters with declarations of filial love, which are magnificently summed up in this letter, sent from Casablanca in 1921. This affectionate tribute, of which there are many other examples in the letters to Marie de Saint Exupéry, decisively contradicts many of the critics who saw in them nothing more than repeated requests for money, expressions of his boredom at being separated from family and friends, and of the complaining tone with which he evoked the difficulties of his life at school, as a student, in matters of love or work.

A letter of 1930 responds like an echo to this hymn to the happiness of family life: "Say to yourself that of all affections yours is the most precious and that one comes back into your arms at difficult moments. And that one often needs you, like a little child. And that you are a great reservoir of peace and that your picture is reassuring."

Right-hand page :
Extract from an unpublished letter to his mother.

vous aimerez cela —

Maman cet article m'a navré
le cœur. Vous avez tout fait pour
moi et je l'ai toujours si mal reconnu.
J'ai été égoïste et maladroit. Je n'ai
pas de toute été l'appui dont vous
aviez besoin. Il me semble que
chaque jour un peu j'apprends à me
connaître et à me armes mieux.
(je prends c'est vrai, la "maman" est
le tout vrai reppe des pauvres hommes.

Mais pourquoi ne m'écrivez vous plus?
C'est terrible d'attendre si impatiemment
le bateau et ne rien recevoir —

J'ai fait ce matin six atterrissages
que j'estime des chefs d'œuvre..... théoriquement
je fais un trajet déterminé mais chaque
fois je me hasarde un peu plus loin
et fais l'école buissonnière.

Je vais surveiller la construction de
mes villas qui le matin sont sorties
au lever du soleil — ont mètres de
haut à peine. Je fais aussi de

My dear Mama,
Thank you for the money order. I am very angry because Dr. Rivière doesn't want to let me leave. My liver is still giving me some discomfort. I'm seeing him again on Saturday and am hoping he will let me go. I'm absolutely fed up with Vichy. It's stiflingly hot here and the treatment is exhausting me. I, who flattered myself with possessing a mischievous and lively mind, I am unable to think of a single witticism. Didi can sleep peacefully, his Pierre is safe. I don't even have the energy to go to the theater any more. The boxes are like a sauna. I don't do anything with my days except drink and doze and groan. I'm feeling so terribly down in the dumps. I wanted to write a story: up till now I've written one line. And that's only the title. And it's not even original, it's called "story." Apparently there have been some amazing horse races. I offended the St Poulots by not going and getting roasted at them. I'm indifferent to seeing old nags gallop around in single file. It wouldn't be so bad if they all arrived at once; that would be impressive and you wouldn't lose any money. But there are always some who come in late. [...]

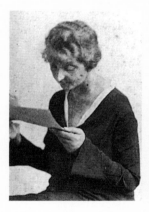

Left : Marie de Saint Exupéry, around 1927.

Right-hand page : Extract from an unpublished letter to his mother, Vichy.

« I'm absolutely fed up with Vichy »

The charms of the thermal treatment, and its length, do not seem to have pleased Antoine, who was obliged to stay in Vichy during the summer of 1923 because of his liver complaint. They led to the writing of this colorful letter on the habits and amusements of a high and idle society who cannot seem to see beyond the finishing line of a horse racing track.

Feeling sad because of the separation from his fiancée, Louise de Vilmorin, and unable to concentrate on his reading and writing, Saint Exupéry tries to give a vitriolic portrait of the people who surround and try to amuse him, but this exercise brings him little consolation in his enforced exile.

Casino
de
VICHY

ou 147

Ma chère maman,

Merci du mandat — Je suis dans une grande colère
parceque le docteur Rivière ne veut pas me laisser partir
encore. Mon pied n'est pas complètement dégonflé. Je le
revois samedi et fais des vœux pour qu'il me lâche — (Rivière, pas le pied)

J'en ai par dessus le dos de Vichy. Il y fait une chaleur
innocente et le traitement m'abrutit. Moi qui me flattais

de jouir d'une intelligence espiègle et folâtre je suis
incapable d'un seul jeu de mot. Didi peut dormir en paix
son Pierre est à l'abri.

Je ne vais même plus au Théâtre faute de courage. La
tête est une douce étuve. Je ne fais rien de ma journée que
boire et sommoler et penser. J'ai un cafard rougeur. J'ai
voulu écrire un conte : il a jusqu'à présent une ligne. Et encore
c'est le titre. Et encore il n'est pas original, ça s'appelle "Conte"

Il y a eu des courses de chevaux sensationnelles paraît-il —
J'ai réalisé les St Poulot en m'abstenant d'y aller croire.
Ça m'est égal de voir des canassons galopper en file indienne.
Encore s'ils arrivaient tous en même temps ce serait imposant
et puis on ne perdrait pas d'argent — Mais il y en a toujours
qui sont en retard.

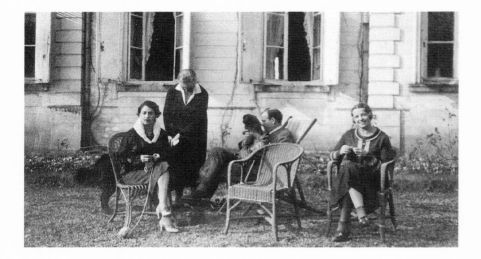

« You've been the kindest of mothers to Consuelo »

The fact of being far from home requires that explanations, even on the most delicate topics, be spelled out clearly. Such is the theme of this long letter, in which Antoine attempts to convince his mother to agree with his point of view, doing so quite forcefully, while realizing, to his own relief, that he will not succeed in this task.

These differences of opinion were not serious when they concerned, essentially, the frivolous gossip making up the conversations of summer, which the aviator who was based in Morocco, could easily do without hearing. More serious were the differences of opinion between mother and son on moral questions and choices in life. Marie de Saint-Exupéry, having criticized Antoine for some of the kinds of people he was seeing and their influence on him, he calmly writes back: "I don't know what it is that's worrying you. What I think and love, my moral views, you will find them in my books. [...] How worried and tormented you are about a son who adores you and who is a perfectly good man and how your solitary reflections invent phantoms that do not exist! I would so much like to set your mind at rest."

Above, left : At Saint-Maurice, in June 1932, Consuelo and Antoine, who is holding Youki the dog, beside Marie de Saint Exupéry. On the right, Gabrielle d'Agay.

Right-hand page : Extract from an unpublished letter to his mother. Casablanca, August 1931.

compris et il ne comprendrait jamais
que les gens se racontent les uns
sur les autres des histoires qui ne
répondaient d'ailleurs plus rien
parce qu'elles sont déformées. On ne
vit qu'une fois, difficilement, et il
faut ainsi se gâter la vie? Ça
ne vaut pas la peine.

Ma petite maman je sais que vous
avez été pour Consuelo à Fribourg
la plus douce des mères, Et de cela
je vous suis infiniment reconnaissant.
Je sais aussi que vous avez de la
peine de croire que je m'éloigne de
votre cœur. Mais ma petite maman
quand je ne vous écrivais pas, personne
non plus n'avait de lettres. Vous

Dearest Mama, Didi, and Pierre, whom I love so much, from the bottom of my heart, what's happening to you, how are you, how are you living, what are you thinking? This long winter is so terribly sad!
And yet I hope so very much to be in your arms in a few months, my dear Mama, my sweet Mama, by the fireside at home, telling you what I'm thinking, chatting with you and contradicting you as little as possible... listening to you speaking to me, you who have always been right about everything in life...
My dearest Mama, I love you.

Antoine

Left : Saint Exupéry in 1944.

Right-hand page : Letter to his mother, January 5, 1944.

« My dear Mama, my sweet Mama »

While he was in Algiers, Saint Exupéry was alerted to the imminent departure for France of one of the leaders of the Alsatian Resistance, Paul Dungler, a plan immediately countermanded by an order signed by Charles de Gaulle and Jacques Soustelle, but supported by the Americans, especially by Colonel Hyde. He immediately appreciated the proposal Dungler was making to courrier letters into France.

Written on January 5, 1944, this letter was received by Marie de Saint Exupéry during that same month. It was one of the last letters that she received from her son while he was still alive. His last letter did not reach her until July 1945, a year after his disappearance, the significance of which she refused to accept for many months.

Marie de Saint Exupéry was, at the time, living in Cabris, in a small house that she had bought and named "Les Fioretti," in honor of Saint Francis of Assisi, whom she fervently admired. She died there in February 1972, at the age of 97.

Maman chérie, Didi, Pierre me tiennent sous leur
têtu humeur, au fond de mon cœur, que deviennent vous,
comment aller vous, comment vivez vous, comment
pensez vous ? Il est tellement, tellement triste le long
hiver !

En attendant j'espère si fort être dans vos bras
dans quelques mois, ma petite maman, ma
vieille maman, ma tendre maman, au coin du
feu de votre cheminée, à vous dire tout ce que j'ai
pensé, à discuter en contredisant le moins possible...
à vous écouter me parler, vous qui avez eu raison
dans toutes les choses de la vie ..

Ma petite maman je vous aime
 Antoine

Aéroplace de Cap Juby

Rapport concernant le dépannage du BRGT 232

Monsieur Riguelle s'étant posé en panne le 18 Juillet, par suite d'une rupture de bielle, à 30 km Sud de Juby, monsieur Dumesnil, son coéquipier, revint nous avertir de cette panne avant de tenter d'atterrir à proximité; il ne lui semblait pas y avoir de terrain propice, puis repartir.

L'insécurité de la région étant complète et un capitaine d'aviation espagnol ayant été capturé il y a quelques mois et gardé prisonnier seize jours à 12 km seulement de Juby j'ai immédiatement formé et expédié une caravane de secours, tandis que l'on me préparait un avion. Après retour de MM Dumesnil et Riguelle, que je croisai en l'air, ces maures assurèrent deux jours la garde du 232. Coût 187 Pts pour chameaux, chevaux et vivres.

Above : Report concerning the rescue of BRGT 232, July 1928.
Right-hand page : Aviator asleep in the desert, not far from his plane, after an accident. Preparatory drawing for *The Little Prince*.

The Desert and Solitude

« You cannot penetrate into the intimacy of the desert
when you drag the noise of the cities with you. »

Saint Exupéry had his first contact with the desert while he was doing his military service. In order to complete his pilot's training he was sent to Morocco, where he stayed from June to December 1921. He had dreamt of the desert and sand dunes stretching out as far as the eye could see: "Seen from an airplane, the desert must be sublime", but he was very disappointed: "Do you believe that your imagination may be stimulated by seeing thirteen pebbles and ten tufts of grass". Saint Exupéry returned to France after six months, having obtained his military pilot's license, and never wanted to go back to that country, which, with the exception of Rabat and the old medina of Casablanca, had so disappointed him. "I spent days of dreadful boredom in a rotting shack and I now look back on it as a period that was full of poetry."

Saint Exupéry did not realize that his definitive links with the desert had only just begun to be formed. Hired in October 1926 as a mechanic, and then as a pilot, by the Latécoère Company, Saint Exupéry began flying down the coast from Casablanca to Dakar, and flew over the desert once again, as he transported the mail. In one of his first missions, an engine problem forced him to land on the sand. Since there were only two revolvers for the crew's protection, he was asked to watch over the cargo of mail while his comrades went to find items needed to make the necessary repairs. Thus, Antoine spent his first night alone, out in the open, in the middle of the desert. He learned to recognize the thousand noises of the immense Sahara. That first experience was to mark the the contemplative man forever. It is reflected in several of his writings. Recounted as an anecdote in a few lines, in a letter to his mother, this episode was explained in more detail in a letter addressed to his friend Henry de Ségogne, and was later developed in an article that appeared in *Marianne*, in November 1932, before undergoing a final revision that would form part of Chapter VI of *Wind, Sand and Stars*.

For an entire winter, Saint Exupéry struggled to tame the desert, which seemed to him, from his first sight of it, to be hostile, not only because it harbored dissident tribes, but by its very nature: "The sand is deceptive; you think it's firm and you sink into it." Wishing to reveal itself only to those who deserved it, this "enemy" would gradually reveal its true personality and would enable the aviator who had been stranded in its silent vastness to give himself up to the "delights of his memory", rediscovering the happy moments of his childhood, in the company of Moisi, the old governess and guardian of the rites. "Sahara, my Sahara, I see you know all this, bewitched by a spinner of wool!"

Saint Exupéry was made director of the aerodrome of Cape Juby, in Mauritania, in October 1927. For eighteen months, he would lead the ascetic life of a desert dweller. Cape Juby was a Spanish enclave whose fortress dominated the surrounding desert and ocean like an eyesore. Caught in a pincer movement between the Spanish prisoners who played the role of guardians of the fortress and the Moors who rejected Spanish occupation and rose up regularly or attacked the airplanes of the Aeropostale, which had been forced, by a mechanical problem, to land on the desert sands, Saint Exupéry "did

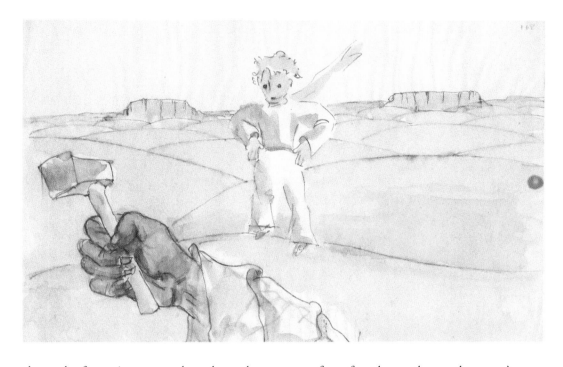

Left : Preparatory drawing for *The Little Prince.*

the work of an aviator, an ambassador and an explorer". Facing the silence and the solitude (mail planes came once a week, and the delivery of supplies by ship once a month), Saint Exupéry came under the spell and encountered the traditions of a civilization of silence. Instead of ignoring the Moorish tribes, he attempted to understand them. "The marabout comes every day to give me an Arabic lesson. I am learning to write and am already getting by a little. I invite the Moorish chiefs to take tea with me and they, in turn, invite me to drink tea in their tents, which are two kilometers inside rebel-held territory, where no Spaniard has ever gone. And I shall go further."

Gradually, Saint Exupéry allowed himself to be captivated by the desert, whose silence encouraged his meditation. "It's true that the Sahara only offers, as far as the eye can see, a uniform surface of sand, or rather, as there aren't many dunes, a sort of pebbly shore. You bathe in the conditions of pure boredom. And yet, invisible deities form a network of directions, of slopes and signs, a secret and living muscle structure. Nothing is uniform any more, everything has a direction. Even silence there, is not like silence anywhere else." When, after eighteen months of solitary life dedicated to the mail planes, which he awaited as though they were chicks that he was hatching out, Saint Exupéry returned to France with "a small book he doesn't know what to think of", in his luggage, and he was glad to leave that solitude which had begun to weigh down on him: "I've had enough of watching the Sahara like a guard."

But the "commandant of the birds", as the Moors called him, had still not finished with the desert. He found himself in it again when he least

expected it. "The desert? I found myself, one day, in the heart of it. In the course of a flight to Indochina, in 1935, I found myself in Egypt, almost on the border with Libya, caught in the sands, as in glue, and I thought I would die there." With his mechanic, André Prévot, Saint Exupéry left the cockpit of the airplane to try to find people or a saving well. They wandered across the desert for almost three days. At the very moment when they thought that their final hour had come, utterly exhausted, they were saved by a Bedouin. In *Wind, Sand and Stars*, Saint Exupéry writes about his crash in the desert and about the days when he was lost in the vastness of the sands and thought, for a moment, that he would never get out alive. Every one of Saint Exupéry's books evokes that landscape, which marked him so deeply. Whether it is mentioned in a few lines or described in entire chapters, its presence is closely linked to the life of the writer and pilot. It is no coincidence that the action of his two most important books takes place in the desert, that magical place in which, "a thousand miles from any inhabited region", he found a kind of serenity: "I have always loved the desert", he confessed, in *The Little Prince*. "You sit down on a sand dune and you see nothing. You hear nothing. And yet, something is shining in the silence." The Little Prince travels, first of all, through inhospitable landscapes. Out of the story of his encounter with the pilot who is lost, a literary monument was to be born. Once again, the magic of the desert will have had its effect. *Wisdom of the Sands*, Saint Exupéry's final work, "my posthumous book", he would say, laughing, whose provisional title was *The Kaid*, began as follows: "I was a Berber lord and I was coming home." The memory of the times he spent in the Sahara Desert led Saint Exupéry to choose the desert as the place in which he reflected on life. *Wisdom of the Sands* unfolds like a psalm that is being sung by a very young man who is listening to his father's advice and who, as the years go by, will himself become the chief of a tribe and will ask himself all the questions that are asked by people who are confronted by power. In these pages of profound philosophy, Saint Exupéry makes constant reference to the customs and traditions of the peoples of the desert. These ideas, which can seem surprising if they are expressed by a European in the twentieth century, take on their full significance when they are uttered by an inhabitant of the Sahara. The desert offered Saint Exupéry the same solitude and the same aspirations as those that he felt when he flew over the vastness of the sands in his airplane.

You are a bit alone in the desert.
- You are also alone when you're among people, said the Snake.

Right-hand page :
Preparatory drawing for
The Little Prince.

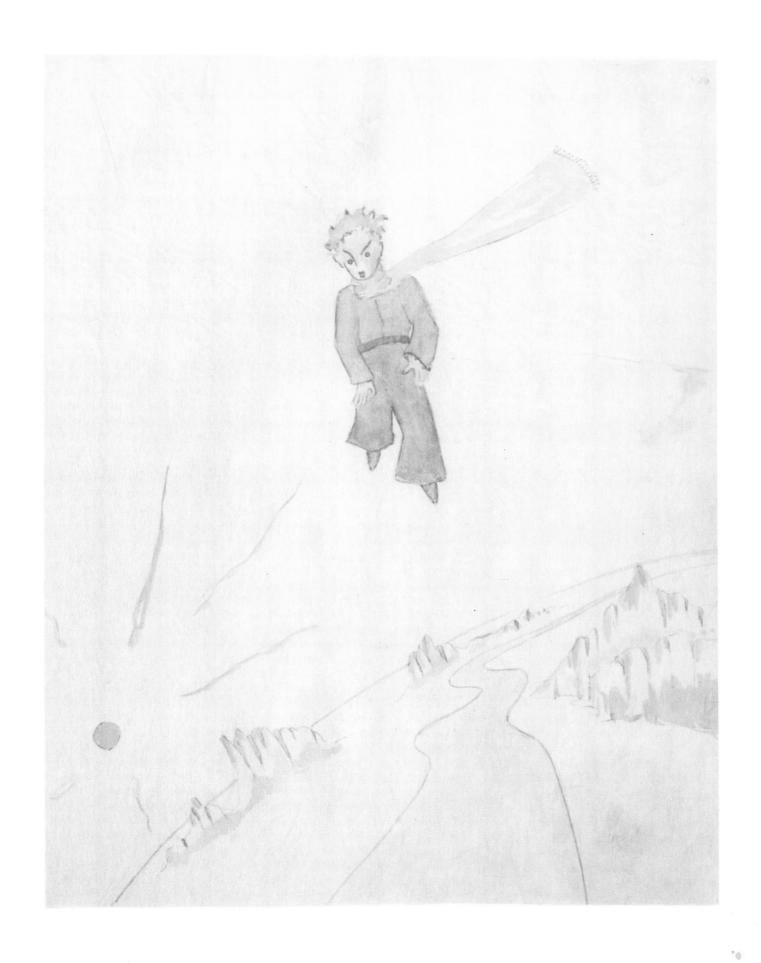

« Where are the banana trees, date and the coconut palms of my dreams? »

Having decided to become an air force pilot, Antoine de Saint Exupéry had volunteered to be sent to Morocco while he was doing his military service in Strasbourg. His departure, which had been set for mid-June 1921, was eventually postponed for several weeks. It was in July that he set off, with understandable excitement at the prospect of a long journey, passionate discoveries in an unknown land and the promise of a new career as an aviator. As soon as he arrived, he was frustrated: he had been expecting immense stretches of desert, and he discovered the uninteresting landscape around the suburbs of Casablanca, covered with rocks and large sad-looking cacti. Where was the desert, its mirages and its oases? Why was this land without color, without life, except for the dogs that were running around the dirty-looking sand? "I miss the greenery," he wrote to his mother. "Green is a spiritual food, green maintains gentle manners and the calm of one's soul. Remove that color from life and you will soon become dry and evil."

My dearest Mama,
It's incredible how hard we're working! I still haven't set foot inside an airplane and my days are spent catching crabs at low tide, in the ocean. The pilots are as free as birds and instead of going into town, which is too far away, we play chess, sleep, go on fig-picking raids in the Arab gardens, and go for refreshing swims in the ocean.
It's much cooler than in France. I don't think the temperature ever gets above 30° C. A slight, cool breeze is always blowing. The countryside around here is desertlike and rocky. The interior of North Africa is a plain exactly like the area around Carnac. Where are the banana trees, date and coconut palms of my dreams? Possibly I shall find some when I head further inland. Except for Tangiers (ideal) and Rabat (adorable) the countryside that I've seen is ugly. You can sum it up as a café, a single set of railtracks and some pebbles. From time to time you come across a small donkey bearing the load of an elephant. On that load is perched an Arab and, behind him, walks a veiled woman, heroic, like a warrant officer.
I would gladly take some correspondence courses but you probably couldn't arrange that. Could you at least have them send me the first three volumes of Brauzzi's course in aeronautics [from your bookshop in Lyons?]

Right-hand page:
Extract from an unpublished letter to his mother, Casablanca, 1921.

dernière heure
Je viens de recevoir votre mandat — merci.
J'ai enfin fait aujourd'hui mon premier vol au Maroc

Ma petite maman

C'est incroyable ce qu'on travaille ... Je n'ai pas encore mis le pied dans un avion et mes journées se passent à pêcher les crabes, à marée basse, dans l'océan. Les pilotes sont libres comme l'air et

faute de nous rendre en ville — trop loin. — nous jouons aux échecs, dormons, faisons des razzias de tripes dans les "douars" arabes ou prenons de réconfortants bains de mer.

Il fait infiniment plus frais qu'en France. Je ne crois pas que la température excède 30° jamais. Une brise légère et fraîche souffle sans fin.

Le pays d'alentour est désertique et rocailleux

le "bled" est une plaine pense Carnac, exactement.
Où sont les bananiers les dattiers et les cocotiers de mes rêves. J'en trouverai peut-être quand je cinglerai vers l'intérieur. Sauf Tanger (idéal) et Rabat (adorable) le pays que j'ai vu est laid ... Il peut se synthétiser par un bistro, un chemin de fer decauville et des cailloux.

on y rencontre de temps en temps un petit âne qui porte la charge d'un éléphant. Sur la dite charge un arabe juché — et derrière, héroïque — une femme voilée qui marche comme un assistant.

Je suivrais volontiers des cours par correspondance mais vous ne pourrez probablement pas — Pourriez-vous au moins me faire envoyer les 3 premiers volumes du cours d'aéronautique de Brauzzi

There is only one thing that I like here and it's the sunrises. They develop in a theatrical way. First, out of the night comes a gigantic décor of violet and black clouds which gets clearer and settles in on the horizon. Then, behind the light, behind a ramp of black velvet, rises a second layer that shines brightly. Then the sun – a red sun, red such as I've never seen. After rising for a few minutes it disappears behind a chaotic ceiling. It seems to have crossed a cave.

I found "The Return" here and, laughing as though I were going to die of it, I relived our evening at the Athénée. My dearest Mama, how far away that all is. You ought to buy it, you'd laugh out loud, even by yourself, and having seen it performed helps the imagination.

Mama, if you give me permission for the universal school I shall write to them myself, because of a whole lot of details I have to give them.

The sunrises

Several weeks passed, and Antoine de Saint Exupéry was beginning to be happy: he had started flying again. He liked the colors of the landscape in the early morning and the sun as it starts to light up the earth. All the magic of *The Little Prince* is already contained within these few sentences.

Saint Exupéry obtained his air force pilot's license and received the badge that announced proudly: "The wings that carry you, the Star that guides you, the Crown that awaits you." His new title authorized him to apply for admission to the officer cadet reserves. He went to Rabat to take an examination in general knowledge, which he just passed, coming in last in his group. He met up there with Marc Sabran, whom he had met as a fellow boarder at the Villa Saint-Jean, and, with him, he visited the Arab old city of Rabat. The season had changed and "Morocco, the awful dry plain, had just become covered with fresh greenery and long, shimmering pastures."

Above, left : Caravan in the desert. Photo taken during the filming of *Southern Mail.*

Right-hand page : Extract from an unpublished letter to his mother, Casablanca, 1921.

est ce Robert?

Robert (?) de Curel le père de l'amie
de Mama —

Il a déjà, d'ailleurs cassé un
appareil, moi rien —

Il n'y a qu'une chose qui me
plaise ici ce sont les levers de
soleil. Ils se développent théatralement
D'abord sort de la nuit en deux
gigantesque de nuages violets et noirs
qui se précisent et s'installe sur
l'horizon. Puis de la lumière monte
derrière, une rampe, noire
révelant tout un second plan plein
de clarté — Alors monte le soleil — un soleil
rose, rose comme je ne l'ai jamais
vu — Après quelques minutes d'ascension
il disparait derrière un plafond chaotique.
Il semble avoir traversé une grotte —

J'ai trouvé ici "Le Retour,
et tout en riant à en mourir j'ai
revu notre soirée à l'Athénée — ma
petite maman, comme c'est loin. Vous
devriez l'acheter, on rit tout seul très
fort et le l'avoir vu joue aide
l'imagination. —

Maman si vous me donnez
l'autorisation pour l'école universelle
j'écrirai moi même qu'à cause
d'un tas de détails a donner

119

Dear Sir,
You must be wondering whether I'm dead or alive… Shortly after my visit, during which I showed you "Manon, the dancer", I was asked to come to Toulouse by the Latécoère Airlines. Hired, first of all as a pilot on the flights to Spain and Morocco, I am now in the South, six thousand kilometers [four thousand miles] from Paris.
I fly regularly from Dakar to Cape Juby. It's a short flight of two thousand kilometers, fifteen hundred of which are over the French Sahara and rebel-held Sahara. You get quite a strange impression flying for hours over a hostile land and tribes whose main quality is not Christian charity. But you cannot imagine the degree to which I love this life of adventures. I broke down twice in the middle of the desert but was able to be picked up by [my team-mate, because over those territories we always fly two planes together and, if it's possible to land, your comrade rescues you.]

« I broke down twice in the middle of the desert »

Antoine de Saint Exupéry was released from his military service on June 5, 1924. He had served for two periods of two weeks at Orly, in April 1925 and 1926, before flying as a trainee pilot for the Compagnie Aérienne Française. Having obtained his license as a public transport pilot on July 5, 1926, he joined the Latécoère company in Toulouse on October 14, 1926. In the years 1927-1928, he flew the flights between Toulouse and Casablanca, sometimes flying on to Dakar.

He describes, to a friend who had remained in France, his enthusiasm for this new job, his appreciation of the Sahara and its infinite plains, the quality of the contacts he had established with the Moors, his disappointment with Dakar and with the Senegalese in general, as well as his discovery of new sports: "My great joy – for I have a lot of freedom – has been to leave for Mauritania, and to spend a few days amongst the Moors. I have even hunted lions, like Tartarin, because the place is full of them."

Above, left : Sand dunes in the desert. Photo taken during the filming of *Southern Mail.*

Right-hand page : Extract from an unpublished letter sent by airmail to Mr. Charles Brun, March 1927.

J. GUILLEMAN
HOTEL DE L'EUROPE
DAKAR (SÉNÉGAL)

Cher _____

Vous devez vous demander si je ne suis pas mort... — mais peu de temps après _____ où je vous ai quitté "maison dangereuse" j'ai été convoqué à Toulouse aux lignes aériennes Latécoère. Engagé alors comme pilote sur les lignes d'Espagne et du Maroc je suis actuellement dans les cinq ou six mille kilomètres de Paris.

Je vais régulièrement de Dakar au cap Jubi. c'est un petit vol de deux mille kilomètres dont quinze cents sur le Sahara français et le Sahara dissident. Et c'est une impression assez curieuse de naviguer pendant des heures au dessus d'un pays hostile et de tribus dont la principale qualité n'est pas la charité chrétienne. Mais vous ne pouvez imaginer combien j'aime cette vie d'aventures. J'ai eu la panne deux fois en plein désert mais ai pu être recueilli par avion

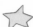

They're like scales of metal, and all the domes that surround us are as shiny as armor. We fell into a mineral world. We are locked into a landscape of iron. After you've crossed the first ridge, another, similar ridge appears up ahead, shining and black. We walk along scraping the ground with our feet, in order to mark a trail, along which we can return later. We go forward facing the sun. It was against all logic that I decided to go directly eastwards as everything leads me to think that I have crossed the Nile: the weather and my flying time. But I tried going west for a while and I felt an unease which I couldn't explain. So I have left the West for tomorrow. And I provisionally gave up the idea of going north, even though it leads to the sea. Three days later, when we decided, in a semi-delirious state, to abandon our aircraft once and for all and to walk straight ahead of us until we collapsed, it was towards the East that we set off. Or, more precisely, east-north-east. And that, too, was against all reason, as well as against all hope. And, once we were saved, we found out that no other direction would have enabled us to come back, because if we had gone north, we would have been too exhausted to have stood any chance of reaching the sea. As absurd as that may appear, it seems to me today, that given the absence of any other notion that could have affected our choice, I chose that direction for the sole reason that it had saved my friend Guillaumet in the Andes, where I had searched for him for so long. It had become, for me, in some confused way, the direction of his life. After five hours of walking, the landscape changes. A river of sand seems to flow in a valley and we started to walk along the floor of that valley. We took large strides –
We had to go as far as possible and come back before nightfall if we didn't discover anything. And suddenly I stopped:
"Prévot.
– What?
– The tracks…"

« We are locked into a landscape of iron »

The trials of accidents and the dangers of the desert are some of the themes of *Wind, Sand and Stars*, which was based on articles previously published in the press. This piece had appeared in *Paris-Soir* in 1936.
If the life of heroes was threatened by the hostility of the natural environment, Saint Exupéry had not lost his affection for the Sahara and this passage begins with a declaration of love: "I have loved the Sahara very much. I have spent nights as a rebel. I awoke in this blond immensity where the wind marks its swell just as the sea does."

Right-hand page :
Wind, Sand and Stars,
preparatory chapter on
the desert, folio 29.

[handwritten manuscript, largely illegible cursive French]

— Prends !
— Quoi ?
— Les Gaus...

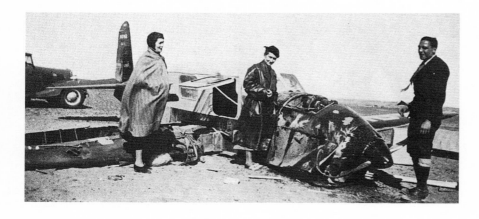

Could you please pay my guide two guineas?
I don't have any of the local currency.
After walking for five days in the desert,
seeing hardly a drop of water, my engineer
and I have just ended up at a small oasis.
We're being taken to your house by camel
but we don't have the strength to stand this
form of transport. May we count on your
very great kindness and ask you to pick us
up as soon as possible, by automobile or
boat?
Our guide will explain to you where we are.

Antoine de Saint Exupéry

We thank you in anticipation

« We have just ended up at a small oasis »

Picked up, with his mechanic, by a caravan after an airplane accident in the desert, Saint Exupéry sent this S.O.S. to Madame Raccaud. She was the wife of Emile Raccaud, a Swiss engineer, who was the director of a factory at Wadi Natroum, in the middle of the desert, between Alexandria and Cairo. Exhausted by his long trek on foot, too tired to sit up on a saddle on a camel, Saint Exupéry wrote his appeal for help on the back of his flight plan over Libya. His request for a boat confirms, as if that were necessary, his state of fatigue, for, in his delirium, he thought he could see lakes of fresh water beside the Nile delta.

Madame Raccaud immediately sent a small truck to fetch the two victims of the desert, and suggested that they rest at her house. Saint Exupéry refused, being eager to go on to Cairo to telephone France and reassure his family and friends. But fate had not been done victimizing him as the vehicle that was taking him to Cairo broke down, forcing him to walk for the last three miles of this journey.

Above, left : Mme. Raccaud in front of the wreckage of the plane.

Right-hand page : Unpublished note to Mme. Raccaud, 1936.

Pourriez vous payer mon guide 2 guinées. je n'ai point le change du pays.

Après cinq jours de marches sans presque une goutte d'eau, dans le desert, nous venons d'aboutir mon mecanicien et moi dans un petit oasis.

On nous emmene chez vous par chameau mais nous n'avons plus la force de supporter ce mode de transport. Pouvons nous compter sur votre très grande obligeance et vous demandons de nous recueillir le plus tot possible en auto ou canot :

votre guide vous expliquera ou nous sommes

Antoine de Saint Exupéry

Nous vous remercions d'avance

Left: Illustration by
André Derain
for *Wisdom of the Sands*.

Right-hand page:
Wisdom of the Sands,
extract from the
handwritten manuscript.

Near the salt mines

This sheet is taken from the first part of *Citadelle (Wisdom of the Sands)*, which Saint Exupéry had begun writing in 1936, and which he continued to work on during his stay in the United States. In 1943, he had his text sent to North Africa.

It was thus an incomplete and unrevised manuscript that Gallimard published in the "Blanche" collection on November 10, 1948, from a text that was typed by a secretary. When that text was compared to the parts of the manuscript that had been discovered but that were difficult to decipher – and which Saint Exupéry had himself had difficulty reading over, as he dictated it day by day – a new, much improved edition of it was able to be published, in 1959, by the Club des Libraires de France.

The critics were not kind to *Wisdom of the Sands:* Saint Exupéry's friends had already expressed their reservations to him when he had read extracts from it to them. But when it came to reviewing this thick book, which was much longer, the reception it received was severe, even pitiless. It was not until André-A. Devaux published his subtle analysis of it that this text received a more favorable interpretation.

It was near the salt mines. And the men followed each other, living as best they could, among the minerals, for nothing really authorized life to exist here. The sun weighed down and burned, and the interior of the earth, far from supplying limpid water, only provided bars of salt which would have killed the water if the wells had not been dry. Caught between the sun and the gem-filled ground, the men who had come from elsewhere with their full water bottles were working in haste, detaching these transparent crystals, representing life and death, with their pickaxes. Then they turned away from them, tied, as if by an umbilical cord, to the fortunate lands and their fertile waters.

Here, the sun was like this, harsh, hard and white like the famine. And the rocks cracked the sand in places, flanking the salt mines with their strata of ebony that was as hard as black diamonds and whose crests were whipped, in vain, by the winds. Anybody who had witnessed the secular traditions of that desert would have guessed them to be lasting and fixed for centuries. The mountain would continue to be worn down slowly, as though rubbed by a file that was too weak; men would continue to extract salt, and caravans would continue to bring in water and food and to relieve these convicts...

8)

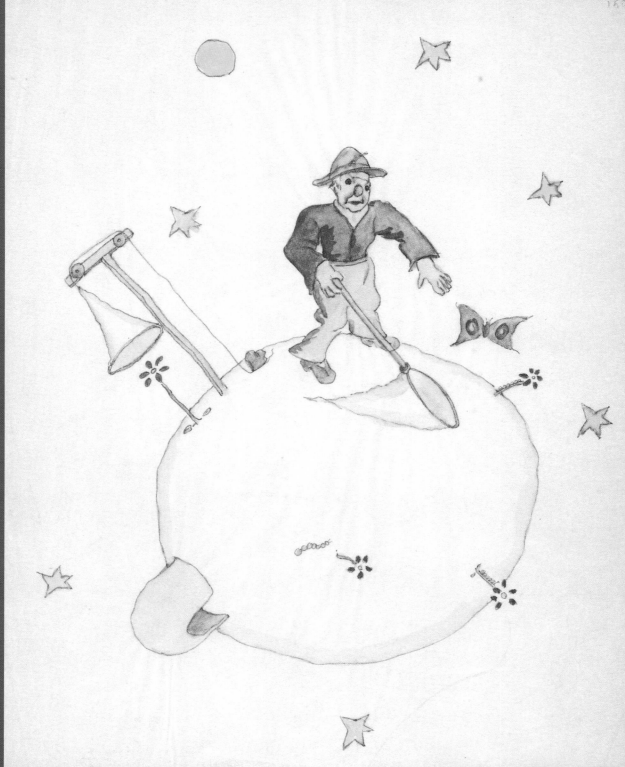

Above : Preparatory drawing for *The Little Prince.*
Right-hand page : Self-portrait of Saint Exupéry, around 1940.

Saint Exupéry, Inventor and Magician

« Neither does a civilization rest
on the use of its inventions,
but only on the fervor of its urge to invent. »

T he earliest exploits revealing Antoine de Saint Exupéry's talents as an inventor appear in his older sister Simone's childhood memories. *In Five Children in a Park (Cinq enfants dans un parc)*, she evokes the various experiments that her young brother tried to improve the performance of his bicycle. He presented the priest with a plan to equip his bike with a gasoline motor. Nothing was missing: pistons, valves, connecting rods, or a gasoline tank. But the child's project was quickly dismissed by the priest, who found it too dangerous. Antoine, who always got what he wanted, then started working on a bicycle with sails that could fly, carried aloft by the wind and energetic ped-

Below: In March 1940, in the officers' mess in Athiès-sous-Laon, Saint Exupéry comments on a patent that he has registered.

aling. But he had not given up the idea of the motor. As soon as he could get one, instead of mounting it on his bicycle, Antoine decided to build an automatic sprinkler to water their vegetable garden, and to speed up the growth of the vegetables, which he was in fact hoping to sell to Tante for some pocket money. This experiment almost took a tragic turn when the motor exploded, projecting a piece of metal into his brother François' eyebrow, who was lucky to get away with nothing more than a scratch.

Saint Exupéry had the clever hands of a handyman and magician. It was during his military service in Strasbourg, that a friend taught him how to handle cards. He elicited the admiration of everyone by performing card tricks with amazing dexterity. Shy by nature, he found that this was a way to approach women and engage in conversation with men. All those who saw what he could do tell the same story. In order to overcome his embarrassment, Saint Exupéry would take a deck of cards out of his pocket, shuffle them, cut them and say in his quiet voice:
– Choose a card.
Then the magic would begin.

Saint Exupéry's hands did not merely help him to express his thoughts. They allowed him to better understand his work as a pilot. In 1925, while working for the Saurer corporation, Saint Exupéry was sent to the workshops, where he learned how to assemble and take apart truck engines to better understand how they worked, before going to sell them in the central region of France. It was also in the mechanical repair workshops that he began his pilot's training when he was hired by the Latécoère Company in October 1926. Saint Exupéry recognized the importance of this manual dexterity. "I have a comrade whose hands

were burned. I don't want my hands to be burned. I look at them and I love them. They know how to write, lace up shoes, improvise operas… And sometimes, they imprison faces…"

Curious about everything, Saint Exupéry kept himself informed about developments in the sciences. He carried with him small notebooks in which he noted his reflections on all the subjects that he was interested in: political, economic, social, scientific, and religious. These notes, gathered together in a book published in 1975, entitled *Notebooks (Carnets)*, reveal how eclectic his interests and thinkings were. One is not at all surprised to learn that, between December1934 and March 1940, Saint Exupéry registered ten patents for his inventions in France, and three additional supplements. All of these patents were related to aviation. They were all prompted by the desire to eliminate deficiencies and to improve on the faults that the pilot encountered in the course of his flights. None of these invention patents were realized in France, but some were developed in the United States after the War.

One of his most remarkable inventions was what, today, is called the DME (Distance Measuring Equipment), registered on February 19, 1940 (with a supplement on March 7) and not published until August 20, 1947 with the title "New method of locating positions by means of electromagnetic waves." This instrument for measuring distances, with which all airplanes are equipped today, did not exist yet in 1940. Saint

Right : Patent of July 1939, registered by Antoine de Saint Exupéry for the « Perfecting of the control of engines in flight by a single indicating instrument. »

RÉPUBLIQUE FRANÇAISE.

MINISTÈRE DE LA PRODUCTION INDUSTRIELLE ET DU TRAVAIL.

DIRECTION DE LA PROPRIÉTÉ INDUSTRIELLE.

BREVET D'INVENTION.

Gr. 6. — Cl. 4. Nº 861.203

Perfectionnements aux moyens de contrôle des moteurs en vol par un appareil indicateur unique.

M. Antoine de SAINT-EXUPÉRY résidant en France (Seine).

Demandé le 22 juillet 1939, à 10ʰ 2ᵐ, à Paris.
Délivré le 22 octobre 1940. — Publié le 4 février 1941.

[Brevet d'invention dont la délivrance a été ajournée en exécution de l'art. 11 § 7 de la loi du 5 juillet 1844 modifiée par la loi du 7 avril 1902.]

Sur un avion multimoteur, les instruments de contrôle de la marche des moteurs mis à la disposition des mécaniciens sont trop nombreux pour être tous placés ou répétés sur la planche de bord. En rassemblant sur un seul indicateur le maximum de renseignements utiles à ce contrôle, il devient possible de disposer cet indicateur unique sur la planche de bord du pilote.

Le but de la présente invention est de fournir une méthode permettant de réaliser un tel indicateur, grâce auquel il est possible soit de contrôler individuellement pour chaque moteur le fonctionnement de l'allumage et le réglage de l'avance à l'allumage, soit de contrôler la synchronisation des différents moteurs.

Dans son principe, le dispositif comporte la combinaison des éléments suivants : un oscillographe cathodique, du type à déviation permanente circulaire ; des générateurs d'excitation polyphasée convenant audit tube, chacun des moteurs de l'avion comportant un tel générateur rendu solidaire en rotation avec le moteur correspondant ; des connexions électriques, avec commutateurs, permettant d'appliquer aux plaques de déviation radiale les tensions des rampes de bougie d'un ou de plusieurs moteurs.

L'invention sera mieux comprise au moyen des figures ci-jointes et de la description s'y rapportant, lesquelles en fournissent, à titre d'exemple non limitatif, un mode de réalisation et d'utilisation.

On connaît un type d'oscillographe cathodique dans lequel sous l'effet de tensions ou de courants polyphasés appliqués aux organes déflecteurs usuels le faisceau cathodique décrit la surface d'un cône, et sa trace sur l'écran fluorescent un cercle. Le faisceau cathodique passe dans l'entrefer d'un système déflecteur supplémentaire comportant deux pièces conductrices concentriques dont les surfaces en vis-à-vis sont coniques ; sur ce déflecteur supplémentaire sont appliquées les tensions correspondant au phénomène à analyser, l'effet d'une tension sur ce déflecteur se traduisant par une modification du rayon de l'image cathodique. Si la tension appliquée est de durée brève par rapport à la période de révolution du faisceau cathodique elle se traduit par une pointe sur la trace circulaire du faisceau, cette pointe pouvant être dirigée vers le centre ou vers l'extérieur, suivant le sens de la tension appliquée. La figure 1 montre l'aspect du diagramme ainsi obtenu.

Suivant l'invention, on associe un oscil-

Prix du fascicule : 10 francs.

Above : **Two drawings for the study of a torpedo.**

Exupéry had perfected one of the basic principles of radar.

While he was staying in Orconte in the winter of 1939-1940, Fernand Holweck, a professor at the French Center for Scientific Research, came to visit Saint Exupéry. Léon Werth was present: "One would have had to have been a very unreliable informer not to see that Professor Holweck was taking this amateur physicist absolutely seriously. Today's subject was an equation. I heard Holweck discussing it with Saint Exupéry. That day, I heard a scholarly discussion on the refrigeration of oil at high altitudes."

As soon as he arrived in New York at the beginning of 1941, Saint Exupéry got in touch with the War Department to offer the American army patents concerning navigational instruments, but these discussions did not lead to anything concrete. While he was turning round in circles in this New York milieu that did not support him, Saint Exupéry spent his free time posing mathematical problems to his friends. *The Problem of the Pharaoh*, which he had already described in 1935, remains a great classic. The game of chess had no secrets for him. In his diary from February 1943, Denis de Rougemont wrote: "Saint Ex has practiced a lot of chess at his air bases, and he is quite clearly much better than I am. But there is more: he hums constantly, while playing, sometimes a little out of tune – on purpose? – which is infuriating and makes me lose every time." Rougemont goes on: "what has often intrigued me, is the nuclear business. Saint Ex was the first to explain to me the possibilities of

atomic fission, which Juliot-Curie revealed to him. As early as 1942, he spoke to me about experiments that had been planned in the Sahara just before the War, but whose promoters were apprehensive that they might escape their control and, by a chain reaction, might blow up the Earth." His statements are confirmed by those of Jean Renoir in 1941: "He was passionate about everything that had to do with the atomic bomb and spoke to us about the heavy water that was transported out of France so that the Germans wouldn't get it. He seemed to be very well informed. He was in favor of holding experiments in the vast wastes of the Sahara in order to minimize fallout."

Saint Exupéry's mind was always on the look-out and he was constantly experimenting with new ideas. That's how, in 1941, his editor, who had come to take him out to dinner, rang the doorbell of his apartment in New York in vain. As he had a key to it, he went in. Intrigued by the sound of water and the annoyed shouts coming from the bathroom, he approached, a little apprehensively. How surprised he must have been to discover Saint Exupéry, on his knees, testing the varying speed of the movement of small rafts in his bath, as he let a stream of hot or cold water into it…

In order to prepare the counter-offensive of the Allied invasion of Normandy, Saint Exupéry planned to equip the soldiers with individual and silent helicopters with no engines, which would surprise the enemy. After he consulted Robert Boname, the former director of technical services at Air France, who was now in exile in New York, the project was abandoned because the blades of the autogyros showed themselves to be too heavy for one man to carry.

Helicopters always fascinated Saint Exupéry. Jean-Gérard Fleury, a former airline pilot, testifies to this when he writes: "For some time, he would cut helicopter blades out of sheets of paper. Their dimensions varied according to his calculations and he launched them out of the window to check their range." Much later, in 1944, once he had gone back to 2/33, Saint Exupéry, now a reserve captain, joined General Eaker, the commander of the American forces in the Mediterranean, in Naples to ask his permission to once again fly a Lightning. From the top floor of the house in which he was staying, he amused himself by making light helicopters out of paper, which he launched through the window, to the great joy of the children who were playing in the street.

Who exactly was Saint Exupéry? A musician who played the piano with oranges, interpreting a tune in the manner of Erik Satie, a magician who delighted his friends with his card tricks, or an inventor? Theodore von Karman, the specialist in aerodynamics at the War Department, in Washington, used to say: "I have just received Antoine de Saint Exupéry, who has explained to me his ideas concerning aerodynamics. These ideas are extraordinarily new and capable of bringing considerable upheaval to our science."

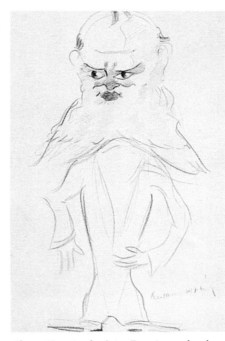

Above : Drawing by Saint Exupéry, undated.

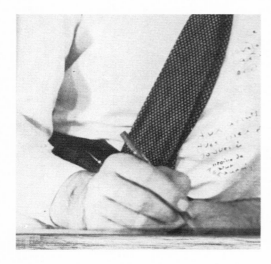

Left : Saint Exupéry's
hand, writing.

Right-hand page : Letter
to his mother, 1910.

[Le Mans, 11 June 1910]

My dear Mama,
I have made myself a fountain pen. I'm
using it to write to you. It works very well.
Tomorrow is my name day. Uncle Emanuel
said that he would give me a watch for my
name day. So could you write and tell him
that tomorrow is my name day? There is a
pilgrimage, on Thursday, to Notre-Dame-
du-Chêne. I'm going with the school. We
have very bad weather here. It's raining all
the time. I have made myself a very pretty
altar with all the presents I've received.
Goodbye
Dearest Mama, I would like to see you again
soon.

Antoine

It's my name day tomorrow.

« I have made myself
a fountain pen »

As a fifth grade student at the Jesuit elementary and
high school of Sainte-Croix since October 7, 1909, the
young Antoine had, as his teacher Monsieur Erragne,
whose class that year consisted of twelve students. His
grades, which made him ninth in the class until the
end of that year, did not seem to overly concern him.
Neither did the punishments he quite regularly received
for being undisciplined.

Ingenious from a very early age, as well as a budding
handyman, he liked to take apart and put back together
a recent invention that had become extremely popular:
the fountain pen. As his friend Jean-Marie Lelièvre
later recalled, these pens, of English and especially
American origin, released streams of ink when they
were taken apart, as was confirmed by ink-stained fin-
gers on homework, or, as here, on letters.

One notes that the first line of this letter, the first one
to have been preserved, "I have made myself a fountain
pen" is quite fitting for someone who was to be a writer.

maman

je me suis fait un stylographe
j'avois écris avec il va très bien
Demain c'est ma fête

Est que l'oncle
emanuël a dit qu'il me donnerai
une montre pour ma fête
alors es que vous ne pouvrez
lui écrire que c'est demain ma fête
J'ai à un pélerinage jeudi
à notre dame du fer je vais avec
le collège il fait très mauvais
temps il pleut tout le temps
je me suis fait un très jolie

avec toutes les cadeaux
que l'on m'a donné
Adieu
maman cherie je
voudrais bien vous
revoir

Antoine

c'est ma fête demain

A pharaoh decided to erect a massive parallelepiped rectangular stele, using blocks of stone cut into cubes the sides of which were 10 cm long. The height of the stele was to be equivalent to the diagonal of the base.

He ordered a certain number of employees to assemble an equal proportion of the materials needed to build the stele. Then he died.

Contemporary archaeologists only found one of these deposits. They counted 348,960,150 cubical blocks of stone. They knew nothing of the other deposits, except that the total number of deposits was, for some mystical reason, a prime number.

This discovery did allow them, however, to calculate precisely the dimensions of the planned stele and to demonstrate that there was only one possible solution. Do the same thing.

N. B.

A) This problem does not require any numerical trial and error, so, in order to save you the only time-consuming part of this task, the breakdown of 348,960,150 into prime factors is as follows:

$$2.\ 3^5.\ 5^2.\ 7.\ 11.\ 373$$

B) Solving the problem by laborious empirical calculation does not count.

• Solution of the Pharaoh's problem

I. – The necessary and sufficient condition, in order that the expression: $a^2 + b^2 = c^2$ be true for WHOLE NUMBERS is that the numbers a, b, and c be in the form:

$$a = 2\ p\ m\ n$$
$$b = p\ (m^2 - n^2)$$
$$c = p\ (m^2 + n^2)$$

Theorme which Saint Exupéry had previously established.

II. – We know that we have:

a, b, c = 348,960,150 x x (1) = kx
$$a^2 + b^2 = c^2\ (2)$$
a, b, c whole numbers (3)
x prime (4)

III. – We have: a, b, c = $2\ p^3\ m\ n\ (m^2 + n^2)$
$(m^2 - n^2) = kx$
one deduces immediately that:
x = 2 because x is a PRIME number.

IV. – We know that:
k = 348,960,150 = 2. 3^5. 7. 11. 373 with the expression p3 m n
(m + n) (m - n) (m2 + n2) you establish that p2 can only be 33, then we draw up the following table:

2. 3^5. 5^2. 7. 11. 373

18	25	7	11	373
9	50	7	11	373
9	25	14	11	373
9	25	7	22	373
9	25	7	22	746

One must then find
 m. n. M + n, et m – n.
which can only be realized with:
11 + 7 = 18 25 – 19 = 7
(line 1)

Finally we have: p = 3
 m = 18 – 2. 32
 n = 7
 from which: m + n = 25
 m – n = 11
 $m^2 + n^2 = 373$

V. – And finally: a = 6. 18. 7 = 75.6 m
 b = 3 (182 – 72) = 82.5 m
 c = 3 (182 + 72) = 111.9 m

Right-hand page : Cover of *The Problem of the Pharaoh*, Ælberts, 1957.

Below : Drawing by Saint Exupéry.

Problem of the Pharaoh

Saint Exupéry had visited the Pyramids during his stay in Cairo in 1935. That was what prompted the idea of *The Problem of the Pharaoh*. He liked to propose enigmas to his circle of friends, and this was one he was particularly fond of. He had not had the intention of publishing it but fifty-one copies of a booklet containing it were printed in Liège, in 1957, by Pierre Aelberts.

Saint-Exupéry

PROBLÈME DU

PHARAON

It is necessary, in many situations, to slow down the velocity of falling material objects. Aviation may indeed have as its mission the resupplying of combatants with water, food or munitions. There are also models of torpedos that it is advantageous to deposit on the ground with reduced vertical velocity. The braking method generally used is a parachute.

Given the extremely high cost of such a manner of assuring lift, it may be interesting to study its replacement by a simple rotary wing, taking into account the very simple manufacture of such a system. It is, in fact, unnecessary to foresee a material of ball and socket joints or of ball bearings. If it is true that in the case of the lifting of a man, it is important to stop that man from experiencing a rapid rotation and the centrifugal forces that result from this. This disadvantage does not arise in the case of material objects. It does not matter if those objects spin around with their rotary lifting canopy.

We are sending you herewith a certain number of these rotary wings, made of paper, which are designed to prove that it is sufficient to bend a sheet of metal around a horizontal axis in order to obtain a perfectly balanced rotary wing. Taking into account the fact that tolerable velocities of fall can be quite high, even in the case of munitions and water supplies, and that the surface of rotary wings is, for the same positioning, much lower than that of a wing or parachute, and, lastly, bearing in mind that the rigidity of a system is assured, without the intervention of any beam, by simple centrifugal force, we find ample evidence of the fact that such a construction can be light, economical and not bulky.

In order to ensure the initial rotation that will tend to tilt the planes near to the horizontal, it is sufficient that any force, torsion force in the case of paper, tend to prevent the two planes from remaining in the same vertical plane during the descent. By the effect of air resistance, the force of torsion is transformed into a frame of rotation and that rotation frame, in turn, by the effect of centrifugal forces that act upon it, tends to push the sheets of metal back towards the horizontal plane.... [continued on p. 140]

Left : Sketch for a study on aeronautical lift.

Right-hand page : First page of *Scientific Essays on Aeronautics.* Typescript of section entitled "Aerial Torpedo".

On aeronautics

From 1934 to 1940, Antoine de Saint Exupéry registered around ten patents at the I.N.P.I., the French National Institute of Industrial Property. On November 28, 1939, he registered the patent for the "Aerial torpedo," under the pseudonym Max Ras, the typed plan and several drawings of which are reproduced here.

Il est nécessaire dans de nombreuses circonstances de freiner la vitesse de chute d'objets matériels. L'aviation peut en effet avoir pour mission de ravitailler des combattants en eau en vivres ou en munitions. Il est enfin des modèles de torpilles qu'il est avantageux de déposer au sol à vitesse verticale réduite.

Le frein couramment utilisé est le parachute.

Etant donné le prix de revient extrêmement élevé d'un tel mode de sustentation, il peut être intéressant d'étudier son remplacement par une simple voilure tournante, en tenant compte de l'usinage extrêmement simple d'un tel dispositif. Il est en effet inutile de prévoir un matériel de dédaxe tournant, de rotule ou de roulement à billes. Si en effet dans le cas de la sustentation d'un homme il importe d'éviter à cet homme une rotation rapide et les forces centrifuges qui en découlent cet inconvénient ne se pose pas s'il s'agit d'objets matériels. Peu importe si ces objets tournent avec leur voilure sustentatrice.

Nous vous remettons ci-joint un certain nombre de ces voilures tournantes réalisées en simple papier, destinées à prouver qu'il suffit de cendres et de replier une plaque de tôle de part et d'autre d'un axe horizontal pour obtenir une voilure parfaitement équilibrée. Si l'on tient compte de ce que les

The theoretical state of balance limits and holds the parallel with this horizontal plane. If the sheets are indeed horizontal, the rotation frame disappears, the velocity decreases and thus so does the centrifugal force, which brings about an upward bending of the two planes, a bending which, in turn, causes an increase in the frame of rotation. At equal amounts of energy expended, the perforation of a sheet of metal is more easily achieved at the higher speed of the projectile. This depends on the make-up of the matter. It may thus seem advantageous to project, at a high initial velocity, a projectile of low mass, raised to a low initial velocity. However, the ratio of surface to volume rising rapidly as the volume decreases, a projectile of low mass, especially if it is fired at a high initial velocity, is rapidly slowed down by the air resistance. It may therefore seem interesting to make a projectile in such a way that it be transformed, at the point of impact, into a secondary firearm that will liberate a low mass at a very high initial velocity.

It must, in fact, be considered that in many instances the section of the perforation plays a minor role in relation to the depth of that perforation. If, for example, a hole is punched in the wall of a cylinder, even if that hole is as small as a pinprick, that cylinder will deteriorate in a few seconds because of piston-jamming. Similarly, the chances of an explosion of the fuel tank are independent of the section of the perforation. An aircraft crew is in many cases prevented from engaging in combat by punctures that are, in fact, very small.

One could be tempted to make a projectile that, at the point of impact, transforms itself into a sort of mobile canon which, as a result of the igniting of an internal store of powder, fires, in its turn, a projectile of narrow width. But in such a case, the following two disadvantages arise:

a) In order that the desired process be realized, it is important that it take place in a very short time from the moment when the spark causes the igniting of the internal explosive. In fact, the igniting and combustion of even a very fast-burning powder requires a length of time that is higher than the time available.

b) If one wishes to transfer a considerable amount of energy to the internal mass, it is important to place within it a rather large store of powder, which in turn poses another problem.

But it may be just as tempting simply to transfer to a projectile of low mass a part of the quantity of movement of the mass of the whole, if that mass is the wing and the mass of the small sized projectile m over a thousand and if I use only one hundredth of the quantity of movement of the heavy whole, in order to transfer it to the light projectile, I notice that I shall cause that projectile to have an initial velocity that is ten times higher than that of the whole at the moment of impact.

This quantity of motion being an appreciable source of energy, since it suffices to take a hundredth of it to obtain an initial velocity that is higher than could be hoped for, it may be of interest to imagine and to study the following possibility:

The front part of the projectile is formed of a low mass punctured or pierced by an axial tonal and set within a cylinder.

c) The cylinder in question, of high mass, will serve as an energy reservoir. Now if a secondary projectile d is placed at the rear opening of the axial tonal, as it would be placed in the barrel of a rifle, and if a chamber filled with liquid or with a substance that becomes liquid by the effect of compression (lead, for example), is held between the head of the projectile p and the internal face of the cylinder, it is clear that, at the moment when the nose of the projectile is blocked by the wall of the target, the cylinder's mass will continue to move forward and will expel the liquid out of the explosive chamber. Now if, in order to bring about an elastic release, we have introduced into that chamber a pocket of air, that pocket of air being maintained in the center by centrifugal force, due to the rotation of the projectile, since heavy liquids will tend to take up positions that are furthest from the axis, it is this pocket of air that will, first of all, be thrust backwards in the barrel of the secondary cannon and will play the precise ballistic role that a discharge of powder would have played.

Above: Sketch for the study of lift.

Right-hand page: Another page from the *Scientific Essays on Aeronautics*.

vitesses de chute tolérables peuvent être assez élevées même
s'il s'agit de munitions ou de réserve d'eau, et de ce que la
surface de la voilure tournante est, pour une même sustentation,
très inférieure à celle d'une aile ou d'un parachute, en tenant
compte enfin de ce que la rigidité du système est assurée, sans
l'intervention d'aucune poutre, par la simple force centrifuge,
on constate avec évidence qu'une telle réalisation peut être à la
fois légère, économique et peu encombrante.

 Pour assurer la rotation initiale qui tendra à incliner
les plans au voisinage du plan horizontal il suffit qu'une force
quelconque (force de torsion dans le cas du papier, tende à empê-
cher les deux plans de demeurer, durant la chute, dans un même
plan vertical. La force de torsion, par l'effet de la résistance
de l'air, se transforme en couple de rotation, et ce couple de
rotation, à son tour, par l'effet des forces centrifuges qui
l'entraînent, tend à ramener les plaques de tôle dans le voisinage
du plan horizontal. L'état d'équilibre théorique limite et
tend le parallélisme avec ce plan horizontal. Si en effet les
tôles sont horizontales le couple de rotation disparaît, la vitesse
décroît et donc la force centrifuge, ce qui entraîne un fléchisse-
ment des deux plans vers le haut, lequel fléchissement, à son
tour, entraîne un accroissement du couple de rotation. A énergie
dépensée égale la perforation d'une plaque de métal est d'autant
plus aisée que la vitesse du projectile est plus élevée. Ce qui
tient à la constitution de la matière. Il peut donc sembler
avantageux d'émettre à haute vitesse initiale un projectile de
faible masse qu'un projectile de masse élevée à vitesse initiale
faible. Cependant, ìaxxxxfxxx le rapport surface à volume crois-

Left : Binding of
Notebook I by Saint
Exupéry.

Right-hand page :
Notebook I, no. 1.

A few concepts

The *Notebooks* of Saint Exupéry allowed their author to set down his intellectual and scientific reflections as they occurred to him. They do not contain any references to his personal life, and are written concisely, without any emotion or existential ideas. They touch on numerous unrelated fields, including politics, psychoanalysis, sociology, economics, biology, religion and metaphysics. We find noted down in them echos of his conversations with scientists of his time, each of whom was, apparently, astonished "to find in him such a clever, receptive and imaginative interlocutor."

Six of these *Notebooks* or *Diaries* have been saved: they deal with the period from approximately 1935 to 1940. The war interrupted his writing in these notebooks and, for the period before 1935, the many letters that he wrote enabled Saint Exupéry to set out his ideas.

I cannot make people understand how useful they would be if they possessed a language. I cannot explain to those who lived before Descartes how clear the world would appear to them if they accepted certain concepts.

However, they conceive of power in the order of natural phenomena, and they have called science the elaboration of a language which Descartes taught them could prove to be useful. In this area, they accept that different points of view exist, that are suffcient to create order and disorder in the world and that order is only ever a form of language. They conceive of the fact that, in the realm of nature, humans are able to understand certain things. But nobody like Descartes (except for Marx, that is) taught them that this was a much more general truth and that human beings could also understand other human beings.

Human beings consider their economic and social contradictions as absolute, irreducible, and they are indeed so in the order of the language that they speak. I can prove something to people – and they understand me – but I cannot make them understand to what extent that proof has only become possible because of those points of view that we call concepts (MV2, MV, germs, the sun as center, social classes, possible science, etc.). I cannot make them understand that there is no order in nature, but only in humankind, or more precisely, that it is we humans who create order in nature and that the first discovery was to accept that we have the faculty of doing so.

The system that I am proposing would not, in point of fact, be a series of inventions: I [cannot make people understand that there is never an invention (discovery of a previous "law"). In science, man, in some sense, discovers his divinity.]

Zahlas 28 rue Bonaparte.

Left : Precautionary
statement by Saint
Exupéry, to have his
notebook returned to him
in case he misplaced it.

Right-hand page :
Notebook I, no. 17.

« It would take another language »

To enter into the realm of the *Notebooks* of Saint Exupéry is to enter into a reserved space, a secret world, the publication of which the writer would not have agreed to if it had been suggested to him during his lifetime.

And yet, the posthumous publication in 1953, and subsequent revised edition in 1975, of this material makes it possible for one to get to know the man and the writer better, in his doubts and certainties, the direction of his thoughts, and the actual process of writing his works.

Often difficult to decipher, the texts were written wherever he was traveling, in often uncomfortable situations, in a car or even in an airplane. Abbreviations, small doodles or drawings and hasty scribbles make them partly illegible.

But was my concept, my mm'/r^t was it anything other than Paracelsus' analogy? And wasn't science born from the belief in the virtue of the analogy with the (universality) of the human mind (inappropriate word, we should say: the fact that man is the image of God).

Is not what Descartes brought to us a method to validly choose the "analogous points"?

My concepts are purely empirical. It is their usefulness that validates them. Not empirical but arbitrary. I do not prove $1/r^t$ or any other axiom. But the interaction is such that I prove them again (sophism), or, if you prefer, that nature shows them to me (by definition).

But by what means did Descartes, that (clear thinker) make them so useful? Everything is a synthesis, more or less, and never in an insignificant way. Systems of maniacs: they always have all kinds of proofs, but they are infertile, which is the only criterion.

When I come up against the growing complexity of contemporary science, I feel that science is becoming more and more difficult.

And yet, it was even more difficult when people were just beginning the study of nature, which must have been so much more contradictory and confusing for the language that was spoken at that time. It would take another language.

There are no civil concepts, for how would they be cultivated? Unless Hitler spoke of morality and love, which would make him look ridiculous. And without religious cultivation how could there be human relationships that wouldn't be based on force and blackmail?

mais mon concept, mon même espace à
autre chose que l'analogie de Paracelse !
Et la science n'est-elle pas née de la croyance
à la vertu de l'analogie à l'[universalité] de
l'esprit humain (mot imprégné, il pourrait dire :
et le pur homme est à l'image de Dieu.)

Si pour Descartes a apparu n'est-ce pas une
méthode pour choisir valablement les points
analogues » ?

Ils sont purement empiriques, mes concepts.
Ce sont leurs efficacités qui les fondent. Leurs
empiriques mais arbitraires. Je ne démontre
plus $\frac{1}{2}$ ni aucun axiome. Mais
l'interaction est telle que je les retrouverai
(sophisme) ... , ni les rêve, que la nôtre me
les montre (par définition)

mais pour pour moi Descartes, ce monde, les ont-ils
leurs tellement efficaces ?

Du reste synthèse sur ce moins et jamais repos sur le.
Systèmes me maintenir : ils ont nervurés pas mal
se pourra : mais imparties, vite le Descartes ma ...

Quand je me mets à la complexité qui ne sais
quiétuysme ... je vois la raison suprême se rend
qu'lui

Et cependant elle et ainsi ... mais qu'il l'avait on a
alors à celle de la nation ... était autrement
outil ou celui et composé pour la langage alors racb.
Il faudrait un univers en langage?

Nous aurait-il un concept celui-ci ... assumer
seraient-ils ou seraient nés ? A moins que Hitler parlot
à mieux et d'ailleurs apparu voulait universel. Et
sans ... voulaient vaincre universelle qu'
... humanité ... en avaient point força et
chantage ?

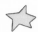

A rectangular parallelepiped whose height is equal to the diagonal of the rectangle of the base is made up entirely of cubic dice whose sides measure 1 cm.
The surface of the rectangle at the base is equal to the product of 311,850 multiplied by an unknown prime number.
Calculate the height of the parallelepiped.

If Colonel Gelée, a former student of the Ecole Polytechnique (Polytechnic University), solves my problem in less than three days and three sleepless nights, I undertake to give him a Parker 51 pen as a present. If he does not solve it in three days, he will give me a present of six packs of Philip Morris cigarettes.

Villacidro, 15 July 1944
Antoine de Saint Exupéry

Problem of the parallelepiped

This problem was posed on July 15, 1944, to Colonel Max Gelée, by Antoine de Saint Exupéry. History does not tell us whether the bet was honored, but one may doubt that it was, since Saint Exupéry went missing on July 31. General Max Gelée later recounted this episode of a friendship that had never cooled, since he had met the writer and aviator as the squadron leader of unit 2/33: "The last time that I saw Saint Exupéry was on July 15. He had come to Villacidro in a P 38. I don't know why, but that day, we had written down our bet. This document had some value, in my opinion; that was why I gave it to the Aviation School in Salon." (*Icare*, no. 96, p. 85.)

Un parallélipipède rectangle, dont la hauteur est égale à la diagonale du rectangle de base, est exactement constitué par des dés cubiques de 1cm de côté

la surface du rectangle de base est égale au produit de 311.850 cm² par un nombre premier inconnu

Calculer la hauteur du parallélipipède

Si le colonel Gelée, ancien élève de l'école polytechnique, résoud mon problème en moins de trois jours et trois nuits blanches, je m'engage à lui faire cadeau d'un stylo Parker 51

Si ne le résoud pas en 3 jours il me fera cadeau de dix paquets de Philipp Morris.

Alghero le 15 juillet 1944

Antoine de Saint-Exupéry

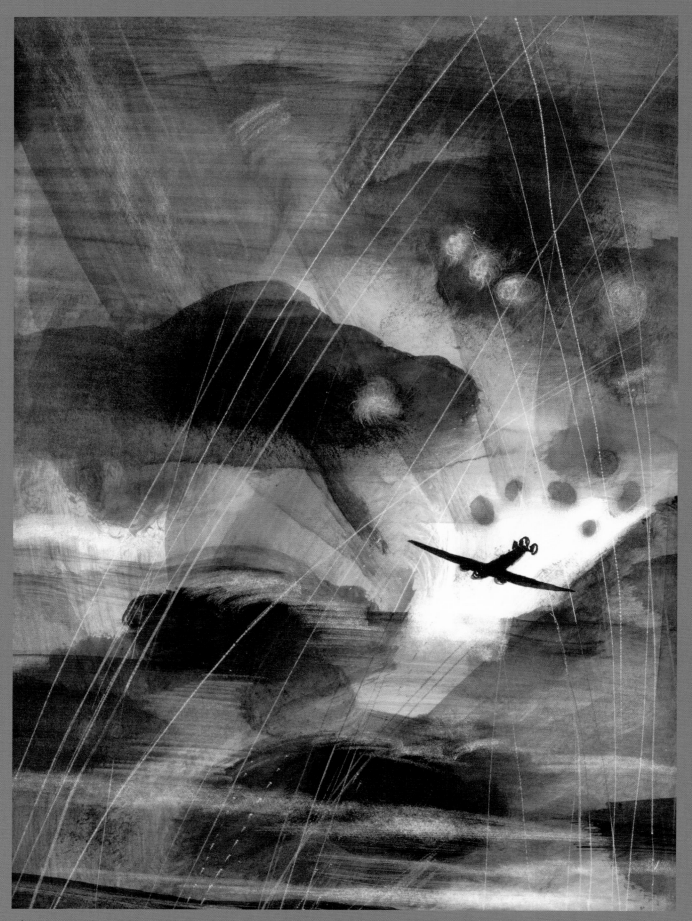

Above : Drawing by Bernard Lamotte for *Flight to Arras.*
Right-hand page : Saint Exupéry. Photograph by John Phillips.

Participation
in the War

« I am suffocating more and more.
The atmosphere of this country is unbreathable.
What are we waiting for, for God's sake?…
If I don't take part in the war, I am morally truly sick.
I have a lot to say about events that are happening.
I can say them as a combatant
and not as a tourist.
It is my only chance to speak. »

On September 4, 1939, on the day after the declaration of war on Germany, Saint Exupéry was sent to the base of Toulouse-Francazal: his mission was to teach aerial navigation. He rejected this posting. "They want to make me into a coach or counselor, not only of navigation, but also of flying heavy bombers. So, I'm suffocating. I am unhappy and all I can do is to be silent… Let me set off in a fighter squadron. I have no taste for war, but I find it impossible to stay at the back and not take my share of the risks," he wrote on October 26, 1939. A month later, on December 3, he was sent to join the 2/33 general reconnaissance unit, based in Orconte, in the Aisne, whose commander was Captain Schunk. He stayed at the home of the Cherchells, who were farmers: "I am living on a small farm where the air does not need to be cooled. In the morning, I break the ice in my jug of water, to wash! We all have large boots as, when it's not freezing, we wade about in mud that comes up to our knees." With his comrades Laux, Gavoille, Israël, Hochedé, Moreau and Dutertre, who would become the heroes of *Flight to Arras*, although they did not know it, Saint Exupéry trained on a Potez 63 fighter aircraft. On December 14, 1939, Saint Exupéry received the Grand Prix for best novel of the year, from the French Academy, for his book *Wind, Sand and Stars*. Joseph Kessel and then Pierre Mac Orlan came to pay him a visit during the month of December, while the planes remained generally grounded because of the cold weather.

However, during the missions, losses were very heavy: "Groups 1/33 and 2/33 have lost, if I am not mistaken, 11 out of 20 or 25 crew teams. They were the only ones who did the work and took the risks. And that sometimes makes me melancholy, in my room."

At the end of February 1940, Saint Exupéry went on a training course at Marignane, near Marseilles, to learn to fly the Bloch 174s, the new reconnaissance aircraft that would replace the Potez in April. As spring came, the German offensive was resuming. Despite the warnings given by observers who could see the German forces regrouping near the French border, the French

Right : Drawing in the margin of notes taken in New York.

government did not make any move. And, in May 1940, it was the German flood that pushed a whole section of the French population out onto the roads of exile: "So I am flying over the routes that are black with the interminable syrup that never stops flowing. They say that they are evacuating the inhabitants."

The missions of group 2/33 increased in intensity and added up to several round-trip flights daily. On May 22, Jean Israël disappeared during a mission over Arras. He was arrested and spent the whole war interned in a prisoner-of-war camp. On May 23, Saint Exupéry, in turn, set off to fly over the city of Arras, to find out whether it was occupied or not.

This mission provided the framework for *Flight to Arras*. Then, there was the retreat, from air base to air base, as far as Bordeaux, from where Saint Exupéry took off for Algiers in a Farman that was so overloaded with men and material that it almost crashed on the runway while landing. Saint Exupéry would have wanted to continue with the war, but the Armistice had just been signed, France had been cut in two and the pilots had been demobilized. Rejecting this state of affairs, he thought that only one nation could help France to get back its unity and its territory: the United States. After spending part of the summer with his family, in Agay, a stay during which he continued working on the book he had begun several years earlier and

which would be his magnum opus, he went to visit Léon Werth in October, to tell him about his intention to travel to America to ask for the country's help. He then traveled to Portugal where, on November 27, he learned of the death of Henri Guillaumet. He set sail for the United States aboard the Siboney and arrived in New York on December 31, 1940. He then began a period of twenty-seven months of exile that was to be difficult, painful and rather inactive.

THE FIFTH AVENUE BANK

OF NEW YORK

IN ACCOUNT WITH

SAFE DEPOSIT VAULTS

Saint Exupéry needed action in order to live: "I am here, undone and provisional. I need to be." In New York, he was criticized both by the supporters of the Vichy regime and by those who worked for De Gaulle, each group reproaching him for not joining them. "Besides, my crime is always the same. I have proved, in the United States, that one can be a good Frenchman, anti-German and anti-Nazi, without saying that the future government of France will need to be led by the Gaullist party."

In fact, Saint Exupéry's strongest desire was not to join either camp, but to see France forget about the factions that were dividing her so that she could be unified again and could regain her former grandeur. He was in near-despair when he realized that the French people living in New York did not understand his message. In order to help him overcome this malaise, his publisher asked him to produce an account of his experiences in France before the defeat and to explain his

Above, left : Bank deposit book used by Saint Exupéry, in New York, in 1942.

country's attitude, which Americans had difficulty understanding. That book, written in memory of his pilot friends who fought with him, in order to spare their people this humiliating invasion, was *Pilote de guerre*, which appeared in 1942, and was immediately translated into English under the title *Flight to Arras*.

Flight to Arras, the first book representing the spirit of the French Resistance, was perceived in America, as the greatest response the western democracies had produced to *Mein Kampf*. The book was instantly a bestseller in the United States. In France, where only two thousand copies were released, it was quickly banned by the censorship authorities. From then on *Pilote de guerre* was circulated and read clandestinely. After the attack on Pearl Harbor in December 1941, and the entry of the United States into the War, Saint Exupéry regained hope, especially at the announcement of the American landings in North Africa in November 1942. At that time, he wrote an appeal to the French people, calling on them to unite and to forget their differences of opinion, by serving under the Stars and Stripes. "They will be very surprised, at the State Department, at the number of Frenchmen who will volunteer to fight for the U.S. And yet, in spite of our reputation, the vast majority of us have only one feeling in the depths of our hearts, our love of their civilization and of their country." "France First" ("D'abord la France") was read on NBC radio on November 29, 1942. It was broadcast by every American radio station transmitting in French, and was published in all the newspapers in North Africa.

Saint Exupéry was asking for only one thing: to be allowed to return to combat. However, he had enough time, before going back across the Atlantic and rejoining 2/33 unit, to write two more books. *Letter to a hostage (Lettre à un otage)* and *The Little Prince (Le Petit Prince)* appeared in

Below and right-hand page: Drawings in the margin of notes taken in New York.

January and April 1943, a few days before Saint Exupéry's departure for Algeria and then Morocco, where he joined his comrades, the French pilots. In spite of his "advanced age" (he was forty-four, the average age of the pilots being thirty), Saint Exupéry learned to fly a Lightning P38 version reconnaissance aircraft. "You fly that monster that is the Lightning P38, aboard which you have the impression, not of moving about in a plane, but of discovering that you have set foot on a new continent." After a second mission, he crashed the plane at the end of a runway and was placed in the flying reserve. Between August 1943 and May 1944, Saint Exupéry dragged his ennui to Algiers. Lodging with Dr. Pélissier, he continued writing his huge book, which would not appear until 1948, with the title *Citadelle (Wisdom of the Sands)*. As he had always done before, he read passages from his book out to his friends, whom he disturbed at any hour of the day or night. Saint Exupéry got very depressed at the idea of feeling that he was being excluded from operations. He launched into a veritable race against the clock in order to be allowed to go back to his general reconnaissance unit and to be able to take part in combat once again. Having pursued General Eaker, the commander of the American forces in North Africa, as far as Naples, he finally got authorization to carry out five missions. He joined his squadron in Alghero, Sardinia. A correspondent for *Life* magazine, John Phillips, was preparing a series of reports on the American soldiers who were based in North Africa. He became friends with Saint Exupéry, who promised him an article. That document was given to the journalist on the morning of May 30 and would not appear in the American press until August 1944. In his *Letter to an*

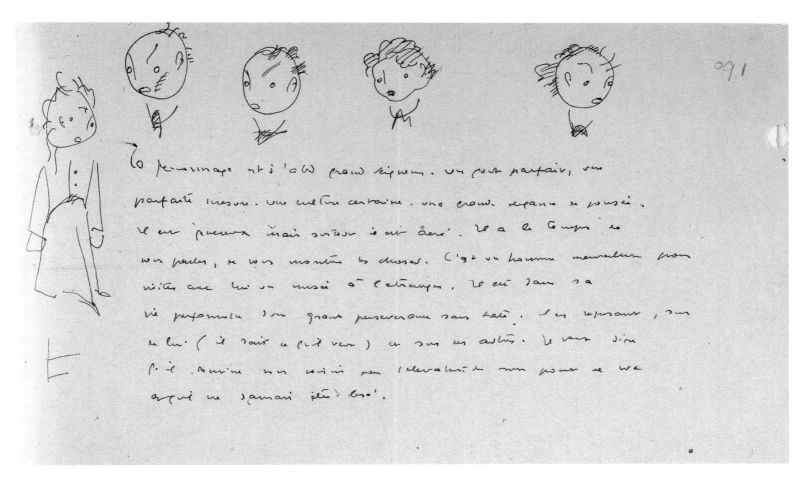

American (Lettre à un Américain), Saint Exupéry thanked the American nation for sacrificing its young soldiers so that the French people could regain their freedom: "Your young people are dying in a war that, for the first time in the history of the world, is for them, in spite of all its horrors, a bewildering experience of love. Do not betray them! May they be the ones who decide that peace is to prevail when that day comes! And may that peace resemble them!"

Saint Exupéry flew not five but eight reconnaissance missions. He always wanted to be present in times of danger. At the end of his final mission, on July 31, 1944, he was to be informed about the forthcoming Allied landings on the coast of Provence and to be definitively instructed not to fly any further missions. But he never came back. He had set off, at the controls of his airplane, without being able to realize the dream that filled his thoughts.

"I shall await the night, if I am still alive, and shall set out, on foot, a little way down the main road that crosses our village, wrapped in my beloved solitude, in order to understand why I must die."

I was profoundly moved, going back to the
Third Flight Squadron of the 2-33 group,
finding the youthful energy, mutual
confidence and team spirit which, in the old
days, made the experience of the old South
American line so valuable for a few of us.
Everything here is like that, and I have a
great fondness, in the squadron, for those
leaders who know how to be young, those
old professionals who know how to be
simple, these comrades who know how to be
faithful, and this quality of friendship
which, in spite of the risks of war, the
muddy fields and the lack of comfort,
enables us to huddle, in the evening, with so
much pleasure, in a simple wooden shed,
around a slightly melancholy gramophone…
I am so happy to be part of the Third.

Antoine de Saint Exupéry
11 February 1940

« I am so happy
to be part of the Third »

Antoine de Saint Exupéry was drafted on September 4,
1939, as a reserve officer in the French Air Force, and
was sent to the military base of Toulouse-Francazal,
where he was given the rank of captain, and attached to
the unit charged with long-distance bombardment.
Saint Exupéry had witnessed the massive destruction in
the Spanish civil war, as a reporter, and he thoroughly
disliked this mission. With the help of the base com-
mander, he managed to get a transfer to a fighter
squadron but he had a long struggle to overcome the
official ban on his flying, as the state of his health (his
left shoulder was practically paralyzed) and his age (39
years) meant that he had been recommended for a desk
job at headquarters.
Through General Davet's intervention, the ban was
lifted and, though he was forbidden to serve as a fighter
pilot, he got permission to fly a reconnaissance plane
and was brought into strategic reconnaissance group
2/33, based 150 miles east of Paris, between the Marne
Canal and Vitry-le-François.

Above, left : Self-portrait
by Saint Exupéry in a
letter to Léon Werth,
whom he tells that he is
leaving for the front.

Right-hand page :
Handwritten text of
February 11, 1940.

J'ai éprouvé une émotion profonde en retrouvant, à la troisième escadrille du groupe 2/33, la jeunesse de cœur, la confiance mutuelle et l'esprit d'équipe qui ont fait autrefois, pour quelques uns, tout le prix de la vieille ligne d'Amérique du Sud.

Tout est semblable ici - et j'estime du fond du cœur, à l'escadrille, ces chefs qui savent être jeunes, ces vieux professionnels qui savent être simples, ces camarades qui savent être fidèles, et cette qualité de l'amitié qui permet, malgré les risques de guerre, les terrains boueux et l'inconfort, de se serrer le soir, avec tant de plaisir, dans une simple baraque de bois, autour d'un gramophone un peu mélancolique...

Avec toute ma joie de faire partie de la 3.

Antoine de Saint Exupéry

le 11 Février 1944

Left : Antoine
de Saint Exupéry, on the
eve of his enlistment.

Right-hand page : *Flight
to Arras.* Typescript with
corrections, preparatory
state, many variants
compared to the
published text.

Military disaster and resistance

The campaign of 1940 was over and the armistice was signed by France and Germany. Having traveled to the United States for a mission that was to last for several weeks, and where he would, in fact, stay for several years, Saint Exupéry decided, in 1941, to write an account of the French campaign, which was to be *Pilote de guerre (Flight to Arras)*. This novel, an homage to his comrades who had been shot down, does not disguise the names of those who sacrificed their lives: Hochedé, alias Dutertre, Pénicot, Sagon; these were the names of his fellow pilots. Similarly, the account of the military defeat and mass exodus of people from the northeast reads like an authentic report by a journalist.

The fact that the book was written in the United States is significant: "The plan to write a book in praise of the heroism of the French Air Force, during the 'phoney war,' and especially of strategic reconnaissance unit 2/33, based at Orconte, one of the pilots of which he had himself been, clearly stemmed from the need Captain Antoine de Saint Exupéry felt to show France the respect and esteem that the United States had for her." (Paule Bounin)

A military disaster is certainly a sad spectacle. Evil men show that they are evil. Looters show themselves to be looters. Institutions collapse. Troops, filled with disgust and fatigue decay into absurdity. A defeat implies all these effects, just as the plague implies open sores. But if a truck runs over the girl you love, will you go around complaining how ugly she was? Some people say: "We cannot replace, in one year, the forty million French people who are missing. We cannot transform our wheatfields into coalfields. We cannot hope for help from the United States. Since the Germans are claiming Danzig, it is our duty, not to save Danzig, which is impossible, but to die in order to avoid shame." What shame is there in owning a piece of land that has on it more wheat than machinery and in the fact that there is one of you instead of two? Why should shame weigh on us instead of on the world? Those logicians were right. Should we have listened to them? I admire the fact that such warnings did not turn France against the idea of sacrifice. I admire the fact that, in our country, the Spirit won out over Reason.

Life always crushes simple formulas. The defeat may prove to be the only path to resurrection, in spite of its unpleasant aspects. I know very well that, in order to cause a tree to grow, I am condemning a seed to decay.

If it arises too late, the first act of resistance will always fail. But it marks the awakening of resistance. From it will date a change in the direction of history. A tree may grow out of it as out of a seed.

France has played her role. For her, it consisted in volunteering to be crushed, since the world was judging without fighting or working, and to see herself buried, for a time, in silence. When you launch an assault, there have to be men who go first, and they are almost always the ones who die. But in order for the assault to take place, the men at the front must die.

~~Mais ce miracle nous ne l'attendons plus. Il est trop tard. Nous~~

~~sommes très sages. Autorthe et moi nous n'espérons aucun miracle.~~

40

~~On se scandalisera surtout de cette débâcle où nous trompons.~~ Mais

le role d'une France acceptant de se mesurer avec trois fois plus fort

qu'elle-meme, ne pouvait être role de vainqueur. Certes une débacle est

triste spectacle. Les hommes bas s'y montrent bas. Les pillards se révè-

lent pillards. Les institutions se délabrent. Les troupes gavées d'é-

coeurement et de fatigue se décomposent dans l'absurde. Tous ces effets,

une défaite les implique comme la peste implique le bubon. Mais celle

que vous aimiez, si un camion l'écrase, irez-vous critiquer sa laideur ?

La France en acceptant la guerre a accepté d'etre enlaidie un temps

par la défaite. Fallait-il qu'elle refusat la défaite, donc la guerre ?

~~La vie dépasse les formules.~~ La défaite peut se révéler le seul chemin

de la resurrection, malgré ses laideurs.

~~du sauvetage.~~ Je sais bien que pour créer l'arbre je condamne une graine

à pourrir.

Le premier acte de résistance s'il survient trop tard est toujours

perdant. Mais il est éveil de la résistance. La bifurcation de l'Histoire

datera de lui. Un arbre peut-être sortira de ~~cette graine.~~ *lui comme d'une graine.*

La France a joué son rôle. Il consistait pour elle à se proposer à

l'écrasement, puisque le monde arbitrait sans combattre ni travailler,

et à se voir ensevelir pour un temps dans le silence. Quand on donne

l'assaut, il est nécessairement des hommes en tête. Ceux-là meurent

presque toujours. Mais il faut, pour que l'assaut soit, que les premiers

meurent.

[note manuscrite, marge gauche :]

Certains nous disaient. "nous ne pouvons pas faire sans l'armée de quarante millions de Français qui nous manquent nous ne pouvons pas changer notre terre à blé en terre à charbon, nous ne pouvons pas espérer l'assistance des Etats unis. Puisque les Allemands revendiquent Dantzig il est de notre devoir non de sauver Dantzig, c'est impossible, mais de mourir pour éviter la honte. quelle honte y a-t-il cependant à posséder une terre qui forme plus de blé que de machines et à à se compter un contre deux ? Pourquoi la honte peserait elle sur nous et non sur le monde."

[note manuscrite, bas de page :]

Les logiciens avaient raison. Fallait il les écouter. J'admire, moi, de la France, que de tels avertissements ne l'aient point détournée du sacrifice. J'admire que l'esprit, chez nous, ait dominé l'intelligence. La vie, toujours, fait craquer les formules. La

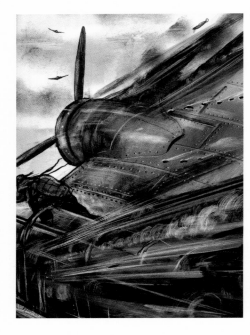

Left : Drawing by
Bernard Lamotte for
Flight to Arras.

Right-hand page : *Flight
to Arras.* Handwritten
manuscript.

The exodus

On May 13, 1940, German tanks crossed the Meuse River and their rapid advance prompted ten million terrorized civilians to take to the roads leading south. When he took off from Orly, at the controls of a Bloch 174, on May 23, in order to "plot the friendly and enemy positions between Arras and Douai," Captain Antoine de Saint Exupéry was on a kind of suicide mission, and it was a miracle that he returned from it safely. The sight of Arras burning transformed him: it was by measuring the full extent of human suffering that he rediscovered his faith in humanity and recognized how blind he had been: "I am not discovering anything new but, as if coming out of sleep, I simply see things once again that I was no longer looking at." He realized that one had to "know how to give before one received and to build a home before one could live in it."

This realization would give birth to *Pilote de guerre (Flight to Arras)*, written in exile and published in the United States in 1942. "I am very happy to be able to declare that I am totally and personally committed to the cause that I know is right," wrote Saint Exupéry in 1943, a few months before he went missing at the controls of his airplane.

So I fly over the roads that are black with the endless syrup that doesn't stop flowing. It is said that they are evacuating the local population. That is no longer true. It is evacuating itself. There is an insane contagion in this exodus. Just where are they going, these refugees? They start walking towards the south, as if there was food and shelter down there, as if there was hospitality, down there, to welcome them. But in the South, there are only towns that are full to bursting point, where people sleep in sheds and where supplies are running out. Even the most generous people there are becoming gradually more aggressive because of the absurd nature of this invasion which is gradually drowning them like a slowly moving river of mud. A single province can not house and feed the whole of France! Where are they going? They don't know! They are walking towards phantom refuges, [for, scarcely has this caravan reached an oasis when there is no longer any oasis.]

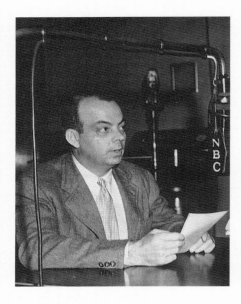

Left : Antoine de Saint Exupéry reading his speech "France first" over the radio.

Right-hand page : "France first," November 1942. Fragment of the handwritten manuscript of the speech.

France first.
The German night has descended on the entire nation. Here is another nation lost in the night with all its lights extinguished. We shall not know anything more about the things we love. We shall not even know the names of the hostages who are being shot.

« France first »

"France first" was an appeal for national reconciliation. This was the first time that Antoine de Saint Exupéry was publicly taking a stand in the political arena.

In October 1942, General Montgomery's troops were forcing the Germans to retreat from Libya. Tripoli would fall on January 23 of the following year. The Allied landings in North Africa, on November 8, prompting the fury of General de Gaulle, who had not been consulted, led to the severing of diplomatic ties between the United States and the Vichy government. It was then that, on November 29, 1942, Saint Exupéry broadcast this appeal, on N.B.C. radio, beginning with the words: "France first". This message was immediately published in English, by *The New York Times* and, the next day, in French, by the Montreal newspaper, *Le Canada*. The appeal was broadcast again on French-language radio, and then reprinted in several newspapers in North Africa. It was aimed at all French people, those in France and also those in other countries.

The manuscript reproduced opposite, is a draft of the first sentences of the message, which would be slightly revised before its publication.

D'abord la France.

La nuit allemande [...] le territoire.

Mais une nation ne peut perdre dans la nuit tous feux
éteints. Nous ne connaissons pas ceux que
nous aimons. Nous ignorons presque nous les
orages [...] La conscience [...]

La nuit allemande

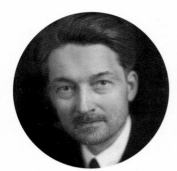

Left : Jacques Maritain in the 1930s.

Right-hand page : Draft of a letter to Jacques Maritain, November 11, 1942. Includes several variants from the published text.

To Jacques Maritain

Saint Exupéry's appeal "France first" did not create the unity among his compatriots that he so desired. Jacques Maritain, the twentieth-century French Christian philosopher, who exerted a wide-ranging intellectual, moral and spiritual influence and authority that would remain strong, was in New York at the time. His positions were close to those of Saint Exupéry, so the latter was shocked by his attitude: the philosopher criticized him for tolerating the Vichy regime to some degree, something that he was not at all prepared to do. For his part, the aviator and writer, like many of the French people in New York, refused to accept all of the declarations of General de Gaulle.

Jacques Maritain, who had heard or read this message, decided to respond to it on December 12, in an article published in *Pour la victoire (For victory)*. Prior to publication, the journal sent Maritain's text to Saint Exupéry, who replied to him in an open letter, in which he repeated that future peace depended on all French people being in basic agreement. A whole generation separated the two men, who analyzed their time and the dramas that were unfolding with conviction and clarity. In spite of a sincere good faith on both their parts, they would never really reach agreement on these issues. The manuscript, one sheet of which is reproduced here, is the first version of this letter. Previously unpublished, it contains several variants compared to the texts of it that have appeared in print.

My dear friend,

I am in despair because of your intervention. I respect and like you tremendously. In my mind you represent decency, justice, disinterestedness and integrity. In spiritual matters, I feel that I am [in total agreement] with you. I have read all of your books with what I must call a kind of love. I give you my word of honor that I am not saying these things in order to please you. I know that such extreme praise might only disappoint you. I write them here because I want you yourself to be the judge of a spiritual disagreement between you and me.

You published a "reply" to me in a newspaper that, for valid reasons that I do not wish to discuss, refused to publish my article. That was its right. But now here you are preparing to attack me before the eyes of readers who will not know what I said. Luckily I don't care about the fact that you are attacking my thesis. I don't possess all of the truth. Anybody can make mistakes in exercising his or her reason. Even if you reproached me for being stupid, I wouldn't care about it. You have a right to that point of view. But it really is the case that because you are immune to spritual attacks your character will play the role of spiritual judge in this debate, that is to say, the role of judge of our intentions.

0749

Mon cher ami

Je suis désespéré par votre intervention. J'ai pour vous
une estime absolue : vous représentez à mes yeux
la droiture, la justice, le désintéressement et la subtilité
[...] J'engage mon honneur sur ce que je ne
lance pas ces mots pour vous plaire. Je sais que
d'aussi brutales louanges ne pourraient que vous
decevoir. Je les énonce parce que je vous fais juge
d'un litige spirituel — et non politique — entre
vous et moi.

[...] me « répondez » dans un journal qu'à [...]
des raisons valables et que je ne [...] discute [...] J'ai refusé
de publier un papier. C'était mon droit, mais mon
[...] à une peine à paraître [...]
[...] le lecteur qui ne raisonne pas ce que j'ai dit. Le
n'est [...] indifférent. On m'attaque une idée : [...]
[...] perd la vérité. Chacun peut se tromper [...]
[...] demain de [...] raison, [...] mais une [...] reproduire
[...] serait indifférent [...]
[...] [...] [...] [...] [...] il ne [...] des votes
[...] — parce que [...]
[...] sans [...]
[...]

Left : Drawing by Saint
Exupéry in the margin of
his manuscript.

Right-hand page :
Unpublished political and
polemical text, some of
the ideas of which were
taken up again in a letter
to André Breton in 1942.
Handwritten manuscript.

But then came New York. I was upset at the
time, because the French people were the
only ones who were opposed to the
resupplying of France. I found there that
old demagoguery that helped to bring about
our defeat. It didn't seem to me that, this
time, it could bring about our victory.
So, in revolutionary times, and to show how
fervent they are, the hard-liners deliver all
their old friends into the executioner's arms.
Oh, people will think that I'm lukewarm…
Well, all those who have ever said a
lukewarm word, I condemn them. And
beneath a mask of passion we cause others
to die. But I think that true passion
expresses itself through actions. I needed to
take part in the war because I was thinking
about the war. I was transferred twice in
order to preserve my precious life. Three
times I managed to have the transferral
rescinded. During the months of May and
June, my own air division, the 2/33, lost
seventeen teams out of 23 and whenever we
had the right to consider ourselves doomed,
I refused to leave. It was just too much to
take.

The French people
who oppose France

This sheet is taken from a long and unpublished polit-
ical and polemical text that evokes some of the themes
Saint Exupéry would write about again in his *Letter to
André Breton*, in 1942. The writer had landed in the
United States on December 31, 1940. In January 1941,
he learned there that, without being consulted, he had
been made a member of the National Council of Vichy.
The New York Times echoed his refusal, of his indigna-
tion and of the riposte that he had published. This
did not please a number of French people living in
New York, including the "pope" of Surrealism, André
Breton, whom Saint Exupéry had known since the
1930s. A polemical exchange took place between the
two men, at the close of which Saint Exupéry sent a
letter to André Breton.

vrai vint new york. [...]
Français [...] la France. [...]

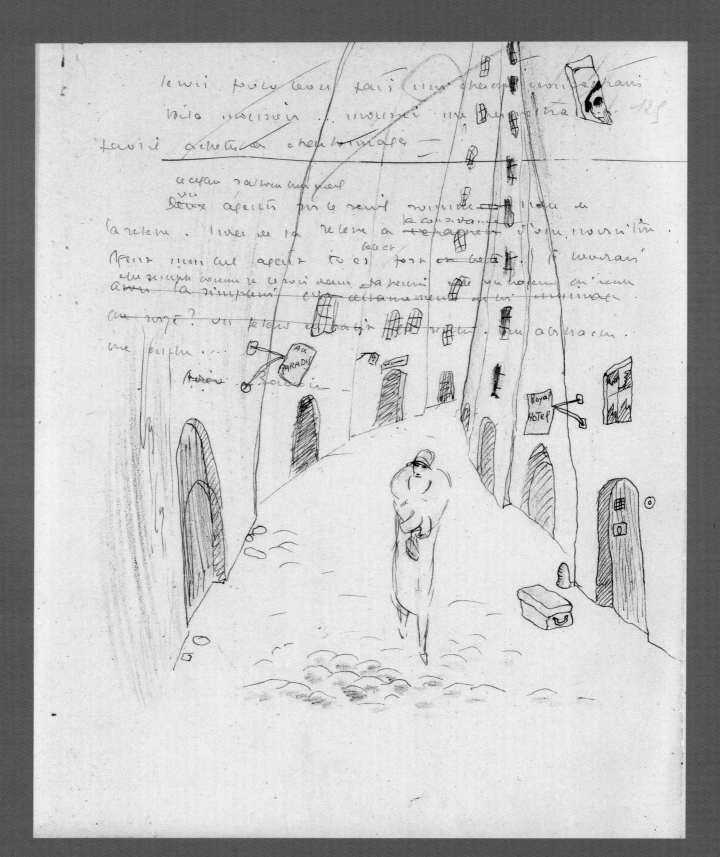

Above and right-hand page : Drawings by Saint Exupéry in the manuscript of *Southern Mail*.

Saint Exupéry
and Women

« And I am waiting to meet a young girl who is
very pretty and very intelligent and full of charm
and reassuring and faithful… so, I don't think I'll find her. »

Below : Drawing by Saint Exupéry on the verso of a page of the manuscript of *Wisdom of the Sands.*

From his earliest childhood, Antoine de Saint Exupéry's world was dominated by women. With the death of his father of a heart attack, when Antoine was less than four years old, the figure of male authority disappeared to be replaced by a number of women, who were very indulgent and none of whom made any attempt to tame the energy of the five imaginative children: Tante de Tricaud, his mother, the various governesses, including Paula and Moisi, the servants, tutors, and the piano teacher, Mademoiselle Anne-Marie Poncet. Antoine's sisters also had an important influence on him: the youngest, Didi, whom he protected as her proud older brother; Monot, who ruled him with an iron hand, but whom he was very fond of because she was extremely resourceful and always ready to take his side against the adults; Marie-Madeleine, who was gentle and often sick. A number of female cousins and Saint Exupéry aunts, who looked after Antoine and François while they were studying in Le Mans and while their mother was traveling, completed this feminine community within which Antoine grew up very happily.

Like all young people at that age, he had crushes on girls that faded quickly: "I cannot understand how I could have been so obsessed by Jeanne for two whole weeks. I believe that she was the first girl who took a real interest in me and that moved my weak heart… Now, I am very annoyed at myself for feeling that short-lived attraction which lowers the esteem I feel for myself. She is the exact opposite of my type."

Saint Exupéry did not experience the shock that young people could eperience when they moved from the calm life in the provinces to the rush and exuberance of Parisian life. Through his family relations, many friendly homes were open to receive him, including that of his cousin, Yvonne de Lestrange, Duchess of Trévise, who invited him to her apartment on the Quai Malaquais and introduced him to the literary world of Paris in 1917. She even gave him a room in the attic so that he could work on his literary efforts in peace and quiet. Saint Exupéry had great admiration for this woman, who was able to recognize her young cousin's literary talents and urged him to give up poetry and concentrate on prose. "I went for a walk on Thursday with Yvonne de Trévise, who is the most charming person I know; she is original, subtle, intelligent, superior in every way, and also extremely kind."

At that time, one young woman would have a great influence over Saint Exupéry's heart, who would be so much under her spell that he even asked her to marry him and, for a time, would be considered her official fiancé. This was Louise de Vilmorin. Why was Saint Exupéry luckier than the many other admirers who appeared before the chaise longue in the Vilmorins' town house on Rue de la Chaise, where "Loulou" received her suitors? Because he was more literary than some? Or was he, in fact, only one of the "pretend fiancés" who gravitated around the young woman? Whatever the case may be, their break up was a painful experience for the jilted aspiring lover. It was especially difficult to accept since he had agreed to give up his profession as a pilot and to settle down to placate the Vilmorins. At the end of 1932, having lost all his illusions, Saint Exupéry was getting bored at the tile factory

of Boiron. He had lost both his fiancé and his prospects of becoming a pilot. After the break up, Saint Exupéry began writing to Rinette de Saussine, whom he had met in 1918 when he became friends with her brother, Bertrand at the Lycée Saint-Louis. A few years older than him, she was part of the group of cousins in whose company he had discovered student life during the war years. It had been she who had introduced him to the Vilmorins. From 1924 to 1927, Saint Exupéry sent to this young lady, whom he called his "imagined friend," letters in which he described his thoughts and feelings. "It may be because I am imagining you that I am so fond of you. Sometimes, however, you conform to your image. In any case, you nurture it. And your musical afternoon gives you a great deal of life, as my friend with whom I'm spending this evening. There is something of an Offenbach about you. You have the color of the lampshades." These letters were published in Paris, by Plon, in 1953, with the title: *Lettres à l'amie inventée (Letters to an imagined friend).*

Between the time when he began to work in 1923 and his meeting with Consuelo in 1930, Saint Exupéry led a solitary life, hoping to find the one woman who could make him happy. Many women were attracted to Saint Exupéry and to what he represented. The aura of a pilot, somebody who braved the elements and always returned in spite of the dangers he faced, and the shyness of this tall man, who was a little awkward especially around women, led them to admire him and to dream of seducing him. Taking his mother as his model, he was permanently anxious and believed that only a feminine presence could cure him of his existential anxiety: "Mama, what I ask of a woman, is to calm down

that anxiety. That's why our need for one is so great. You cannot imagine how heavy one feels and how useless one feels one's youth to be. You cannot know what a woman can give, what she might be able to give."

In spite of this desire to find a kindred spirit and to start a family that would make him feel more stable, Saint Exupéry was afraid of being eaten up by the routine of everyday life. "Yet I don't like people whom happiness has satisfied, like S… and who do not develop any further. One must be a little anxious, in order to read what is around oneself. So, I'm afraid of marriage. It depends on the woman."

Right : The shepherdess from the menu of the Pig, designed for a meal in 1944, in Algiers.

169

He was afraid of everyday life and of routine, and he was to meet a young widow of Salvadorian origin, who was both highly temperamental and spoiled, who would seduce him because, like him, Consuelo Suncin had managed to hold on to the spontaneity of childhood. Married while they were passionately in love, the couple's relationship would quickly disintegrate. Even though their two personalities found it difficult to adjust to each other, they were unable to live far apart from each other for very long. So began a life of break ups, doors slamming, reconciliations, house moves – an exhausting atmosphere for Saint Exupéry, who always carried around with him the image of the gentle and understanding ideal woman. But, despite some aspects of his wife's character, Saint Exupéry had at last found a woman he could protect, like the valiant knights of the stories he read as a child. "It's terrible to leave behind someone who needs me as much as Consuelo does," he wrote in 1936, on the day after he was rescued in the Libyan desert. In order to live peacefully, each of the partners quickly began to lead his or her own life, while still enjoying getting back together and having new disagreements. Consuelo accepted the pretty young ladies who circled around her husband, just as he tolerated the men who showed an interest in his very seductive wife.

In 1929, before he left for Argentina, Saint Exupéry had met a young blonde woman; married to an industrialist, who attended the reading of *Southern Mail* that he gave at Louise de Vilmorin's salon, and who would play a more important role in the life of the writer and pilot. She was the opposite of Consuelo: tall, elegant, refined, intellectual and cultured; she would be the one who would protect Saint Exupéry from his demons. She brought him the reassurance that he needed and that he had always looked for in his relations with women. And yet, it was only after his return from Argentina and once he was himself married that Saint Exupéry established emotional and romantic ties with her that would last until his disappearance, and even beyond it. She was Antoine's muse, even though she knew that Consuelo would always be present in his life. It wasn't that he didn't know how to make a choice between the two. He needed one as much as the other, the practical and realistic businesswoman who supported him in his trials, and the capricious woman-child whom he could look after. Together, they formed a whole. They were never very far from each other. In 1938, after his plane accident in Guatemala, they took turns to be at his bedside. Whenever Consuelo got upset and made a scene, Saint Exupéry telephoned N… so that he could forget his everyday life, which was depressing him and making him suffer more.

In the shadow of these two women, other feminine presences circled around Saint Exupéry, attracted by the great man's aura. They were very young women, platonic friends or possibly more, to whom Saint Exupéry wrote letters. He was sometimes writing to several different ones at the same time.

There were also the wives of his editors, Elisabeth Reynal and Peggy Hitchcock, who helped him out, found an apartment for him, and acted as his interpreters, since Saint Exupéry refused to speak the language of Shakespeare, claiming that he didn't know French well enough.

In the United States, Saint Exupéry made the acquaintance of the actress Annabella, who had played the leading role in the film, *Anne-Marie*. She spent quite long periods of time with him in 1942, when he was in convalecence at Jean Renoir's home in Hollywood after having an operation. Together, they delved into the enchanted world of Andersen's tales. His letters to and from Sylvia Hamilton, to whom Saint Exupéry had presented the first proofs of *The Little Prince*, now in the Pierpont Morgan Library, and then those to Natalie Paley, sent from Canada, have been sold at auction by their heirs. In these intimate letters, Saint Exupéry describes his feelings, speaks of his unease and of the importance that these exciting women had in his life, the life of an exile who was constantly searching for absolute love. Nor should we forget the friendly relations he maintained with Nadia Boulanger, Edda Stern and Nada de Bragance.

All of these women, whom he sublimated into his letters and in his thoughts, and who appear so rarely in his books, apart from Geneviève in *Southern Mail*, Fabien's wife in *Night Flight* and the Rose in *The Little Prince*, lit up Saint Exupéry's life with a gentle glow.

I have had many love affairs, if you can call it love. But I have never misused genuine words. I have never used "my love," "my darling" either in order to seduce or to hold on to someone. I never confused them with mere pleasure. I have often even been cruel by refusing to use them. They may have crossed my lips three times in my life. Even when I liked someone a lot, I used to say "I like you very much", but never "I love you."

Above : The Little Prince looks after the rose on his planet.

171

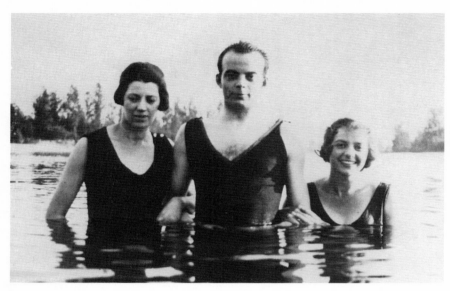

Left: Antoine and two of his three sisters, Simone (left) and Gabrielle (right), bathing in the River Ain in 1923.

Right-hand page and below : Illustrated letter from Antoine de Saint Exupéry to his sister Simone, undated.

Simone

A highly cultured Latinist and historian, Simone de Saint Exupéry, Antoine's elder sister, who had successfully obtained her baccalaureate (high school diploma), was one of the first women to be admitted to the elite French historical and archival university, the Ecole des Chartes.

How did Antoine react? His generation and social class saw young women as irrevocably destined to marry and have children. Simone never married. She pursued a brilliant career as an archivist in Indochina, after defending her doctoral dissertation on the Abbey of Ambronnay, in the Bugey region of France. She lived in Indochina for twenty-five years: in Hanoi, where she supervised the training of local archivists and librarians, and then in Saigon, where she organized the services of the Cochinchine.

Returning to Hanoi, she would publish only technical and practical textbooks, and in order not to interfere with her brother, Antoine's, literary career, she took the pseudonym Simone de Rémens to publish poems and short stories with the title *Météores (Meteors)*.

Following her return to France, she actively supervised the publication of her brother's works, creating the private archives of the National Archive, before her death, in Agay, in the spring of 1978.

Oh my sister,

I shall not hurt you with sharp reproaches as you never fail to do every time something like this happens… Even though this failure is worrying (how many people failed?). You did nothing to help me: you have been punished, that is divine justice.

What I want to tell you is that your path lies not in a severe single life but in the joys of motherhood. Since Mama will receive as lodgers three tall and elegant, well-dressed [intelligent and who come from a country where they don't run after dowries etc., you should come.

You can get one of them. You're not detestable. You are charming, you are witty when you want to be, and you are pretty when you don't pull your head back into your shoulders. Somebody (a man) said to me about you: "she is not one of those women with whom one would not like to sleep"; that's subtly put, that's spontaneous and very tactful.

So, marry one of these Englishmen… – It's a unique opportunity. Be charming, sway your hips and be gracious. You will be an ideal wife and you will leave those manuscripts, that haven't done anything for you, in peace. Believe me, your life will be sweet and fragrant. So, come at once. (Besides, mama wants you to come at once). Your loving brother

Antoine]

Oh ma sœur

Je ne te blesserai pas de reproches pointus comme tu ne
manques pas de le faire chaque fois qu'il m'arrive
quelque chose de ce genre ... Encore ça et cela ça est
vexant (combien de recalés !) Tu ~~n'as rien~~ foutu : tu
es punie , c'est la justice céleste .

Ce que je veux te dire c'est que ta vie est
bien dans un célibat austère mais dans les joies
de la maternité , que maman va recevoir en
pension trois grands anglais élégants , bien mis et

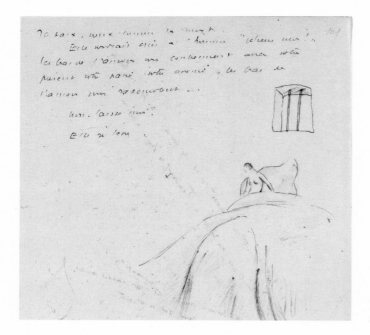

Left and right-hand page: Southern Mail. Handwritten manuscript.

[When he met Geneviève, his childhood friend, everything changed.] But he found Geneviève, his childhood friend. She came to him from the realm of things. She reconciled him with these boulevards, these crowds, these banks. And for a dowry she held out her hand towards the gardens and offered them to Jacques Bernis. She acted as an intermediary [after a thousand divorces in a thousand marriages, a thousand reconciliations after a thousand divorces]. Everything […] her soul. This park was no longer washed, combed [brushed] and weeded out […] dry, this lost rose which walking lovers leave there. [Such negligence by the warden was a victory over life, over empty rules. He was no longer an employee, he became a poet, a man. That negligence revealed the man.] The restaurant's maître d'hôtel, who looked like hundreds of others, recognized Geneviève, she recognized him, and the restaurant was turning into a trap.

Geneviève

Geneviève, the heroine of *Southern Mail*, may well have represented Antoine de Saint Exupéry's ideal woman. Was she Louise de Vilmorin, to whom he was engaged for a short time, and who received, as a present, the manuscript of the novel, which is now at the Bodmer Library in Cologny, Switzerland? Many hints suggest that she was. Was she his little sister, Didi, Gabrielle d'Agay, born a year before their father's death, who is clearly evoked when the writer is describing a terrace (which is specifically the one at Agay) and the surrounding landscape, with its ponds which resound with the croaking of toads? Geneviève is undoubtedly a woman who is idealized through absence and with whom the writer was obsessed, to such an extent that *Southern Mail* is, of all his manuscripts, the one that contains the most descriptions of women, either scribbled in the margin or on the back of a sheet of paper, which interrupts the narrative to give us the portrait of an imagined woman, such as Séléné, who is simultaneously so close yet unapproachable. "And the moon rose…," the writer repeats several times in his novel.

This letter will perhaps appear to be even more stupid and pointless than the last one. But I feel the need for a language that has a meaning. I don't cheat with spring, or with miracles.

All this is very strange for me. Now you can do nothing better than to put a shepherdess's hand on my forehead.

I was lost and unhappy: put me back together again.

I was blind: enlighten me.

I was all dry: make me generous with my love.

Don't hurt me too much if there's no use in it, and save me from ever hurting you.

And be at peace, always.

Antoine

Left : Natalie Paley around 1937-1939.

Right-hand page : Extract from an unpublished letter by Antoine de Saint Exupéry to Natalie Paley, New York, 1942.

Natalie

Antoine de Saint Exupéry's long and enforced stay in New York led him to have a number of friendly and sometimes romantic encounters with young women whom he met through social or professional contacts. Born into the royal family of the Romanovs, Natalie Paley was one of those women. Her presence and her attention reassured Antoine, in his "desire to be pampered like a child and his desperate attempts to behave like a man" (Stacy de La Bruyère). Saint Exupéry explained his feelings to her at length, as well as his doubts about divorce and remarriage and he wrote her affectionate letters, several of which were written on paper bearing the letterhead of the Windsor Hotel, in Montreal, while he and Consuelo were "exiled" in Canada, awaiting the visas needed to return to the United States, where immigration procedures had become more complicated because of the war.

heures. Je suis introuvable et maladroit, mais
tu n'abîmes pas l'amour.

Cette lettre vous paraîtra peut-être plus
stupide encore que l'autre. Et inutile.
Mais j'ai besoin d'un langage qui ait un
sens. Je ne triche pas avec le
printemps. Ni avec les miracles.

Tout cela est bien étrange pour moi.
Maintenant vous ne pouvez rien faire de
mieux que de poser sur moi votre
main de berger.

J'étais seul et malheureux : rassemble
moi.

J'étais aveugle : éclaire moi.

J'étais tout sec : fais moi frileux et
tout amour.

Ne me fais pas trop mal si cela n'est
pas très utile, et sauve moi de n'en
faire jamais.

Et vivez en paix, toujours,

Antony

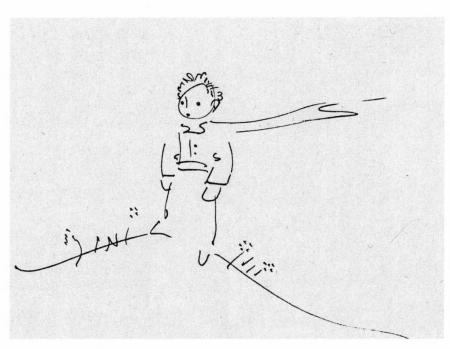

Left : Preparatory drawing for *The Little Prince*.

Right-hand page and below : Extract from an illustrated letter by Antoine de Saint Exupéry to Sylvia Hamilton, Alger, 1944.

You are a very strange person. I read your letters again this evening, Sylvia. Your reproachful letters from the past. (Most often it was you who were right.) Without a language with which to communicate, you understood many things better than other people, with all their words. It's strange, you know, when I think of you I feel enormous gratitude. You are someone I will never be able to forget, as long as I live. I have on my table, here, the small leather suitcase (it hasn't left me) and when I open it I feel a gnawing and a weird gratitude. Ah! Sylvia, I miss the fact that there is nothing for which you can be as grateful to me as I am to you. I wish I had left you something other than the memory of those bitter hours. I am tense, I am often anxious, I am intolerable to live with (especially to myself, Sylvia), but I am neither selfish nor nasty, nor forgetful, nor ungrateful, nor unfaithful. Sylvia, as proof of that I am sending you this letter.
I am the pilot of a P.18 in the Roosevelt Photogroup. High altitude and distant war missions. I hate myself much too much to wish ever to return.

Sylvia

"It was at the begining of 1942 that I made the acquaintance of Antoine de Saint Exupéry at the home of Lewis Galantière, the translator of *Wind, Sand and Stars*," recalls Sylvia Hamilton-Reinhardt. She was born in New York, where she was, at the time, a journalist at Columbia University. She noticed Saint Exupéry's unease at being obliged to stay in the United States, at being unable to fly and being separated from France, which he was certain he could serve usefully. "He was dying to put at the service of France the superior abilities he knew he had."

Their friendship, based both on intellectual and amorous relations, ended when Saint Exupéry left for North Africa, in 1943. "I would like to give you something magnificent, but this is all that I have," Antoine told her before leaving her. "He handed me his old Zeiss Ikon camera and the French manuscript of *The Little Prince*," Sylvia recalled. That manuscript is now in the Pierpont Morgan Library, in New York.

Tu es un personnage bien étrange. J'ai relu ce soir
tes lettres, Sylvia, tes lettres de reproches d'autrefois. (Le
plus souvent c'est toi qui avais raison.) Sans
langage pour communiquer tu as mieux compris
beaucoup de choses que d'autres avec tous leurs mots.
C'est drôle, vois-tu. Quand je pense à toi j'éprouve
un grand mouvement de reconnaissance. Tu es
quelqu'un que je ne pourrai oublier de toute ma vie.
J'ai sur ma table, ici, la petite valise de cuir.
(Elle ne m'a pas quitté) et j'éprouve à l'ouvrir une
sourde et bizarre reconnaissance. Ah Sylvia ça me
manque qu'il n'y ait rien dont tu puisses
m'être ainsi reconnaissante. J'aurais voulu te
laisser autre chose que le souvenir d'heures anciennes.
Je suis tendu, je suis souvent inquiet, je suis
intolérable à vivre (surtout pour moi-même, Sylvia)
mais je ne suis ni égoïste ni méchant, ni oublieux,
ni ingrat ni infidèle. Sylvia je t'en donne
comme preuve cette lettre-ci.

Je suis pilote sur P.38 au Photogroup
Roosevelt. Haute altitude et missions de guerre
lointaines. Je me déteste bien trop pour me
souhaiter de revenir. Je suis bien trop

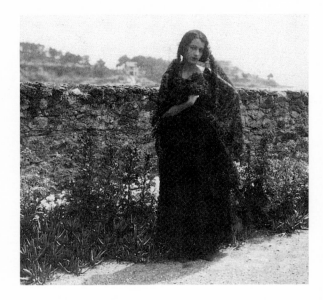

Left : Consuelo, on the day of her marriage to Antoine de Saint Exupéry, still dressed in mourning for her first husband.

Right-hand page : Extract from an unpublished letter to Consuelo.

Consuelo

The beautiful Consuelo Suncin, from El Salvador, was the only woman Antoine de Saint Exupéry ever married. He won her over by taking her on her first flight, in Argentina, in a Latécoère 28. He had already known her for some time. The church wedding took place in Agay, in the South of France, on April 12, 1931, and was followed, on April 22, by their civil wedding in Nice. Consuelo, aged 28 when she met Antoine in Paris in 1930, was dressed in a long black lace dress and mantilla. This was an unusual color for a young bride to wear, but it was explained by the fact that she had recently lost her first husband, the poet Enrique Gomez Carrillo. In spite of their well-known marital disagreements, they separated many times but never got divorced. Their relationship was a blend of passion and irritation. Unable to live together harmoniously for more than a few days, they nonetheless felt pain and irritation whenever they were apart, whether through their own choice or because of circumstances that kept them apart.

Like Mermoz, Guillaumet, and so many other aviators of that exceptional time, Saint Exupéry did not have any children.

Consuelo, little girl, please believe that the letter I sent you yesterday was not meant to hurt you. If you were as intelligent as burnet, a plant in the fields, if you had a really simple heart, you would know how to read in those letters more true affection than in whole litanies of praises!

What do you think I desire, little girl, burnet, if it isn't that you be as pretty as possible – and worthy of yourself, you who are worth so much more than the odds and ends that surround you!

Consuelo, burnet, my beloved, write me a long, calm, cheerful and reassuring letter. You have the sun on your side, you mustn't be too selfish. You must give a little to those who are freezing in the cold. You must write happy letters. You should be like the little stove of my childhood in [Saint-Maurice, which crackled reassuringly in my room when the winter night frosted over the window panes.

I used to wake up and hear the little stove's fat belly humming. I had the impression that I was being protected by that little god of the house – and I used to go back to sleep happy to be alive.]

Consuelo, petite fille, voyez vous ma lettre d'hier
ne voulait pas vous faire de la peine. Si vous
étiez aussi intelligente que la pimprenelle, herbe des
champs, ni vous étiez tout à fait simple de
cœur, vous sauriez lire dans ces lettres là
beaucoup plus de tendresse vraie que dans les
litanies d'éloges !

Que croyez vous que je désire, petite fille,
pimprenelle, sinon que vous soyez la plus
jolie possible — et sûre de vous même, qui
valez tellement mieux que le bric à brac qui
vous entoure !

Consuelo pimprenelle mon amie rassurez moi
par une longue lettre calme et paie. Vous
avez le soleil pour vous, il ne faut pas être
trop égoïste. Il faut en accorder un peu à
ceux qui gèlent par vingt degrés de froid.
Il faut écrire des lettres souriantes. Il faut
être comme le petit poêle de mon enfance, à

Above : Preparatory drawing for *The Little Prince*.
Right-hand page : Antoine de Saint Exupéry, preparing his flight plan, May 1944.

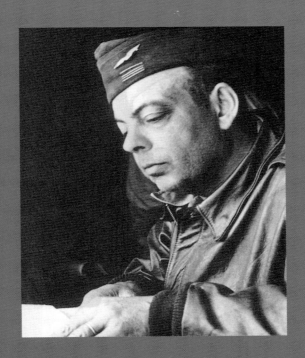

Saint Exupéry
and Death

« That's how life is.
We have enriched ourselves,
we have planted for years,
and then come the years when death undoes that work
and takes our friends away from us. »

Below : « He fell gently,
as a tree falls. »
The Little Prince.

Antoine de Saint Exupéry was confronted with death from his earliest childhood, as he had lost his father at the age of four. That loss does not seem to have disrupted his life too much, at least not at first sight. Nowhere does he evoke the absence of the paternal figure. Nor did he write about his regret concerning the death of his brother François in 1917. If Antoine did feel an immense sorrow, he never alluded to his younger brother, who had died so tragically early, except for a brief mention in *Flight to Arras.* Death was to become a constantly present companion for him, as so many members of his family died before Antoine even reached adulthood: his maternal grandfather in 1907, his godfather and uncle, Roger de Saint Exupéry, in 1914, his paternal grandfather and his aunt Tricaud in 1919. Two of his childhood friends died in Morocco, within one year of each other: Marc Sabran (1926) and Louis de Bonnevie (1927), in the same year as his sister, Biche. There, too, we do not have any record of how exactly he was affected. And yet! "People think I have no heart because I don't express anything, but I shall die of sadness at the past that has been destroyed. At all those pasts that have been destroyed."

In 1918, he was in Paris, preparing for the entrance examination to the Naval Academy. During a night-time air raid, he climbed up onto the roof of the Lycée Saint-Louis, without permission, to watch the fighting. In a letter to Louis de Bonnevie, he wrote about what he saw: "All that they write in the newspapers is rubbish. It's amazing how many deaths there have been… On every side, there are dead people, and again, this evening, a bomb that hadn't exploded yet has just gone off. Many people have died… many were killed near the School of Medicine… many in Belleville… You have no idea." He describes these events with the detachment of a professional who is used to seeing death close up.

When he joined the Latécoère Company in 1926, which was to become Aeropostale, Saint Exupéry knew that he was opting for a dangerous profession and that the mission he was being given obliged him to accept a high degree of self-denial. He was close to death every day, because of the precarious state of the planes that he flew and because of the risks that he encountered while flying over rebel territories, where human life was valued only in terms of camels or rifles. Hostages' lives were not very important when faced with hatred, and mouths that were not necessary to feed were easily disposed of. Saint Exupéry displayed a certain ironic detachment in the face of death that was never far off: "They killed two of our pilots last year (out of four)

and, for miles, I had the honor of being shot at like a partridge." After the desert, flying over Patagonia, crossed by violent winds, and over the snow-covered Andes, was a new way in which Saint Exupéry was confronting the elements and the dangers they represented. The pilots sometimes fell victim to the wind or snow. Lost on the Laguna Diamante, Guillaumet had been obliged to gather up all his strength in order not to allow himself to die of cold in the Andes. "You only had to close your eyes to bring peace to the world. To wipe the rocks, the ice and the snow from the world." Saint Exupéry evokes the death of a pilot, in *Night Flight*, not as a violent break, but as a gradual forgetting of small daily pleasures. "For this woman, too, Fabien's death would barely begin tomorrow, in every action that would be pointless, from now on, in every object, Fabien would slowly leave his house."

But it was absence, rather than death itself, that seemed to cause anguish in Saint Exupéry's heart: "We don't ask to live forever, but only not to see actions and things suddenly lose their meaning. The void that surrounds us shows itself at such moments."

Three airplane accidents forced Saint Exupéry to confront death. First, in December 1933, when an error of judgment made him set down the hydroplane he was flying a little too abruptly in the bay of Saint-Raphaël. The plane gradually filled with water and sank beneath the sea. Saint Exupéry, stuck in the nose of the aircraft, submitted to the torpor that surrounded him. "In fact, death does not at all have the unpleasant aspect that we attribute to it," he admitted, once he had been pulled out of the cockpit. In the course of his accident in the Libyan desert, on December 30, 1935, he saw death close up,

because of water, once again, but this time because there was none at all around him. At the time, he believed that his life was over: "Farewell, those I have loved. It's not my fault that the human body cannot survive for three days without anything to drink. I did not think that I was, to such a degree, a prisoner of wells. I did not suspect that my independence was so short-lived. We believe that man can go off ahead right in front of him. We believe that man is free… We don't see the rope that binds him to the well, attaching him, like an unmbilical cord, to the bowels of the earth. If he takes one more step, he will die. Apart from your suffering, I do not regret anything. All in all, I have been lucky. If I returned home, I would begin again. I need to live."

His third serious accident took place in February 1938, in Guatemala. His airplane, had too much fuel on board; it could not take off and crashed at the end of the runway. After three days in a coma and surviving serious injuries, Saint Exupéry slowly learned to live again, in spite of the after-effects, which caused him pain for many years. He had never been so close to death. He never spoke of that last accident.

In 1936, as a war correspondent in Madrid and Barcelona during the Spanish Civil War, Saint Exupéry witnessed several mock trials, followed by immediate executions: "Here, a man is simply placed against the wall and his innards fall onto stones. We caught you. We shot you. You did not think as we do…" He was outraged at the lack of respect for human beings and at all the deaths that this fratricidal war had caused: "Here they shoot people, as they clear forests." Nothing was more intolerable, in his eyes, than to see one man decide the death of another.

Saint Exupéry experienced the death of his

Above : Unpublished drawing by Saint Exupéry.

friends, who disappeared one by one, as if they were abandoning him. Mermoz disappeared over the sea on December 6, 1936. For a long time, Saint Exupéry refused to believe that he had died. Then he resigned himself to it: "Mermoz. His dead man's face does not hurt us any more, does not draw tears from us, but we miss his presence more and more profoundly, more and more seriously, as we would miss the presence of bread. The longer we do not hear his clear laughter, the more we begin to ask ourselves, not in the language of the mind any more, but in the language of our most basic reflexes, in the rush of our oldest habits: 'So where is he?' It is today that our mourning begins, because we are hungry."

In his turn, Guillaumet disappeared over the sea on November 27, 1940: "Guillaumet is dead… It seems to me, this evening, that I have no friends left. I do not pity him. I have never known how to pity those who have died, but as for his disappearance, it will take me a long time to learn to accept it – and I already feel so heavy because of this terrible responsibility. It will take months and months; I will need him so often…' I believed that this only happened to very old people, that they sowed all their friends along their path, all of them."

The War that broke out in 1939 would give him the opportunity to come face to face with death. As a reconnaissance pilot in 2/33 squadron, he was to see his comrades fall one by one: "In three weeks, we have lost seventeen teams of crew out of twenty-three. We have melted away like snow in the sun… Everything is breaking up around us. Everything is collapsing. It is so complete that death itself appears absurd. Death itself is lacking in seriousness, amidst all this mess…"

After the signing of the Armistice, after his exile in New York, Saint Exupéry wanted to go back into the services and fight the enemy who had reduced his brothers to the state of hostages. He knew that each departure could be his last: "I almost remained there four times. That is something that I am absolutely and completely indifferent to."

In his final letter, dated July 30, 1944, which he left on his table on the very morning of his departure, he displayed a weariness that many people would interpret as discouragement: "If I went down, I would regret absolutely nothing. The termite hill of the future scares me. I hate their virtue, which is like that of robots. I, myself, was born to be a gardener." These few words, which everybody can interpret how they wish, because he is no longer here to explain them, form a kind of counterpoint to those spoken by the luminous little character he created. At the moment when he is leaving, the Little Prince, in order to reassure his friend, the pilot, tells him: "I shall appear to be dead, and that will not be true."

Right-hand page:
Unpublished drawing by Saint Exupéry.

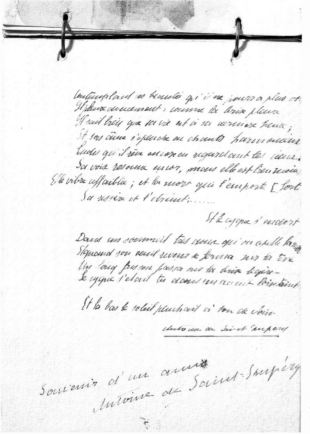

Left and right-hand page : Poem by Antoine de Saint Exupéry, 1914.

The swan has injured himself; his red blood colors
The splendor of his being; he raises himself up again
And with a last effort, still trembling
He clings to life; and wants to live out his days.
He lifts his neck; from his trembling throat:
He sings only a heavenly song, which resembles
The song of a man; he has something human:
It is his last effort; it is death, it is the end!
He shakes, sad and gentle, melancholy and serious;
He bends down, very beautiful, rises in gentle song.
Already his eye is cloudy and his body weakens
But he is still singing and in all that he says
A great sorrow arises: because he is giving up
His waters which he loves so much;
their monotonous dream;
His water lilies bowing before the evening breeze.
Contemplating these beauties
which he won't be able to see any more
He weeps softly; as the showers wept
He knows that this is the last hour of his life;
And his soul is expressing itself in harmonious songs
While he is still dreaming as he looks at the sky
His voice is still sounding, but it is much weaker
It sings weakened; and death which takes him away
Hugs and clasps it; …

And the swan falls asleep
Into a very gentle sleep which is called death
And when his dreamy eye closed on the earth
A long shiver passed through the light breeze
The swan fell silent in a distant accent.
And over there, the sun was going down.

« Death of the swan »

"Death of the Swan" is one of the poems that Antoine de Saint Exupéry wrote and illustrated in the drawing notebooks of his De Sinéty cousins; in this case that of the blonde Odette, who was two years older than him and with whom he was in love. Inspired by the kinds of things in nature that had inspired Lamartine and Vigny, Antoine found Romantic accents to evoke the swan's agony and death.

Odette de Sinéty would later confirm Antoine's love for nature: "He could spend long periods observing a fly or a butterfly. He felt the greatest sympathy for all animals. He would never have harmed one and, seeing a bird hopping about, he used to say: 'I wonder what's going through its mind right now.'" (Curtis Cate, *Antoine de Saint Exupéry, laboureur du ciel*)

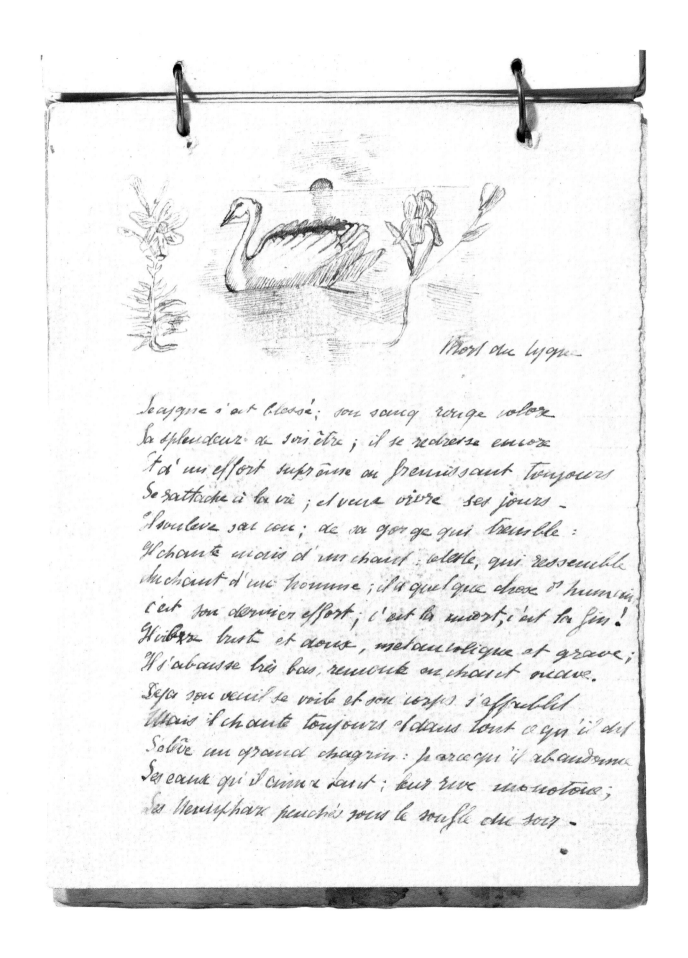

Mort du Cygne

Le cygne s'est blessé; son sang rouge colore
Sa splendeur de son être; il se redresse encore
Et d'un effort suprême en frémissant toujours
Se rattache à la vie; et veut vivre ses jours -
Il soulève son cou; de sa gorge qui tremble:
Il chante mais d'un chant... qui ressemble
Au chant d'un homme; il a quelque chose d'humain
C'est son dernier effort; c'est la mort, c'est la fin!
...triste et doux, mélancolique et grave;
Il s'abaisse très bas, remonte en chant suave.
Déjà son œil se voile et son corps s'affaiblit
Mais il chante toujours et dans tout ce qu'il dit
S'élève un grand chagrin: parce qu'il abandonne
Ses eaux qu'il aime tant; but rive monotone;
Les nénuphars penchés sous le souffle du soir -

Left : François de Saint Exupéry on his deathbed at Saint-Maurice-de-Rémens. Photograph taken by Antoine, July 10, 1917.

Right-hand page : *Flight to Arras*, preparatory state. Typescript with corrections.

The death of François

Two years younger than his brother Antoine, François was his partner in every game, the companion of all his discoveries and of his schooldays at Saint-Croix, in Le Mans, in Mongré and in Fribourg. He was the most handsome of the Saint Exupéry children, was gifted with a sense of humor and of repartee, and was capable of resisting his older brother's dominant influence over him. He had a talent for music, playing the cello and composing tunes from his childhood.

The freezing cold winter of 1916-1917 ruined his health. Afflicted with rheumatoid arthritis, for which there was no treatment at the time, his health got worse and worse until he died, in July, in Saint-Maurice-de-Rémens. He had made a will, leaving a steam engine, a bicycle and a rifle to Antoine. His death would have a lasting effect on Antoine, even though he mentioned it very seldom in his letters, with the exception of one letter to his mother, in 1918: "If only I were with a friend, de Bonnevie, for example, we could talk about François and it would be just a little bit less burdensome to be away from you at this time."

Apart from the fabulous disappearance of the Little Prince, three other children die in the course of Saint Exupéry's books: Geneviève's child in *Southern Mail*, François in *Flight to Arras* and Ibrahim's child in *Citadelle (Wisdom of the Sands)*.

At the age of fifteen I received my first lesson: a brother younger than I had, for several days, been considered about to die. One morning, at about 4 am. his nurse woke me up:
– Your brother is asking for you.
– Is he feeling bad?
She did not reply. I hastily got dressed and went to my brother.
He said to me in a normal voice:
– I wanted to speak to you before I die. I am going to die.
A fit of nerves paralyzed him and made him silent. During that fit he gestured "no" with his hand. And I did not understand the gesture. I imagined that the child did not want to die. But, when he had calmed down, he explained to me:
– Don't be afraid… I am not suffering. It doesn't hurt. I can't help it. It's my body. His body, foreign territory, already different. But he wanted to be serious, that young brother who would die in twenty minutes. He felt the pressing need to assign himself in his inheritance. He said to me: "I would like to make my will…"

se trouve. Ceci n'est point du reve de moraliste. C'est une vérité

usuelle. Une vérité de tous les jours. Mais qu'une illusion de tous les

jours couvre d'un masque impénétrable. Comment eussè-je pu prévoir,

tandis que je m'habillai, et éprouvai la peur pour mon corps, que je me

préoccupais de pacotilles. Ce n'est qu'à l'instant de rendre ce corps,

que tous, toujours, découvrent avec stupéfaction combien peu ils tiennent

au corps. Mais certes au cours de ma vie, lorsque rien d'urgent ne me

tient, lorsque mon corps n'est pas en jeu, je ne conçois rien de plus

important :

J'ai reçu à seize ans ma première leçon : un frère de quinze ans

était grièvement malade. Un matin vers quatre heures, son infirmière me

réveille :

- Votre frère vous demande.
- Que se passe-t-il ? [Elle ne répond rien. Je m'habille en

hate et rejoins mon frère.

Il est tout blanc, éclairé par une faible lampe. Il me dit d'une

voix ordinaire :

- Je voulais te parler avant de mourir. Je vais mourir.

Il se tait longtemps, puis une crise nerveuse l'agite. Durant la

crise il fait "Non" de la main. Et je ne comprends pas ce non. J'imagine

qu'il refuse de mourir. Mais, l'accalmie venue, il m'explique :

- Ne t'effraie pas ... Je ne souffre pas. Je n'ai pas mal. Je ne

peux pas m'en empecher. C'est mon corps.

Son corps, territoire étranger, déjà autre.

Mais il désire etre sérieux, ce frère de quinze ans, qui sait bien

que l'on rédige des testaments. Il fait le partage de ses biens. Il me

[The Farewell

A departure is always sad but this departure
Seems truly marked by a special sadness
François Coppée

Your song goes away and I remain…
Barbusse]

Before the farewell

So, it is true ? You are going ?
You see, that seems strange to me…
What! I won't have your shoulder any more
To rest on when I am weary!

Gaily you will sing there:
Life, after all, is only a role.
… Like a prisoner in his gaol
Discreet, I shall weep quietly…

Slowly, I shall forget, no doubt
In order to wait for a long time by the road
One would have to believe in the old love…

And my heart, weary of its tumult
Will be like a temple with no service
– Sad – where daylight might fail.
[…]

Left : Drawing
illustrating *The Farewell.*

Right-hand page : Extract
from *The Farewell.*
1925 (?), illustrated
handwritten manuscript.

The Farewell

A youthful text, written around 1925, *The Farewell* is
made up of five illustrated poems by Antoine de Saint
Exupéry, which Michel Autrand has analyzed percep-
tively: "The familiar tone, the weary and casual non-
chalance, in the style of Jules Laforgue, the repeated
variations on the theme of death and forgetting are
enough to make these pieces interesting. But what is
most striking, in the manuscript, is the care with which
each page has been written and decorated. An artificial,
vertical and lengthened hand transforms Saint Exupéry's
usual writing style into a garland of foliage that pre-
figures the fine 1900-style ink drawings adorning two
or three sides of the pages. The whole thing is a minor
masterpiece that is deliberately old-fashioned and has
such a perfect coherence that drawing, writing-style
and inspiration are indistinguishable in it. The same
thing would be true of *The Little Prince.*"

Avant l'adieu !

I

— Alors c'est vrai ? Tu t'en iras ?
Vois-tu cela me semble drôle...
Quoi ! Je n'aurai plus ton épaule
Comme appui quand je serai
 las !

Gaiment tu chanteras là bas :
La vie, après tout n'est qu'un rôle.
........Tel un prisonnier dans sa geôle
Discret je pleurerai tout bas......

Peu à peu j'oublierai sans doute
Pour guetter longtemps sur la route
Il faudrait croire au viel amour....

Et mon cœur las de son tumulte
Sera comme un temple sans culte
— Triste — où défaillerait le jour

I do not know of anything more tragic than delay. A comrade does not land at the time he was supposed to. The other one, who was supposed to arrive, signal his arrival by a message, remains silent. And when ten minutes have gone by, whilst in ordinary life you wouldn't even have the impression that you had been waiting at all, suddenly everything is blocked. Fate has made its appearance. It holds some men in its power. A judgment has been pronounced upon them. Fate has already judged them and we are holding our breath. We are no longer free. An iron hand has decided.

Left : Jean Mermoz.

Right-hand page : Extract from *The Farewell to Mermoz.*

The death of Mermoz

Jean Mermoz became a legend on December 7, 1936, when he went missing at the controls of "The Southern Cross." Born on December 9, 1901, Jean Mermoz wanted to become a writer or a sculptor but, at the age of 19, he joined the French Air Force. After a mission in Syria lasting 18 months he was invited to join the Latécoère Company, for whom he flew planes between Barcelona and Malaga, and then Casablanca and Dakar. In 1927, Jean Mermoz was sent by Pierre Latécoère to Rio de Janeiro, as chief pilot, in order to develop new lines in South America. On January 30, 1930, he left South America, leaving the responsibility for those lines to his friends: Brazil to Etienne, Paraguay to Reine, the routes across the Andes to Guillaumet and Patagonia to Saint Exupéry. This may explain the restrained and rather formal style that the writer used to evoke the memory of the lost aviator after his death.

As for me, I think, like a peasant, that the existence of France matters. In spite of its errors, in spite of its weaknesses, in spite of its failures, France. There is still something permanent about her that has not had the opportunity to express itself, which felt itself, not betrayed – I really don't believe in betrayal – but drowned in the absurd. Unused. And those people were ready to die but they wanted their death to become a cement. It's a bitter thought, to think that you are giving your life for a fire of straw. May death build you up.

Do you believe that one can die with impunity for nothing? And yet, that absurd thing is what we had accepted. And so, I imagine, had many others apart from ourselves. Obediently. As one accepts a pill. One was dying in order that there be more deaths…

Left : Draft in ink of a drawing for *The Little Prince*, 1940.

Right-hand page : Extract from an unpublished handwritten manuscript of a political and polemical text.

« May death build you up »

All his life, Antoine de Saint Exupéry had reflected on death. World War II brought back those obsessions in a compulsive manner. He asked himself questions about its absurdity while admitting the unavoidable character of death and man's impotence when facing it. In his submission to what could not be avoided, he attempted to give a meaning to the sacrifice that was required or imposed by conflict.

In the opinion of those who knew him in the United States or in North Africa, these reflections regularly brought him to the point of despair and to the acceptance of death, because of a disgust with life. "We have to admit that Saint-Exupery no longer had the will to live," declared one of his friends who had met him in 1944, and who had been struck by his weariness and disenchantment. This attitude would seem, wrongly, to support the theory that his disappearance was, in fact, a suicide.

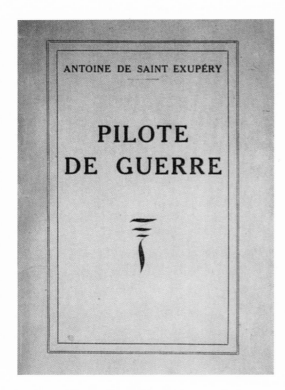

Left and below : In France, two versions of *Flight to Arras* were published, one for the occupied and one for the unoccupied part of the country.

Right-hand page : Extract from *Flight to Arras*. Typescript with handwritten revisions, several variants compared to the published text.

« These sacrifices have a meaning »

The sacrificing of one's life and the acceptance of that sacrifice were compatible with the outlook of Antoine de Saint Exupéry, who believed that dying for the cause of France fit in with his own ideas and with what was expected of a man of his education and background. Had his friends and his comrades not already given their own lives for that cause?

John Phillips, who stayed with him in Alghero, in Sardinia, during the month of May 1944, remembers: "I can recall our meeting. When he evoked the memory of his two closest friends, Mermoz, who had disappeared in the South Atlantic and Guillaumet, who had been shot down over the Mediterranean, he confided in me, saying: 'I am the last survivor. I assure you that that makes a very strange impression on me.'"

And so, at the same time as you are asking the United States: "Why are they not dying in greater numbers?" I am asking myself, as I watch crews leave and being annihilated: "What are we giving ourselves up to; who is paying us?"

Since we are dying. Since two hundred thousand have died. Perhaps those deaths do not illustrate an extraordinary resistance. It is impossible. But there are certain kinds of people who sacrifice everything. There are units of infantry that get themselves massacred in an indefensible farm. There are air squadrons that melt like wax when it's thrown into a fire. That is the expression of something!

As episodic, as drowned in the havoc of the retreat as these sacrifices may be, they do have a significance. These representatives are the delegates of the nation. They are its fruit, as apples are the fruit of the apple tree. If even individual terrorist attacks follow each other in a region, they prove the tense feelings of an entire population. The sacrifice of two hundred thousand lives, freely given, though without hope, are also signs that have value for an entire people. We are signs. We are fruit. Two hundred thousand fruit.

XXII

Je ... je ne savais pas. J'observais cette bataille de fleurs,
je n'ai pas vu s'accumuler dans le silence ces matériaux sombres. Les
nuages me dominent ici de très loin; absorbé par le tir je n'ai pas
remarqué qu'entre eux et moi s'édifiait ce tribunal où je m'agiterais
en vain. A l'échelle de ses perspectives démesurées je suis immobile.

Celui-là éprouve le poids du silence, qui reconnaît trop tard une
conjuration. Il se croyait seul, le rideau tombe. Mille conjurés, les
bras croisés, le regardent et se taisent.

Les traçantes versaient une lumière de blé, et c'est à mon insu
qu'au sommet de leur ascension elles distribuaient, comme on plante des
clous, ces flocons noirs. J'ignorais que déjà fussent entassées des
pyramides vertigineuses, et installés, plus haut encore, ces congrès
de vautours. J'ignorais que le fourmillement des coups de lances était
signe d'un charroi invisible; et que des milliers de blocs sombres avaient
déjà chu dans le ciel comme dans un chantier.

D'un coup tout s'est montré. Je suis noyé dans un décor monumental.
Je progresse à la base de pyramides qui défilent avec une lenteur de
banquise. Je mesure des yeux le piège immense que l'on bâtissait pour
moi seul, dans le silence, tandis que je m'inquiétais de jeux de lumière.

I, myself, take part in the war as meaningfully as possible. I surely am the most senior fighter pilot in the world. The age limit is thirty, on the type of one-seater fighter plane that I fly. And the other day, one of my engines broke down, at 30,000 feet, over Annecy, at the very hour when I was turning forty-four! Whilst I was rowing over the Alps with the speed of a turtle, at the mercy of [the whole German pursuit, I chuckled at the thought of those ultra-patriots who ban my books in North Africa. That is funny.

I have experienced everything since my return to the squadron (that return was a miracle). I have had breakdowns, I have fainted through lack of oxygen, I have been pursued by fighters, and I have even had a fire on board and in flight. I don't believe I'm too miserly and I feel that I'm a healthy carpenter. That is my only satisfaction! And also, to fly solo in the only airplane, for hours at a time, over France, taking photographs. That is strange.

Here, one is far from the sea of hatred but, in spite of all the kindness in the squadron, it's still, to some extent, the old human misery. I never have anybody to talk to. Having someone to live with is a very good thing. But what intellectual and spiritual solitude!

If I had gone down, I would have regretted absolutely nothing. The termite hill of the future scares me. And I hate their robot-like virtue. I, myself, was born to be a gardener.

I embrace and hug you.

Saint Ex]

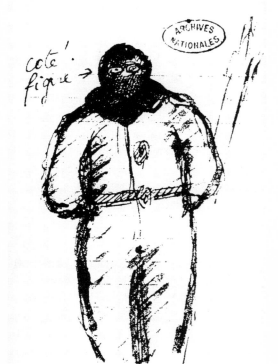

Left : Self-portrait of Saint Exupéry as an aviator, drawn in a letter to his mother, 1921.

Right-hand page : Extract from a letter to Pierre Dalloz, July 30, 1944.

« If I had gone down… »

This letter was written by Antoine de Saint Exupéry to his friend Pierre Dalloz, an architect, whom he had met in 1939, and whom he had seen again in Algiers. The quite specific circumstances of this letter, possibly the last one he ever wrote, give it the status of a kind of last will and testament. The hand of Fate appears in this evocation of his death, written so soon before his disappearance.

That disappearance was recounted in very stark and simple terms in the *Journal of the Activities of the 2/33*, dated July 31, 1944: "A very sad event is casting a shadow over the joy that everybody is feeling at the approaching Victory. Captain de Saint Exupéry has not returned. Having left at 0900 hours for Savoy, in his 223, he did not return at 1300 hours. Radio calls to him have not been answered and the radar stations that were alerted have looked for him in vain. At 1430 hours, there was no longer any hope that he was still airborne."

E II 190

Secteur postal 99027

Cher cher Dalloz que je regrette vos quatre lignes! Vous êtes
dans doute le seul homme que je reconnaisse comme tel
sur ce continent. j'aurais aimé savoir ce que vous pensiez des
temps présents. moi je désespère.

J'imagine que vous pensez que j'avais raison sous tous les
angles, sur tous les plans. Quelle odeur! Fasse le ciel que
vous un souvenir tout . que je serais heureux de votre
témoignage!

moi je fais la guerre le plus profondément possible. Je suis
ici le doyen des pilotes de guerre du monde. La limite d'âge
en de trente ans sur le type) j'aurais inauguré de chasse
que je pilote. Et l'autre jour j'ai eu la panne d'un moteur, à
dix mille mètres d'altitude, au dessus d'Annecy, à l'heure
même où j'avais ... quarante quatre ans! Tandis que je
ramais sur les Alpes à vitesse de tortue, à la merci de

Then the agony begins, which is merely the wavering of a consciousness that is, in turn, emptied and then filled up again by the tides of memory. They come and go as the tides ebb and flow, bringing back, just as they took them away, all the supplies of images, all the shells of memory, all the conches of all the voices we have heard. They come back up, they bathe the weeds of our heart once more and all our affections are re-ignited once again. But the equinox prepares its definitive flow; our heart is emptied and the tide and its supplies go back to God.

I have certainly seen men fleeing from death, seized in advance by the confrontation. But as for the person who is dying, make no mistake: I have never seen him be terrified.

Left : Drawing in the margin of the manuscript for *Wisdom of the Sands.*

Right-hand page : *Wisdom of the Sands.* Handwritten manuscript.

« The agony begins at that time »

"I shall appear to be dead and it will not be true," the Little Prince tells the aviator in the desert just before finding the snake again. This serenity in the face of death, which marked Antoine de Saint Exupéry's last years, had been transmitted by him to his friends, who were therefore not too surprised when he went missing. "He had been saying goodbye since 1942," writes his biographer, Stacy de la Bruyère. "During his last meeting with Fleury, in New York, at the end of the year, he bade him farewell with a handshake and this comment: 'And if I disappear, be quite sure that I shall have no regrets.'" Anne Lindbergh, one of his closest friends during his stay in America, had also been expecting the news of his death for some time: "He wanted to make the supreme sacrifice," she wrote. "He went back to look for it." And an officer who saw him regularly in Algiers suggested: "It's better like this. He has found relief."

French Line à bord, le

[Handwritten letter in French cursive, largely illegible]

Chronology

1900

Antoine Jean-Baptiste Marie Roger de Saint Exupéry, is born on June 29, at 8, rue Peyrat, in Lyons, France. He is the third child (after two daughters: Marie-Madeleine, born in 1897, and Simone, born in 1898) of the Vicomte Jean de Saint Exupéry and his wife, Marie, née de Fonscolombe.

1902

Birth of François, brother of Antoine.

1903

Birth of Gabrielle, third and only younger sister of Antoine.

1904

Death of Jean de Saint Exupéry. The family spends the winter at the Château de la Mole (Var).

1908

Antoine enters the third grade at Christian Brothers' school, in Lyon.

1909

Marie de Saint Exupéry moves to Le Mans, in northwestern France, in order to be close to her husband's family. Antoine enters fourth grade, as a day pupil, in October at the Jesuit elementary and high school of Sainte-Croix, which he and his brother will attend until 1914.

1911

Antoine makes his First Holy Communion at Sainte-Croix (May 25).

1912

Defying his mother's will, Antoine takes his first flight from Ambérieu, in a Berthaud-W, airplane, piloted by Gabriel Wroblewski-Salvez (end of July).

1914

Antoine creates an ephemeral class journal, *L'Echo des Troisième*. He receives the prize for the best French composition of the year, for "The Odyssey of a hat."
At the beginning of the school year, Antoine and François become boarders at the Jesuit high school of Notre-Dame de Mongré (Villefranche-sur-Saône), in order to be closer to their mother, who is supervising a military infirmary at the railway station in Ambérieu.

1915

Experiencing difficulties at the high school in Mongré, Antoine and François go back to complete the school year at Sainte-Croix, in Le Mans (February). From November, they are boarders at the Marianist Fathers' high school at the Villa Saint-Jean in Fribourg, Switzerland.

1917

Antoine passes his baccalaureate (high school graduation) examinations (June). Death, in July, of his brother, François de Saint Exupéry, of rheumatoid arthritis. Antoine spends his vacation in Carnac. Antoine enters the Lycée Saint-Louis, in Paris, while boarding at the Ecole Bossuet, in order to prepare for the entrance examination to the French Naval Academy (October).

1918

Because of the War, Antoine continues to prepare for the Naval Academy at the Lycée Lakanal, in Sceaux, near Paris (spring).

1919

Antoine passes the written examination, for the Naval Academy, but fails the oral. Mme. de Tricaud bequeaths the Château of Saint-Maurice-de-Rémens to her niece, Marie de Saint Exupéry.

1920

Antoine enrolls at the Ecole des Beaux-Arts (School of Fine Arts), in Paris, in order to audit classes.

1921

Antoine is drafted, to do his military service, in the 2nd RAC in Strasbourg (April 9). Transferred to the 37th RA, in Morocco, he arrives in Casablanca (August 18).
On June 18, he flies for the first time in a dual command airplane, in Strasbourg, and is then allowed to fly the Sopwith F-CTEE, on July 9. At the end of July, he has his first plane accident, after making an emergency landing. He obtains his military pilot's licence in Rabat, on December 23. Antoine passes the examination of the EOR (Officer Cadet Reserves).

1922

Antoine, made a corporal on February 5, completes his military service in Istres, at the school of Avord, in the Cher *département* (March-July), and then trains in Versailles and Villacoublay (August-September). Promoted to second lieu-

tenant, in the air force reserve, he chooses the 34th RA at Le Bourget (October 10).

1923

Antoine has an accident, at Le Bourget, in a Henriot HD-14, which he was not authorized to fly. He escapes with a skull fracture and is placed under arrest for two weeks (January). Released from military service (June 5), Antoine wishes to pursue a career in the French Air Force, but, persuaded to begin a civilian career by the family of his fiancée, Louise de Vilmorin, he works for the Tuileries Boiron (a general business company). His engagement is broken off in the autumn. His youngest sister, Gabrielle, marries Pierre d'Agay in October.

1924

Antoine becomes a representative for Saurer trucks in the central region of France. When he is in Paris, he stays at the Hôtel Titania, 70 b, Boulevard d'Ornano.

1925

Antoine works at Orly from April 1-15. He writes a short story which was never published, "Manon the dancer," as well as a poem "The Farewell."

1926

Antoine is promoted to lieutenant in the Reserve (January 15). He publishes a short story, "The Aviator," which appears in *Le Navire d'argent* (April 1). Out of this will develop the novel, *Southern Mail*. Antoine obtains his public transport pilot's license (July 5) and joins the Latécoère Company in Toulouse (October).

1927

Saint Exupéry is a pilot on the Toulouse-Casablanca-Dakar line. His older sister, Marie-Madeleine, dies (June 2). On October 19, he is named Director of the airspace in Cape Juby (Rio de Oro).

1928

Antoine spends the year in Cap Juby. July-November: many rescue missions, including those of Riguelle, Reine, Serre and Vidal.

1929

Gaston Gallimard gives Antoine a contract for seven novels. Interview with André Gide. Antoine arrives in Buenos Aires, having been appointed Director of Aeroposta Argentina (October 12). He writes *Night Flight* there. Publication, by Gallimard, of *Southern Mail*, with a preface by André Beucler.

1930

Antoine de Saint Exupéry is awarded the Order of Knight of the Legion of Honor, for his work in civil aeronautics. Antoine takes part in the search for and rescue of Guillaumet, in the Andes (June 13/18). He meets Consuelo Suncin de Sandoval, the widow of Enrique Gomez Carrillo (end of the summer).

1931

Antoine goes back to France for two months, with his mother, who has traveled to Argentina to stay with him (February). He marries Consuelo Suncin in Agay (April 12). Following a financial scandal, Aeroposta Argentina folds, and he returns to pilot the Casablanca-Port Etienne route (May-December). Publication, by Gallimard, in Paris, of *Night Flight (Vol de Nuit)*, which is awarded the Prix Femina.

1932

Antoine de Saint Exupéry is transferred to the seaplane route from Marseilles to Algiers (February 12), and then, in August, to the Airmail service between Casablanca and Dakar. Madame de Saint Exupéry sells the property of Saint-Maurice-de-Rémens. Antoine de Saint Exupéry writes the preface to Le Boucher's book, *Destin de J.-M LeBris* and publishes, in the first issue of *Marianne*, founded by Gaston Gallimard, an article entitled "Airline Pilot."

1933

Antoine de Saint Exupéry, a test pilot of seaplanes for Latécoère, writes the preface to Maurice Bourdet's book, *Grandeur et servitude de l'aviation*, as well as the scenario of *Anne-Marie*. He has another plane accident while landing, caused by pilot error, and almost drowns (December 21).

1934

Antoine joins Air France. Mission to Saigon, where he meets up with his sister, Simone, who is an archivist there. He writes an article, for *Marianne*, about the disappearance of Maurice Noguès and of Emmanuel Chaumié, and registers his first application for a patent for a new form of landing gear.

1935

Antoine and Consuelo experience severe financial difficulties. Consuelo moves into the Hôtel du Pont-Royal. Antoine meets Léon Werth and publishes, in *Air France Revue*, his "Memories of Mauritania" (spring), a report on the URSS. in *France Soir* (May), a report on "The Lieutenant of the Ship Paris" in *Excelsior* (June), a short story entitled "A Mirage" in *Le Minautaure*, No. 6, and an article on "Mermoz, the airline pilot," in *Marianne*. Raymond Bernard directs the filming of *Anne-Marie* and, in November, he gives a series of lectures in Algiers, Cairo, Beirut, Istanbul and Athens. At the end of the year, his article entitled "One might have thought that the airplane would make the world a smaller place" is published in *Air France Revue*. Flying a Caudron "Simoun" he attempts to break the Paris to Saigon flight-time record, but crashes, with André Prévot, into the Egyptian desert, in the night of December 29 to 30.

1936

Antoine leaves his apartment in the Rue de Chanaleilles, and moves into the Hôtel Lutétia, and then into rooms on the Place Vauban. That same year, he will live in Rue Barbet-de-Jouy, and later, in Rue Michel-Ange. He takes a spa treatment in Vichy, in September. From January, he has given the exclusive rights to the story of his "dramatic adventure in the desert" to *L'Intransigeant*, and has recorded his *Forced Landing in the Desert*, for the radio. He publishes an article, "Pour mieux vivre" ("To live better") in *Toute l'Edition*. In December, he devotes several articles to Jean Mermoz: "After 48 hours of silence…" and "We must go on looking for Mermoz" in *L'Intransigeant*, and "To Jean Mermoz", in *Marianne*.

1937

Antoine de Saint Exupéry continues his homage to Mermoz in *L'Intransigeant* (January), publishes an article entitled "Hurry up and travel" in *Air France Revue*, in the summer, and a report on Spain in *Paris-Soir*, in June-July. He inaugurates a new air route from Casablanca to Timbuktu to Bamako, in February, for Air France, is promoted to Captain in the Reserve (June 9), and registers four invention patents.

1938

Antoine leaves for the United States and spends several months in New York. On February 14, he attempts to break the record for flying from New York to Tierra del Fuego, but his plane crashes in Guatemala and he is badly injured (February 14).

He begins writing a new novel and writes a preface to Anne Morrow-Lindbergh's book, *The Wind is Getting Stronger*. He publishes a series of articles in *Paris Soir*, in October, and decides to change the title of his new book, at proof stage, to *Terre des hommes (Wind, Sand and Stars)*.

1939

He is promoted to the Legion of Honor (January). After a brief trip to Germany (March), Saint Exupéry visits Léon Werth, in Saône-et-Loire, and then travels to the Landes region, in south-western France, with the Guillaumets. He moves into the Château of La Feuilleraie, in the forest of Sénart, and makes a brief trip to the United States with Guillaumet, who is the pilot of the Lieutenant-de-Vaisseau-Paris, during the summer. Drafted in Toulouse on September 4, with the rank of captain, he is rejected at his military flight crew medical, a decision which he manages to have reversed in November. On November 26, he becomes a member of aerial reconnaissance group II/33 in Orconte.

The publication, by Gallimard, in February, of *Wind, Sand and Stars*, which was reviewed by Robert Brasillach in *L'Action française*, leads to him being awarded the Grand Prize for the Novel, by the French Academy. He is promoted to Officer of the Legion of Honor (January). *Terre des hommes* is translated, in the U.S.A., as *Wind Sand and Stars* (June). It will be singled out as the "Book of the Year" for 1940. Saint Exupéry publishes several articles, including "Princess from Argentina" and "The Pilot and Natural Powers," in *Marianne*, and "On board the Lieutenant-de-Vaisseau-Paris" in *Paris Soir Dimanche*, and the preface to Pilotes d'essai *(Test Pilots)*, by Jean-Marie Conty.

He has registered two patent applications during the year.

1940

On March 29, he flies his first wartime mission, followed, on the 31, by a mission over Cologne, Dusseldorf and Duisburg. On May 23, he takes off from Meaux for a mission over Arras, which forms the basis of his book *Flight to Arras*. His plane is hit by flak. On June 2, he is awarded the Order of the Air Force and receives the Croix

de Guerre (War Cross). He carries out his last war mission on June 9, and is demobilized on July 11. After a stay in Algeria, he returns to France to rest in Agay and to obtain a visa to the U.S.A., from Vichy. He learns of the death of his friend Guillaumet just before setting sail from Lisbon aboard the transatlantic liner *Siboney*, together with Jean Renoir, and lands in New York in December.

1941

Saint Exupéry moves into an apartment at 240 Central Park South. In January, he rejects his nomination, by the Vichy government, to the National Council, in an article in *The New York Times*, writing that he would have refused it if he had been consulted. In July, he stays at Jean Renoir's home in Hollywood, where he meets Annabella, the wife of Tyrone Power. After undergoing a medical operation, he convalesces at the home of Pierre Lazareff before returning to New York, in November, where he joins Consuelo. In April, he publishes "Books I remember", in *Harper's Bazaar* and, in January, he receives a National Book Award for 1939.

1942

In April-May, Antoine de Saint Exupéry gives a series of lectures in Canada. Returning to the United States, he lives, first, near Northport, Connecticut, and then in the house that had belonged to Greta Garbo, in Beekman Place, New York. In July, he asks Lewis Galantière, his English translator, to submit a plan for an Allied landing in North Africa, to General Giraud.

In February, *Flight to Arras (Pilote de guerre)* is published, with illustrations by Bernard Lamotte, followed by the "Letter to the French People", in November. The French edition of *Flight to Arras* is published by Gallimard on November 27, but is banned by Vichy in December. He writes and illustrates *The Little Prince*.

1943

Having received his embarkation orders for North Africa, as a member of the Béthouard mission, Saint Exupéry leaves the United States in April with the American fleet, debarks in Morocco and joins his friends in the 2/33 on May 5. In May, he meets André Gide, in Algiers. From April to June, he logs tens of hours of flying time and is sent on a special mission to Morocco. He is promoted to the rank of captain, on June 25, trains in June and July, on a P. 38 Lightning, and carries out his first photographic reconnaissance mission in the South of France on July 21. As the result of an accident, he is placed in the reserves and forbidden to fly.

In March, *Amérique Française* publishes the *Lettre à un ami (Letter to a friend)*. In April, *Le Petit Prince (The Little Prince)* is published by Raynal and Hitchcock, in New York. In June, Brentano's, in New York, publishes the *Letter to a Hostage*, followed, in July, by the *Letter to General X*. A clandestine edition of *Pilote de guerre*, bearing a green cover, appears in France. From September, Antoine de Saint Exupéry is at work on *Citadelle (Wisdom of the Sands)*, the drafts of which he asked Consuelo to send him.

1944

In April, Saint Exupéry is transferred, at his urgent request, to the 2/33 for five missions. In the night of May 28 to 29, he writes an article to accompany photographs of him by John Phillips promised to *Life*, which will be published as *Letter to an American*. From May to the end of the month of July, Saint Exupéry flies eight reconnaissance missions before being placed in the reserves.

His last mission takes place on July 31. He is officially declared missing on September 8.

1945

On September 20, he is officially deemed to have "died for France."

1948

On March 1, Gallimard publishes *Citadelle (Wisdom of the Sands)*.

List of Illustrations

recto. Private collection.

p. 123. *Terre des hommes (Wind, Sand and Stars)*. handwritten manuscript, preparatory chapter on the desert, folio 29. © Estate.

p. 124. Madame Raccaud in front of the wreckage of the plane. Private collection.

p. 125. Note to Madame Raccaud, 1936. Private Collection.

p. 126. Illustration by André Derain for *Citadelle (Wisdom of the Sands)*. © ADAGP, Paris, 2003.

p. 127. *Citadelle*, handwritten manuscript. Bibliothèque Nationale de France, Paris, Department of Manuscripts, NaF 18 264, folio 114. © Estate.

Chapter VII

P. 128. Preparatory drawing for *The Little Prince*. Illustrated handwritten manuscript. The Pierpont Morgan Library, New York. © Estate.

p. 129. Self-portrait by Saint Exupéry, around 1940. Private collection. © Estate.

p. 130. In March 1940, in the officers' mess in Athiès-sous-Laon, Saint Exupéry comments on a patent he has registered. D.R. [Rights reserved].

p. 131. Patent of July 22, 1939, registered by Antoine de Saint Exupéry for the "Perfecting of the control of engines in flight by a single indicating instrument." INPI.

p. 132. Two drawings for the study of a torpedo. Collection of Philippe Zoumaroff. © Estate.

p. 133. A drawing by Saint Exupéry, undated. Private collection. © Estate.

p. 134. Saint Exupéry's hand, writing. © Collection of the D'Agay family.

p. 135. Letter to his mother, 1910. Archives Nationales de France, 153 AP 1, folios 1 and 2. © Estate.

p. 136. Drawing by Saint Exupéry. Private collection. © Collection of the D'Agay family.

p. 137. *The Problem of the Pharaoh*. Liège, Aelberts, 1957.

pp. 138 and 140. Sketches for a study of aerondynamic lift. Private collection. © Estate.

pp. 139 and 141. Sheets from the *Essais scientifiques sur l'aéronautique (Scientific Essays on Aeronautics)*. Unpublished typescript of the patent for an "Aerial Torpedo". © Estate.

p. 142. Binding of *Notebook I*, by Saint Exupéry. © Collection of François d'Agay.

p. 143. *Notebook I*, no. 1. © Collection of François d'Agay.

p. 144. Precautionary notice by Saint Exupéry to have his notebook returned to him in case he misplaced it. © Collection of François d'Agay.

p. 145. *Notebook I*, no. 17. © Collection of François d'Agay.

p. 146. Drawing presented by Saint Exupéry to Colonel Max Gelée. Private Collection. © Estate.

p. 147. Problem posed on July 15, 1944 to Colonel Max Gelée. Autograph by Captain de Saint Exupéry. Gift of General Gelée to the Aviation School in Salon-de-Provence. Photograph belonging to the Aviation School. © Estate.

Chapter VIII

p. 148. Drawing by Bernard Lamotte for *Pilote de guerre (Flight to Arras)*. © Estate.

p. 149. Saint Exupéry, photograph by John Phillips.

pp. 150, 153, 154. Several drawings in the margins of notes taken in New York. Collection of Philippe Zoumeroff. © Estate.

p. 151. Bank deposit book used by Saint Exupéry in New York in 1942. Collection of Philippe Zoumeroff.

pp. 152-153. Drawing in the margins of notes taken in New York.

p. 154. Drawing in a letter to Léon Werth. Collection Werth. © Estate.

p. 155. Autograph text of February 11, 1940. Private collection © Estate.

p. 156. Antoine de Saint Exupéry at the time when he was drafted. D.R. [Rights reserved]

p. 157. *Flight to Arras*. Typescript with handwritten corrections, preparatory state, numerous variants compared to the published text. Bibliothèque Nationale de France, Paris. NaF 25126, folio 40. © Estate.

p. 158. Drawing by Bernard Lamotte for *Pilote de guerre*. © Estate.

p. 159. *Pilote de guerre*, handwritten manuscript. Bibliothèque Nationale de France, Paris. Department of Manuscripts, NaF 25136, folio 101. © Estate.

p. 160. Antoine de Saint Exupéry reading his speech, "France first," over the radio. © Estate.

p. 161. "France first", November 1942. Fragment of the handwritten manuscript of the speech. Collection of Philippe Zoumeroff. © Estate.

p. 162. Jacques Maritain in the 1930s. © Martinie-Viollet.

Nationale de France, Paris. Department of Manuscripts, NaF 25 126, folio 113. © Estate.

p. 200. Self-portrait of Saint Exupéry, as an aviator, drawn in a letter to his mother, 1921. © Estate.

p. 201. Extract from the letter to Pierre Dalloz, July 30, 1944. Archives Nationales de France, Paris, 153 AP 1, dossier 1, folio 641. © Estate.

p. 202. Drawing in the margin of the manuscript of *Citadelle*. Bibliothèque Nationale de France, Paris, Department of Manuscripts, NaF 18 264, folio 16. © Estate.

p. 202. *Citadelle*, handwritten manuscript. Bibliothèque Nationale de France, Paris, Department of Manuscripts, NaF 18 264, folio 5 © Estate.

Bibliography

Books by Antoine de Saint Exupéry

Courrier Sud, 1929. *Southern Mail*, translated by Curtis Cate, New York, Harcourt Brace, Jovanovitch, 1971.

Vol de nuit, 1931. *Night Flight*, Preface by André Gide, translated by Stuart Gilbert, New York, H.B.J., 1932.

Terre des hommes, 1939. *Wind, sand and Stars*, translated by Lewis Galantière, New York, H.B.J., 1967.

Pilote de guerre, 1942. *Flight to Arras*, translated by Lewis Galantière, New York, H.B.J, 1942.

Lettre à un otage (Letter to a hostage), 1944.

Le Petit Prince, 1946. *The Little Prince*, New York, H.B.J., 1971.

Citadelle, 1948. *Wisdom of the Sands*, Chicago & London, University of Chicago Press, 1979.

Lettres à sa mère (Letters to his mother), 1984.

Écrits de guerre, 1994. *Wartime Writings*, 1939-1944, New York, H.B.J, Translated by Norah Purcell. Introduction by Anne Morrow Lindbergh, 1986.

Carnets (Notebooks), 1999.

Œuvres complètes (Complete Works), 2 volumes, Bibliothèque de la Pléiade, 1994 and 1998.

Cahiers Saint Exupéry (Journal), 5 volumes, 1980, 1981, 1989, 1999, 2000.

In French, all of the novels, as well as the *Letters to his mother* and *Carnets* are available in the "Folio" paperback collection (Editions Gallimard).

In English, paperback editions of the novels are available from H.B.J.

Article: "Books I Remember," In *Harper's Bazaar*, April 1941, p. 82.

Books about Antoine de Saint Exupéry

In English:

Curtis Cate, *Antoine de Saint Exupéry*, New York, Paragon House, 1990.

Manuel Migea, *Saint-Ex*. New York, McGraw Hill, 1960.

Joy D. Marie Robinson, *Antoine de Saint Exupèry*, Boston, Twayne Publishers, TWAS 705, 1984.

Consuelo de Saint Exupéry, *Kingdom of the Rocks: Memories of Oppède*. New York, Random House, 1946.

Consuelo de Saint Exupéry, *The Tale of the Rose: The Passion that inspired The Little Prince*. Translated by Esther Allen. New York, Random House, 2001.

Stacy Schiff, *Saint Exupéry, A Biography*. New York, Da Capo Press, 1996. (first edition: Alfred A. Knopf, Inc., 1994)

Paul Webster, *Antoine de Saint Exupéry, The Life and Death of the Little Prince*, London, Macmillan, 1993.

Articles by Lewis Galantière: Antoine de Saint Exupéry, *The Atlantic*, April 1947, pp. 133-141; "The most unforgettable character I've met," *Reader's Digest*, December 1957, pp. 174-179.

In French:

Curtis Cate, *Saint Exupéry, laboureur du ciel*. Paris, Grasset, 1984.

Pierre Chevrier, *Saint Exupéry, la bibliothèque idéale*. Paris, Gallimard, 1958.

Nathalie des Vallières, *Saint Exupéry. L'archange et l'écrivain*. Paris, Gallimard, collection Découvertes, 1998.

François Gerber, *Saint Exupéry. De la rive gauche à la guerre*. Paris, Denoël, 2000.

Stacy de La Bruyère, *Saint Exupéry, une vie à contre-courant*. Paris, Albin Michel, 1994. Includes lengthy bibliography.

John Phillips, *Au revoir Saint-Ex*, Paris, Gallimard, 2000.

Hugo Pratt, *Saint Exupéry, le dernier vol*. Paris, Castermann, 1994.

Simone de Saint Exupéry, *Cinq enfants dans un parc*. Paris, Gallimard, 2000.

Léon Werth, *La Vie de Saint Exupéry*. Paris, Éditions du Seuil, 1948.

Léon Werth, *Saint Exupéry tel que je l'ai connu*. Paris, Éditions Viviane Hamy, 1994.